THE NEUROANATOMY OF LEONARDO DA VINCI

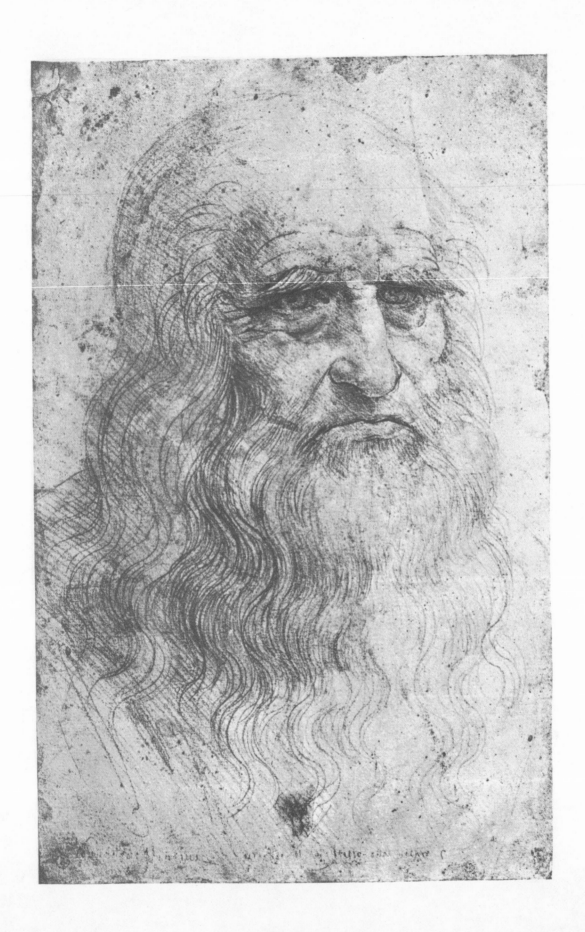

THE NEUROANATOMY
of
LEONARDO da VINCI

EDWIN M. TODD

Preface by
CARLO PEDRETTI

Foreword by
KENNETH D. KEELE

CAPRA PRESS
SANTA BARBARA

Printed in the United States of America
Published by Capra Press
Post Office Box 2068
Santa Barbara, California

ISBN 0-88496-214-8

To Adalene

CONTENTS

PREFACE

The author of this book is an accomplished neurologist, an internationally renowned brain surgeon who has followed a natural impulse to learn more. Aristotle, Dante, and Leonardo, all said the same thing to inspire him: "By nature, good men desire to know." And so our good Dr. Todd has become a student again. The result is a much needed assessment of Leonardo's neuro-anatomy considered analytically and historically in all its intensity and limitations, and presented with a forceful and fastidious style that characterizes the writings of a humanist—one, however, who approaches the minds of the past with scientific humility.

Dr. Todd shows how scientific truth can be revealed through poetry. One may say that the example is provided by Leonardo himself with his drawings which are both scientific diagrams and works of art. There is a lesson in this. When a drawing is beautiful—and Leonardo's drawings are consistently so, regardless of the subject—it becomes an irresistible object of study, a powerful tool in the service of knowledge.

Dr. Todd proves the point. He shows us how there is beauty in scientific precision. And he does so by presenting Leonardo's drawings in their chronological sequence, to explain them as extraordinary documents of a lifelong preoccupation with the idea of replacing traditional belief with a knowledge of facts based on experience. To quote Leonardo: "The eye which thus clearly offers proof of its functions has even down to our own times been defined by countless writers in one way, but I find by experience that it acts in another." It is a factual knowledge that calls for a factual language. To quote Leonardo again: "Men and words are facts, and you, O painter, if you do not know how to make your figures, you are like an orator who knows not how to use his words."

The Leonardo drawings in general, and those reproduced in this book in particular, are therefore a synthesis of the working of his mind. But it takes the probing perception and knowledge of a neurologically-oriented mind to penetrate their character. And because the mind of this author is also endowed with poetic inspiration, their beauty is now fully revealed to us.

CARLO PEDRETTI

University of California
Los Angeles
22 February 1983

FOREWORD

The name of Leonardo da Vinci casts a spell over the twentieth century mind—a spell which carries the dual dangers of excessive adulation and excessive reactionary criticism. Praised as "a man who awoke too early in the darkness while the others were still asleep," he was in his day criticised as a heretic and sorcerer possessed of secret knowledge. It is not always realised that such a reputation put him in danger of his life let alone ideological intolerance. Even Vasari describes him as a man who had "offended God and man" by his work. The sensitive Leonardo would be well aware of this. So to his other virtues one must add that of a quiet courage which is seldom sufficiently recognised.

This courage was accompanied by two outstanding characteristics; an all-consuming curiosity combined with a superlative visual faculty which expressed his powers of observation and experiment in drawings.

Dr. Todd has concentrated on Leonardo's research in Neuroanatomy. In doing this he has painted a detailed picture of Leonardo's progress from ancient and medieval views to his final achievements. He seems embarrassed by Leonardo's erroneous early drawings. This in my judgement is unnecessary when one comprehends Leonardo's circumstances and objectives. Leonardo's visual capacity was not limited to the direct observation of nature; it extended to the written words of the ancient authorities from whom he took his early views of the nervous system. Therefore it is no criticism of Leonardo when he visualises, for example, in one vivid drawing of K/P 35r, the nervous system as described by Plato in his **Timaeus**. *This overflows with anatomical errors. Many of these Leonardo corrected, some he did not. The research which Dr. Todd carries out so logically throughout the work presents clearly and succinctly just how successful and unsuccessful Leonardo's efforts in this field were.*

It is helpful to compare Leonardo's visualisation of the views of his authorities with his visualisation of natural objects, particularly in this context, his drawings of the skull and the spinal column. Here his achievements rightly receive universal praise. They are triumphs of descriptive anatomy. But to Leonardo they were more than that. The drawings of the skull in Figs. 20 and 21 of this book (K/P 43r) contain geometrical figures which purport to locate both the "senso comune" and the centre of gravity of the skull balanced on the cervical vertebrae. These figures reveal Leonardo's intense desire to see all natural events in geometrical terms, even including the location of the soul in the third

ventricle of the brain. No wonder that any contemporary who understood his work at all dubbed him a heretic.

The nature of the soul occupies a very lengthy discussion in the midst of his anatomical studies. Here at first sight it seems out of place but on deeper consideration this debate, carried out with typical Leonardian thoroughness, can be seen to be very relevant to his anatomy and physiology of the nervous system. Indeed, it is in relation to Leonardo's concept of the function of the soul in the nervous system that I can perhaps make a contribution to Dr. Todd's Neuroanatomy.

Leonardo's concept of the sensory and motor functions of the central nervous system were intimately tied to his laws of physical powers. Throughout Nature he saw "four powers" at work; movement, weight, force and percussion. Each of these is described and discussed at great length in his thousands of pages of notes. He applies them to the microcosm of the human body as intensively as he does to the macrocosm of the external world. For example, on K/P 153r Leonardo writes, "Why Nature cannot give movement to animals without mechanical instruments is demonstrated by me in this book on the active movements made by Nature in animals. And for this reason I have drawn up the rules of the four powers of Nature without which nothing through her can give local motion to these animals. Therefore we shall first describe this local motion, and how it generates and is generated by each of the other powers." He then proceeds to describe the powers of weight, force and percussion in relation to physiological movements. At the centre of all sensation and movement is the soul which exerts what he calls a "spiritual" force throughout the nervous system. This rests on his definition of "spirit" and "soul"; and this is the subject of his lengthy discussion occupying four pages of script from K/P 50r to K/P 48v. Here he explains that, "The definition of a spirit is a power united to a body." (K/P 49r and v) Leonardo used the word "spiritual" to describe all his four physical powers—and others, including the power of the magnet. "Spiritual" force, in his view, is physical force. It is "invisible life, incorporeal since the body where it arises does not increase in size or weight." (Codex Atlanticus 253c) Thus the soul becomes for him a source of physiological "power" which he eventually locates in the third ventricle where, he is careful to point out, it "resides" but does not occupy any space. A good analogy is the power of a magnet, or an electrical charge. The forces emanating from the soul, according to Leonardo, exerted both sensory and motor functions of the body through what he called the "tree of the nerves."

Writing of the force which is distributed through the nerves, Leonardo says, "Force has its origin from spiritual movement, and this movement

flowing through the limbs of sentient animals broadens their muscles. Whence these muscles contract and draw back the tendons connected to them....And this is the cause of the force of the limbs in man." (Codex Arundel 151r) Thus he took the view that all the movements of man's body consist of transmutations of its shape, in infinite variety.

And the soul, "Finding itself enclosed in the human body is ever longing to return to its Author. And you must know that this same longing is that quintessence which is inseparable from Nature; and that man is a model of the world." (Codex Arundel 156v) Here is obtained just a glimpse of Leonardo's integration of man's soul with that of the macrocosm of the world and its "Author" or Creator. It was a view closer to Aristotle and some twentieth century scientists than the orthodox Christianity of his day. Indeed, as Vasari said of Leonardo, "He formed in his mind a heretical view of things, not in agreement with any religion; evidently he preferred being a philosopher to being a Christian." And one vector along which Leonardo progressed towards his uniquely integrated concept of art, science and religion was that of the neuroanatomy which Dr. Todd so stimulatingly decribes for us in this book.

KENNETH D. KEELE

Leacroft House
Leacroft
Staines
Middx TW is 4NN
6 August 1982

ACKNOWLEDGEMENTS

This book could not have been prepared without the generous assistance of many individuals and the kind cooperation of several institutions. I am deeply grateful to the late Dr. Elmer Belt for his warm and friendly encouragement, and for the many doors that were opened for me precisely because of his patronage, not the least of which was the door of the Belt-sponsored library at Vinci, Italy, on a certain holiday Sunday.

To the Hon. Mrs. Jane Roberts, Curator of the Print Room, Windsor Royal Library, I wish to express particular appreciation for allowing me access to the Windsor collection of anatomical drawings, and for providing me with such delightful study accommodations overlooking the distant spires of Eton and the playing fields of St. George across the Thames. The drawings and text are reproduced by gracious permission of Her Majesty Queen Elizabeth II.

The inspirational source of all my studies on Leonardo was to be found in the person of Professor Carlo Pedretti whose assistance, patience, and profound erudition were the recurring springs that nourished my research activities. These studies were amplified and refined under the concerned and dedicated personal tutelage of Professor Amos Funkenstein in Renaissance and Reformation studies, Professor L. R. C. Agnew in the History of Medicine, Professor John Burke in the History of Technology, and Professor Robert G. Frank in the History of Science. I remain indebted to Professor Frank, my advisor, for his contributions, guidance, criticism, and careful attention to the preparation of the original dissertation manuscript from which this book derives.

Dr. Kenneth Keele kindly furnished critical commentary and material support to my research efforts, and I am most grateful to him for his thoughtful and provocative Foreword.

It was in the Elmer Belt Library of Vinciana at the University of California, Los Angeles, that the greater part of this research was carried out. A complete collection of facsimile editions of the Leonardo manuscripts as well as most of the material pertaining to the study of the manuscripts and their sources facilitated the research process. My task was greatly eased by the assistance and moral support provided by Mrs. Joyce Ludmer, head of the Art Library of the Dickson Art Center and her assistants, Victoria Steele and Eva Jane Boranian in the Belt Library. I have also profited greatly from the resources of the Research Library, the Biomedical Library, especially the History and Special Collections Division headed by Dr. Sandra Colville-Stewart, all at the University of California, Los Angeles.

Grateful acknowledgement is made to the many librarians and curators who furnished kind support at the Wellcome Library in London, the Biblioteca Ambrosiana in Milan, and the Biblioteca Laurenziana in Florence.

Finally, sainthood would scarcely reward the extraordinary services of my dear wife, Adalene, who serenely endured my bearish manners and miserable handwriting to patiently edit and type out the finished manuscript.

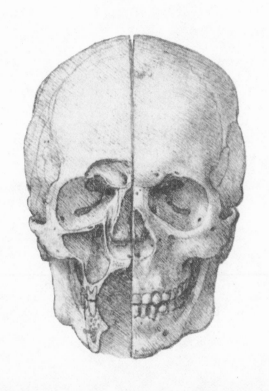

CHAPTER ONE

Reflections on Leonardo and the Nervous System

TACIT SUBMISSION TO MENTAL BLINDERS WHICH RIGIDLY CONFINE OUR VIEW OF
the world is a curious but cogent condition of the human
predicament. Most of us see only what we know. A chosen few
manage to peek beyond the psychological barriers for a fleeting
glimpse at the hidden springs of creativity. Rare indeed is the
unencumbered mortal mind that freely pierces the veil of
authority to dwell at ease in the wondrous unknown. Such a
blithe anomaly was Leonardo da Vinci.

A fortuitous commingling of extraordinary genes from the
illicit union of a young Tuscan notary and a peasant girl produced
one of the most complex and enigmatic intellects of all time. By
happy chance his timely arrival coincided ideally with a march of
circumstances over the previous two hundred years that had
culminated in a rich Renaissance artistic heritage, peculiarly
suitable to his incipient talents. In this environment he was quick
to sharpen his sensory endowments and cultivate the keen habits
of observation essential for accurate descriptive illustration.

In his search for knowledge Leonardo was direct and uninhib-
ited. His fiercely independent gaze ranged widely over the known
and ever flirted with the unknown in the arts and sciences of his
day. With these perceptive gifts of visual penetration he assid-
uously examined the natural world about him, conjuring vivid
mental images that materialized into original thought-forms on
paper in a uniquely personal style. Such is the province of genius
that these strangely marvelous thought-forms were recorded on
whatever scraps of paper at hand, and in a most irreverent
manner; i.e., as a free flow of random ideas, seldom true to any
single theme on a separate sheet. This book attempts to gather
the scattered evocations from the moments when his attention
lingered ever so briefly on the anatomy of the nervous system.

A list of the abbreviations used in the
footnotes appears on page 184. A bib-
liography follows on page 185.

Scattered widely through his notebooks, of which more than five thousand pages survive, and randomly juxtaposed among an extraordinary diversity of subjects, the neuroanatomical drawings and descriptive commentary of Leonardo da Vinci invite and deserve a comprehensive appraisal. Of these notebooks, Leonardo remarked prophetically, "This will be a collection without order, made up of many sheets which I have copied here, hoping afterwards to arrange them in order in their proper places according to the subjects of which they treat." His prediction was accurate, if understated, but time was unkind and his hope, alas, never materialized. Fortunately, transcripts of the original manuscripts and high quality facsimiles made with advanced photographic techniques make the task of fulfilling his expressed wishes eminently practicable. Da Vinci scholarship can now focus on the process of distilling, collating, and integrating the various themes that emerge from the restrictive obscurantism of his bizarre handwriting.

A study of Leonardo's concern with the nervous system covers a period of roughly twenty years, from about 1487 to about 1508 or 1509, revealing an early mastery of the artist's craft and a progressive development to the status of mature anatomist. Thus, some of the early anatomical discoveries are no less brilliantly executed than the later works, but as he enlarges his experience, we are able to discern a steady technological improvement and a refinement of methodological skills. This becomes apparent in the superior design and better organized sequences of the later sketches. The analytic process is facilitated by breaking down his nervous system into component subjects and arranging the material of each subject in a tentative chronological order.

A semblance of historical perspective is manufactured by looking backward to review the state of anatomical illustration before da Vinci, and by looking forward to compare his drawings with their counterparts in modern textbooks. However, an assessment of his impact on his own time and the immediate aftermath is untenable, and really undeterminable, owing to the presumed inaccessibility of the notebooks, and the purely inferential nature of the evidence.

An overview of the neuroanatomical corpus cannot fail to perceive a most compatible blending of art and science. With the

inductive firming of his methodology, we are able to mark the narrowing of the quality gap between form and functional explanation. From his early dependence upon authority we can trace a rough course that marks the changes to a more confident reliance on his own research methods. Neuroanatomy reaped a share of the ultimate rewards as his scientific methods became more consciously rational in the general context of his intellectual development. This study hopes to reveal some of these rewards.

So many of the notebooks and loose sheets are missing that a purview of any one subject pretending to measure his true worth is only idle speculation. Be that as it may, it is still clear that elements of the nervous system occupied Leonardo's earliest thoughts as his interest in anatomy began to appear in the notebooks. Moreover, his development and eventual maturity as an anatomist is incompletely reflected in the spotty, recurring indulgences that characterized his dealings with this system. Nevertheless, strung together, these fragments do have a semblance of continuum from which it is possible to distinguish the inductive firming of his methodology, and by anecdotal sequence, a progressive narrowing of the quality gap between descriptive illustration and functional explanation. Kemp marks this change as a movement "towards the resolution of functions to fit known forms; and away from the creation of forms to fit preconceived functions."[1] Kemp's view derived from a plenary appraisal of the anatomical corpus, but the same sentiments, couched in different terms, have been applied by Keele to explicate the evolving precision and logical elaboration of Leonardo's thoughts on the nervous system. Keele proposes a three-stage progression from early dependence upon authority, to a more confident reliance on his own research methods, to a final phase where scientific methods become more consciously rational in the general context of his intellectual development.[2]

We see Leonardo at his worst in his pretentious early efforts to give visual reality to ancient authority on the subjects of generation or the situs of the *senso commune*. We squirm with his tortured quest to discover the true optics of vision under the delusion of preconceived notions that the image had to imprint on the optic nerve in an upright position. We are appalled when brilliant discoveries are marred by slavish repetition of Galen's errors in the same drawings, or by completely erroneous

1. Martin Kemp, "Dissection and Divinity in Leonardo's Late Anatomies," *London Journal of Warburg and Courtland* 35 (1972): 200-25.

2. Kenneth D. Keele, "Leonardo da Vinci's research on the nervous system," *Essays on the History of Italian Neurology*: Proceedings of the International Symposium on the History of Neurology (Varenna:n.p., 1961), pp. 15-29.

interpretation of observed facts as when he fancies lateral auxiliaries of the spinal cord in the vertebral canals.

Our patience is rewarded, however, as his knowledge of the nervous system improves, as diagrammatic fantasies are replaced by masterpieces of observational and experimental revelation. The brain assumes recognizable form when wax castings outline the internal environment of the ventricles; a spinal column appears with accurate curvatures, pelvis alignments, and rib attachments which, for the first time, allows a body to stand, walk, and breathe; a mechanism of peripheral sensory-motor activity is conceptualized under central control; and a more disciplined and logical explanatory text gradually fits function more equitably to superbly rendered forms.

The nervous system is a fair starting point for a study of Leonardo's prodigious anatomical endeavors, but it is only a beginning. In isolation, it will not serve as a true measure of his achievements. It is merely an antipasto to be savored for the delicious insights it provides. The feast lies ahead in the cornucopian anatomical corpus itself if one has a proper taste for exciting discovery, technical innovation, and brilliantly conceived experimental demonstration, all delicately garnished with beauty and stylish artistry from the exquisite recipes of a consummate master of the cuisine.

CHAPTER TWO

Drawing as a Tool

FOR A YOUNG FLORENTINE ARTIST, THE LATE QUATTROCENTO WAS A GREAT
time to be alive. His heritage was a new world-view that had
shifted from a medieval concern with the hereafter to a
contemplation of the things of this world. Haunting memories of
Giotto, Dante, Petrarca, and Boccaccio lingered as inspirational
models for their spiritual heirs in a most seminal milieu for
creative expression.[1] Painting was no longer a matter of cropping
a two-dimensional surface with expressionless religious symbols
of natural objects. Reality was now portrayed with vivid
naturalness giving the illusion of three-dimensional space from
the skillful utilization of geometrical forms, proportion, and
perspective. Leonardo stood on the shoulders of Alberti, Masaccio,
Brunelleschi, Uccello, and Ghiberti to expand the potentials of
these technical devices in new and exciting ways.[2]

Neurological anatomy is only a small segment of the vast
Corpus Vincianum but it is an eloquent expression of the major
thrust of the entire work—the use of drawing for the exposition
of knowledge. This is a unique tradition-shattering aspect of his
genius that deserves our attention. It entails a very personal
theory of knowledge which synthesizes art and science into a
distinctive intellectual force that persists and transcends the
vagaries of fragmented, incomplete, defaced, often incoherent
surviving manuscripts.[3] We can only surmise the impact that the
published works would have had on the contemporary scene. It is
reasonable to suppose that this particular contribution diffused
through the art and engineering communities by various leaks
from his students, friends, and patrons, but there is little evidence
to support a presumption that it filtered into academic circles, and
we can only speculate cautiously regarding its influence on
learning methods.[4] In this regard, Chastel felt compelled to

1. Brian Pullan, *A History of Early Renaissance Italy* (London, 1973), p. 169; for a fuller discussion of these changes, see P. O. Kristeller, *Renaissance Thought: The Classic, Scholastic, and Humanistic Strains* (New York, 1961), A. J. Huizinga, *Men and Ideas: History, the Middle Ages, the Renaissance* (New York, 1959), and Ernst Cassirer, *The Individual and the Cosmos in Renaissance Philosophy*, trans. Mario Domandi (Oxford, 1963), but still most revealing in the words of Jacob Burckhardt, *The Civilization of the Renaissance in Italy* (in many editions), the nineteenth-century historian who did most to evoke the modern concept of the Renaissance.

2. These general statements are supported by a host of authors among whom I have consulted Kenneth Clark, *Leonardo da Vinci: An Account of His Development as an Artist* (New York, 1973), Carlo Pedretti, *Leonardo: A Study in Chronology and Style* (Berkeley and Los Angeles, 1973) and "Leonardo e i suoi contemporanei," *Studi Vinciani* (Geneva, 1957), André Chastel, *The Genius of Leonardo da Vinci* (New York, 1961), and George Sarton, "Art and Science," in *Leonardo da Vinci: Aspects of the Renaissance Genius*, ed. Morris Philipson (New York, 1966).

3. For information regarding the current status of efforts to integrate and assign a semblance of coherence and chronology to the scattered works, see Carlo Pedretti, *The Literary Works of Leonardo da Vinci Compiled and Edited from the Original Manuscripts by Jean Paul Richter*. 2 vols. (Berkeley and Los Angeles, 1977).

4. Contemporary opinions on Leonardo's influence are scattered through private letters and diaries from which

no convincing overview emerges. Our best references are found in short biographical works, notably Giorgio Vasari, *Le vite de piu eccellenti pittori, scultori e archetettori* (Florence, 1568), Anonimo Gaddiano, *Codex Magliabechiano*, Florence, Biblioteca Nazionale, cl. xvii, 17. ed. C. Frey (Berlin, 1892), and Paolo Giovio, *Leonardo Vincii vita* (ca. 1527) trans. J. P. Richter, *The Literary Works of Leonardo da Vinci* (London, 1939), but also and perhaps most cogently, in other fragmentary writings by Giovio as edited by Pedretti in the *Richter Commentary*, I:9-11.

5. André Chastel, *The Genius of Leonardo da Vinci,* trans. E. Callmann (New York, 1961), p. x.

6. Vesalius, Berengarius, Colombo, and Eustacius, to mention a few, were all notoriously delinquent in citing sources, yet elements of Leonardo's style and technique hang heavily over their works.

7. The contrast is eloquently articulated by comparing such contemporary works as A. Benedetti, *Historia corporis humani: sine anatomice* (Venice, 1502) or G. Zerbi, *Anatomiae corporis humani et singulorum illuis membrorum liber* (Venice, 1502), with a spiritual heir of Leonardo's pioneering activities, A. Vesalius, *De humani corporis fabrica libri septum* (Basel, 1543).

8. Leon Battista Alberti, *Della pittura:* J. B. Spencer, *Leon Battista Alberti, on Painting* (New Haven, 1956).

declare: "...how soon and how assiduously his works were copied, so that one has the feeling that whatever he did produce was observed and made use of with disturbing persistence."[5] It must suffice to note that he existed at a time when a slow, rumbling buildup was occurring in the publication of illustrated texts, many reflecting themes for which we have no precedents other than in Leonardo. There is certainly no precedent for his exquisite anatomical drawings. The sources of the ideas for some of these works, when not original, can be elucidated rather well by research, but the subtle influences of his creations on peers and later anatomists died with the parties. Anatomists were a tight-lipped set who seldom mentioned contemporary sources.[6] The fact that it was not healthy to differ with Galen should not have prevented acknowledgement of technical priorities; nevertheless, this courtesy was universally ignored. We must infer his influence from his stylistic, methodological, and technical innovations that permeate the works of subsequent authors to raise anatomical explication from a morass of textual confusion to a graphic representation of discernable relationships.[7] It becomes apparent that Leonardo's example did not go unheeded in other areas of learning where the favorable contrast of his illustrative drawing techniques sharply accentuated the inadequacies of textual description at a time when terminology was often loose, lacking, ambiguous, or inappropriate. The modern mind, grown accustomed to the luxury of well illustrated texts, may fail to grasp the cataclysmic nature of this change. Prior to Leonardo, anatomical texts were totally devoid of illustrative material. Indeed, this curious incongruity even extended to descriptive texts on the theory of art itself. Alberti's capolavoro, *Della pittura*, is no exception.[8] The first illustrated edition of this work as well as his book on architecture appeared more than a century after they were written. A catalyst was necessary to effect a gestalt-shift in the printing mentality and to pierce the psychological barriers of tradition.

A voice cried out in the wilderness:

> O writer! with what words will you describe the configuration with the perfection that the illustration here gives? This, not having knowledge, you describe confusedly and allow little information of the true form of things, deceiving yourself in believing that you can satisfy the auditor in speaking of the configuration of any corporeal

object, bounded by surfaces. But I remind you not to involve yourself in words, unless you are speaking to the blind, or if, however, you wish to demonstrate by words to the ears, you will be very far surpassed by the work of the painter. With what words will you describe the heart without filling a book, and the more you write at length, minutely, the more you will confuse the mind of the auditor.[9]

9. QII, I. Quoted in J. Playfair McMurrich, *Leonardo da Vinci the Anatomist* (Baltimore, 1930), p. 34.

These sentiments are couched variously as recurring themes throughout his notebooks, as for instance when he declares:

> And ye who wish to represent by words the form of man and the aspects of his membrification, get away from this idea. For the more minutely you describe, the more you will confuse the mind of the reader, and the more you will prevent him from a knowledge of the thing described. And so it is necessary to draw and describe.[10]

10. AnA, 14v., McMurrich, *The Anatomist*, p. 76.

Lest it be supposed from these quotations that his purposes were confined to anatomy it should be stated that his notebooks clearly indicate that the same attitudes are reflected in every subject that his curiosity subjected to scrutiny. As MacCurdy relates in his preface:

> It was the cramping fetter of medieval tradition upon thought which Leonardo toiled to unloose. It was his aim to extend the limits of man's knowledge of himself, of his structure, of his environments, of all the forms of life around him, of the manner of the building up of the earth and sea, and the firmament of the heavens. To this end he toiled at the patient exposition of natural things, steadfastly, and in the proud confidence of purpose.[11]

11. Edward MacCurdy, *The Notebooks of Leonardo da Vinci* (New York, 1954), p. 31.

MacCurdy and others who have devoted a great deal of time and thought to the Leonardo mystique have concluded that the need to know was a merciless driving force which Leonardo in turn interpreted as man's highest aim.[12] The fruits of his quest were enormous. His sincere conviction that pictorial representation was an essential adjunct and superior to the written description for conveying "accurate knowledge" is reflected everywhere in his prodigious output. In his examination of the recently discovered Madrid manuscripts, Pedretti was intrigued by a recurring theme exhibited in numerous specific instances that comprehends the richer expressive possibility of drawing as a language that transcends ordinary language,

12. Ibid., p. 40. Cf. Chastel, *Genius,*, p. 148, Clark, *Development as an Artist*, p. 159, Pedretti, *Studi Vinciani*, p. 12, McMurrich, *The Anatomist*, p. 251.

C'è infatti un elemento nell'opera de Leonardo che serve proprio da commune denominatore, da tessuto, a tutti gli argomenti da lui affrontati, e questo è il disegno— disegno come linguaggio. Si tratta di un tema che ha forse lo stesso fascino, diretto e immediato, che può derivare a chi indugiasse a sfogliare questi magnifici facsimili.[13]

Our interest requires that we confine our attention to anatomical matters once the point has been made that drawing was a constant tool which Leonardo employed assiduously to fashion all elements of his microcosm within the macrocosm. Adolfo Venturi expresses this involvement rather succinctly:

> For Leonardo, drawing was a thought, a phrase, a sentence. His mind expressed itself in silverpoint, pencil, charcoal, or ink rather than in words. His sketches are a kind of ideography which follows the course of his thought and his observations of the life of things. The mobility of his thought can be traced on every sheet...[14]

In his continuing dedication to the study of man's inner workings, especially as it involves anatomy, there is a paradox that defies analysis. How could this man of refined tastes, whose delicate sensitivity is evident in every stroke of his brush, ever endure the revolting environment of a Renaissance dissection chamber, chambers that existed only in dark, subterranean dungeons where the foul, offensive stench of rotting cadavers was his only company. This was before the discovery of fixatives when the dissector's knife had to move quickly lest the insubstantial flesh putrify in his grasp.[15] The enigma is not explained but only emphasized by his own insightful analysis:

> But though possessed of an interest in the subject, you may perhaps be deterred by natural repugnance, or if this does not restrain you then perhaps by the fear of passing the night hours in the company of these corpses quartered and flayed and horrible to behold, and if this does not deter you then perhaps you may lack the skill in drawing essential for such representation; and even if you possess this skill it may not be combined with a knowledge of perspective, while if it is combined you may not be conversed in the methods of geometric demonstration, or you may perhaps be found wanting in patience so that you will not be diligent.[16]

Leonardo's apprenticeship in Verrocchio's bottega in the 1470s occurred at a time of passionate renewed interest in the nude figure, generated at least in part by the humanist's revival of

13. Carlo Pedretti, "Leonardo da Vinci: disegno come linguaggio," *Il Veltro* 1-2 Anno XIX (Gennaio-Aprile 1975): 27.

14. Adolfo Venturi, "The Drawings of Leonardo," in *Leonardo da Vinci,* ed. Costantino Baroni (New York, n.d.), p. 89.

15. Expediency dictated that the most perishable parts be dissected first, and thus, according to C. D. O'Malley, *Andreas Vesalius of Brussels 1514-1564* (Berkeley and Los Angeles, 1964), p. 13, "...the work was first concerned with the contents of the abdominal cavity, next with the thorax, then with the head and the extremities." Little wonder that even Leonardo paid scant attention to the brain itself when we realize how rapidly this organ deteriorates, virtually dissolving into a soupy consistency within a few days.

16. QI, 13v., Richter, *Literary Works*, p. 108.

classical antiquity.[17] Painters and sculptors studied nude models and flayed corpses in great detail. Visually oriented artists, i.e., those artists deriving their expressive language from directly perceived reality, are more intensively motivated when their activities are related to cultural stimulation. Sophisticated techniques for proper demonstration of superficial anatomy soon evolved. It was a time when the physician and the artist first recognized a mutual concern for accurate representation of the revealed parts.[18] Leonardo's gaze was the first among the artists to peer deeper into the mysteries of the inner workings.[19] The conceptualizations of his probing gaze were transmitted to a revealing pen which represented the visual images with a new depth and structural solidity. Organs and interrelationships acquired stereoscopic character as he improvised with creative shading, transverse sectioning, foreshortening, exploded views, and transparency devices to bring a vivid sense of geometrical depth and atmosphere to these drawings.[20] Judicious lighting sharpened contrasts and gave forceful expression to the perspective construction of illusory space. Thus Leonardo used space as a structural abstraction in the objective analysis of form as he sought to articulate the arcane functions of the human figure.[21] Hollow cavities and deeply concealed structures were revealed as operational theaters where the principles of perspective and proportion gave a new reality orientation to anatomical relationships. It was an extraordinary perceptional innovation. This inner penetration of the minor cosmos by analytic drawing techniques sought to hurdle and replace the confusion Leonardo found in descriptive texts as he aspired to expose the hidden laws of human activity much as Ptolemy had revealed the universe.[22]

He was marching to the beat of a drummer different from that of learned physicians and philosophers who dabbled in anatomy, pretending to find discerning revelation in the incongruous dissections of barber surgeons. For these unlettered assistants, the droning Latin intonations of the scholarly reader directing their activities was nothing less than babbling inanity, something totally incomprehensible to them. They could not recognize the errors they were exposing nor could their audience make any perceptive associations between text and anatomical demonstration.[23] The dissection scene with all its absurd implications is admirably captured in Figure 1, a handsomely executed

17. Preoccupation of artists with the construction of the undraped human body reflects another aspect of the return to classical models for use as visual self-image, a concept discussed by Burckhardt, in Part III, "The Revival of Antiquity," *Civilation of the Renaissance*.

18. Florentine painters became associated with the Guild of Physicians and Apothecaries early in the fourteenth century by virtue of their use of pigments acquired from apothecary shops. Intermingling with physicians in guild functions provided a predisposing milieu for generating common dissection interests. See Fielding H. Garrison, *An Introduction to the History of Medicine*, 4th ed. (Philadelphia and London, 1929), p. 215.

19. This is not to detract from the accomplishments of a long list of artists preceding Leonardo such as Andrea del Castagno, Domenico Veneziano, Alesso Baldonnetti, Verrocchio, the Pollaiuolo brothers, possibly Montegna, and Signorelli who, in the quest for uncompromising realism, sought enlightenment in the superficial dissections. Ibid., p. 215.

20. Individual technical devices will be dealt with in subsequent chapters as they apply to specific drawings.

21. Anna Maria Brizio integrates the anatomic works into a "discursive continuum" whereby Leonardo explores the mysteries of the physical world with painting as the point of departure in "The Words of Leonardo," in *The Unknown Leonardo,* ed. Ladislao Reti (Maidenhead, 1974), p. 292. For a succinct account of the marriage of *ars* and *scientia* in his anatomical works, see James Ackerman, "Concluding Remarks: Science and Art in the Work of Leonardo," in *Leonardo's Legacy: An International Symposium,* ed. C. D. O'Malley (Berkeley and Los Angeles, 1969), pp. 205-225.

22. MacCurdy, *Notebooks,* p. 19.

23. Prior to Leonardo, the crude "graphic incunabula" consisting of plates and drawings masquerading as anatomi-

cal illustrations were not based upon original observation or dissection at all, but as shown in the exhaustive researches of Karl Sudhoff, these pale imitations were purely servile copies from manuscript sketches of the past. See *Ein Beitrag sur Geschichte der Anatomie im Mittelalter* (Leipzig, 1908) for an extensive review of available material including the exotic "zodiac man" and various series of characteristic semi-squatting, frog-like man figures, featuring the customary *fünfbildesserie* of schematic bone, muscle, nerve, artery, and vein systems.

24. Johannes de Ketham, *Fasciculo de Medicina* (Venice, 1493), c. 26b. The author of this medical compilation, Latin version first printed in Venice in 1491, is unknown and possibly never existed. Its immense popularity fostered numerous later editions of which the Italian edition was the second and the first to include the *Anothomia* of Mundinus.

25. The independent coexistence of humanism, scholasticism, and neo-platonism as major Renaissance educational paradigms is admirably presented by Paul Oskar Kristeller in *Renaissance Thought: The Classic, Scholastic, and Humanistic Strains* (New York, 1961). An additional educational system existed, according to Ernst Cassirer, *The Individual and the Cosmos*, p. 50, which looked to nature for its lessons. Its adherents "dealt with concrete, technical, and artistic problems, for which they sought a 'theory'." Ignoring authority and tradition they depended upon observation and experience tempered by reason for first principles. Cassirer points out how Leonardo's scientific orientation derives from Nicholas Cusanus, tracing a tradition through Alberti that profoundly affects Kepler and Galileo.

26. Ms E, 55r, MacCurdy, *Notebooks*, p. 528.

27. Max Neuburger, *Geschichte der Medizin* (Stuttgart, 1906), as mentioned in Garrison, *History of Medicine*, p. 116.

woodcut from the 1493 Italian edition of Ketham's *Fasciculus medicinae*, considered the first illustration of the dissection process in a printed work.[24]

Although Leonardo never successfully unravelled himself from the bonds of traditional authority he did loosen them as his enquiring knife disclosed the true form of things to the critical eye. In this investigation he tried to discard the confused ancient texts to read from the book of nature.[25] His methods were observation and experiment; his tool was drawing. A clear evocation of his essential empiricism is apparent in this statement:

> ...first I make a certain experiment before proceeding further, because my intention is first to present the experiment and then by reasoning to demonstrate why that experiment is compelled to behave as it did. And this is the true rule according to which speculations on natural effects must proceed. Since nature begins in reason and ends in experiences, we have to follow the opposite route, beginning with experiences and on that basis investigating the reason.[26]

Inevitably, this approach to anatomy effectuated physiological rewards denied Galen whose teleological heritage preeminently focused upon explaining the "why" rather than the "how" of the phenomena studied.[27] There can be little doubt that Leonardo was familiar with the Arabic versions of Galen available from the works of Mundinus and other medieval writers. Moreover, he was certainly acquainted with the works of contemporary anatomists and philosophers such as Zerbi, Achillini, Benedetti, and Della Torre who largely reiterated Galenic doctrine but who occasionally made modest original contributions.[28] Accordingly, it was hardly a *carta rasa* on which Leonardo recorded his anatomical findings; however, the dubious quality of his anatomical inheritance was inordinately negative as a base of inspiration.

It is never easy to shake off the spell-binding enchantment of tradition and Leonardo's expressed intention to read from nature was no exception. Gross errors of received opinion are repeatedly manifested in his drawings, and obvious mental blocks imposed by a certain subservience to authority continually undermine his theoretical precepts. He was never able to erase these barriers to formulate any valid general principles of neurological function.[29]

When these limitations are placed in proper perspective against the historical background we remain in awe at the extent of his

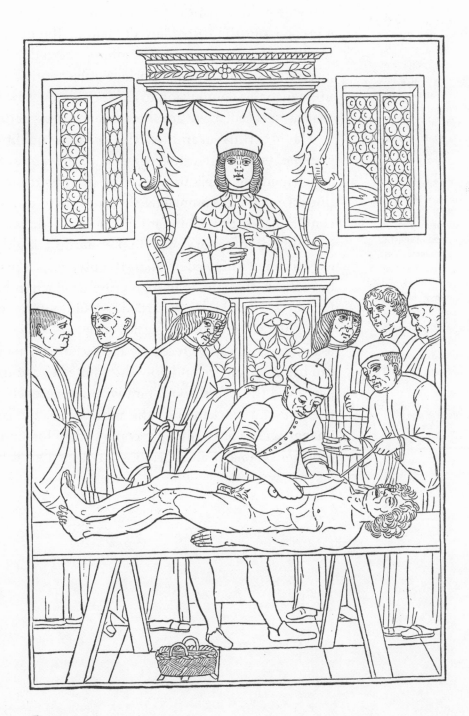

Figure 1.

28. Adalberto Pazzini, "Il pensiero bio-logico de Leonardo da Vinci," *Studi Vinciani Medicina-Fisico-Scienze*, ed. Leo S. Olschki (Florence, 1955), pp. 29-54. Pazzini summarizes Leonardo's exposure to existing texts, stressing the dubious quality of the texts and the totally different spirit that inspired his works and distinguished him from the world of anatomical studies of his times. Short bibliographical accounts of contemporary anatomists are included.

29. Ackerman, "Concluding Remarks," p. 209. The tendency of Leonardo's observations to lead to more observations rather than to principles or laws of nature was reiterated in several papers of the symposium, nevertheless, "...his investigations...were extraordinarily accurate and penetrating, and led to practical applications, but his generalizations were visionary—poetic rather than mathematical." In fairness, it must be stated that his assumptions were often valid but too advanced for mathematical explication with the tools of his day.

30. Pedretti, *Richter Commentary*, p. xi.

accomplishments and of the incomparable beauty and draftsmanship of his artistic creations. Extracted as they were in virtual secrecy from the forbidding domain of the dead, by candlelight for the most part, one must admire the indomitable spirit that inspired his task. The deep springs of his motivation nourished an unquenchable compulsion to expose the unknown. To the extent that he succeeded, we are the heirs and benefactors.

Having thus examined the didactic quality of recurring statements intimately interwoven into the fabric of his notebooks, supplementing, explicating, ever predicating the subject drawings, unexpressed but compelling evidence justifies an overview that contemplates the dominant purpose of drawing as the true instrument of expression in Leonardo's highly personalized exposition of knowledge. Pedretti observes, "It may seem foreign to modern thought that the varied production and activities of Leonardo should be regarded as ultimately motivated by a pictorial vision of the physical world...."[30] Once this premise is assimilated we can be reconciled to its natural manifestations. We can begin to understand how the trained eye of the master artist perceived the world about him with unprecedented penetration; then, in the workshop of the mind's eye, the conceptionalized images were consummately conveyed to his notebooks as vivid representations of an enormous intellect. This is his legacy.

CHAPTER THREE

Anatomical Illustration Before Leonardo da Vinci

THE PUERILE STATE OF PRE-DA VINCI ANATOMICAL ILLUSTRATION IS A trenchant reminder of the quality of medical scholarship at the time. Stifled by dogma and tradition, the medical gaze turned backward to ancient authority for its working models and these came packaged as badly transcribed textual reproductions from a vastly superior past. The oppressive weight of empty knowledge limited medical debate to sterile repetition of once great original works long grown stale. Anatomy stagnated in a quagmire of didactic absurdities accruing from centuries of translation and transcription vagaries. Moreover, obsequious commitment to ancient texts was compounded by a rigid rejection of innovative efforts.[1] Nascent illustrative attempts lay forgotten or ignored in medieval manuscripts. Unfortunately, these Latin works were largely incomprehensible to the unlettered but potentially receptive audience of barber surgeons, midwives, and bloodletters, for whom they would have had some measure of practical appeal. In fact, until a surge of interest in anatomy developed in the late fifteenth-century art colony of Florence, it was this motley group that provided a lonely market for the primitive anatomical works extant.[2]

In anatomical circles the scientific spirit was still slumbering. It is more than passing interest that compels us to review the crude sketches which reveal the trifling degree to which accurate observation in anatomy prevailed, for as Locy cogently reflects:

> Nothing else shows more definitely the state of anatomical knowledge of the time; that which is covered and rendered ambiguous in the text stands exposed in the sketches....[3]

Pictorial representation based upon observation and reasoning awaited the initiative of Leonardo da Vinci. A study of his

1. Charles Singer, *The Evolution of Anatomy* (London, 1925), p. 71. Cf. Fielding H. Garrison, *An Introduction to the History of Medicine* (Philadelphia and London, 1929), p. 166, and Erwin H. Ackerknecht, *A Short History of Medicine* (New York, 1968), p. 88.

2. Ludwig Choulant, *History and Bibliography of Anatomic Illustration*, trans. and annotated by Mortimer Frank (New York and London, 1962), pp. 26-27.

3. William A. Locy, "Anatomical Illustration before Vesalius," *Journal of Morphology* 22 (1911):945.

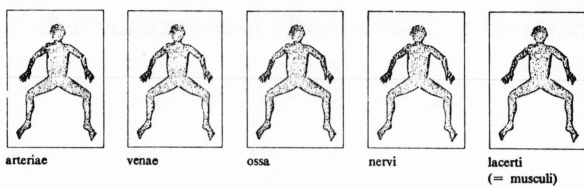

| arteriae | venae | ossa | nervi | lacerti (= musculi) |

Figure 2.

anatomical heritage is essential for a proper understanding of his contribution.

The examiner will find little originality in any of the anatomical illustration available to Leonardo aside from the topographical representations of the human figure by his artistic peers. All medical illustration was characterized by a servile adherence to tradition scarcely improved by centuries of pale imitation.

A statement by Aristotle in *De generatione animalium,* cited by Choulant, to the effect that "paradigms, schemata, and diagrams" were essential visual aids in his teaching of anatomy is the earliest recorded account of this practice. It must be implied that Aristotle was referring to animal sources only since the internal structure of the human body was, by his own admission, unknown to him.[4] Speculators have attempted to trace a tradition of diagrammatic representation from Aristotle through the Dogmatists, Diocles of Carytus, and Praxagoras of Cos, to the Alexandrian anatomists, ·Herophilus and Erasistratus, employing rather tenuous evidential threads.[5] No less fanciful, yet credible as intuitive insight is the educated theorizing of Karl Sudhoff who surmised that the crude, squatting figures of the "Five Picture Series" (Fünfbilderserie),

4. Choulant, *Anatomic Illustration,* p. 42, referring to *De generatione animalium,* 1:7.

5. Robert Herrlinger, *History of Medical Illustration,* trans. Graham Fulton-Smith (New York, 1970), p. 9.

found all over Europe and Asia in the Middle Ages as paradigmatically depicted in Figure 2, may have derived from such a genealogy.[6] On the evidence, these speculations have only entertainment value. Considering the quality of the received product it would be quite as valid to conjecture that the ancient sources would disclaim parenthood. May Genghis Khan, the malicious sackers of Baghdad, Alexandria, and Rome, and all other wretched library vandals of history enjoy eternal damnation on a diet of ink and paper for this woeful loss of historical perspective and continuity.

Speculation aside, we are left to deal with the facts as they existed in the decade or two before and after the turn of A.D. 1500. Availability is not to be confused with existence, as manuscripts containing anatomical illustration for the most part lay hidden in private libraries and monasteries, and some of the fugitive plates enjoyed limited geographical popularity outside of Italy; however, such were the mysterious ways of information transmission in an age before copyright entitlement when plagiarism was an unabashed printer's prerogative, a universal awareness may be presumed.[7] Manuscript sources consisted essentially of rudimentary figures intended to illustrate unsophisticated medical and surgical matters or of monotonous variations of the "five figure series" with occasional additions representing the generative processes.[8] Equally crude were the fugitive plates depicting skeletons, bloodletting and cauterizing diagrams, the multiple wound man, and the zodiac man with labelled parts roughly intimating a seasonal association between vaguely defined medical problems and certain organs. These plates circulated freely for posting in barber shops, hospitals, and other habitats of barber surgeons, midwives, and bloodletters.[9] A more sophisticated source of anatomical demonstration was a product of the evolving interest of artists in a more natural portrayal of the human figure. This concern focused on topographical anatomy but sometimes actually penetrated beyond muscular development to a study of the skeletal system in order to better understand the underlining principles of structure and movement.[10] The creative impulse remained superficial and basically art oriented but it was the cradle in which Leonardo's deeper involvement was spawned.

6. Charles D. O'Malley and J. D. de C. M. Saunders, *Leonardo da Vinci on the Human Body* (New York, 1952), p. 13. The schematic representation in Figure 2 is from Herrlinger, *Medical Illustration*, p. 12.

7. Choulant, *Anatomic Illustration*, p. 87.

8. Karl Sudhoff, *Essays in the History of Medicine*, trans. by various hands and ed. Fielding H. Garrison (New York, 1926), pp. 20-21, 34.

9. Herrlinger, *Medical Illustration*, pp. 26-33.

10. Edward C. Streeter, "The Role of Certain Florentines in the History of Anatomy, Artistic and Practical," *Johns Hopkins Hospital Bulletin* XXVII (April, 1916):113-118.

The "Five Figure Series" and Analogous Works

The remarkable bibliophilic odyssey of Karl Sudhoff ranging across the face of Europe into dark forgotten tombs of ancient monasteries, dust covered storage vaults of public and university libraries, and neglected shelves of private collectors exposed the early-twentieth century to an incomparable treasure of medieval manuscript illustration. Brought to light for scholarly appraisal was an impressive array of anatomical figures, predating by centuries a sprinkling of similar drawings found in Renaissance manuscripts and printed incunabula.[11] "Squatting figures" resembling experimental frog preparations portray the skeletal system on the left and the nervous sytem on the right in Figure 3.[12] They are taken from the oldest manuscript (codex latinus 13002) originating from a Benedictine monastery at Prüfering near Regensburg, bearing a date of A.D. 1158. A common prototype was apparent in this and other manuscript drawings, including one from another Benedictine Abbey at Scheyern in Upper Bavaria, written and illustrated early in the thirteenth century. Sudhoff found the stereotyped attitude in other series from such widely scattered sites as Basel, Stockholm, Dresden, and London.

11. Sudhoff, *Essays*, pp. 8-9. Cf. Mc-Murrich, *The Anatomist*, pp. 36-37; Choulant; *Anatomic Illustration*, p. 49. For a more detailed account of these investigations, see the original sources in Sudhoff, *Tradition und Naturbeobachtung in den Illustrationen medizinischer Handschriften und Frühdrucke vornehmlich des 15. Jahrhunderts* (Leipzig, 1907) and *Ein Beitrag zur Geschichte der Anatomie im Mittelalter* (Leipzig, 1908); also see *Archiv* (Leipzig, 1907-16) I-IX, passim.

12. Reproduced from Herrlinger, *Medical Illustration*, p. 12.

Figure 3.

Figure 4.

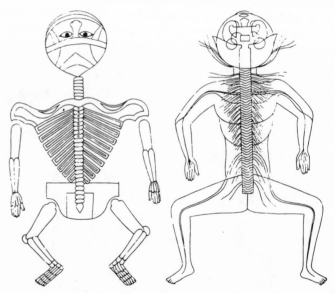

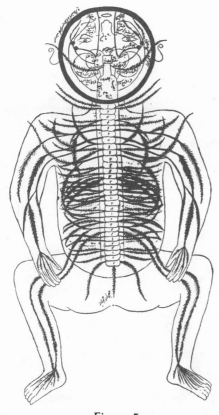

Figure 5.

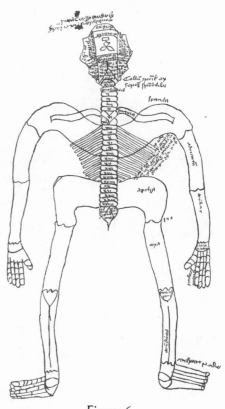

Figure 6.

Certain artistic and stylistic variations in the traditional schematic diagrams were noted as in Figure 4,[13] taken from a manuscript (Ms Fraser 201) in the Bodleian Library at Oxford; however, there was little evidence of any changes wrought by original observation or dissection through the course of centuries. Accordingly, Figure 5 depicting the nervous system from Persian Ms, No. 2296, in the Indian Office, London,[14] presumed to derive from antiquity by way of Arabic transmission, merely emphasizes the servile tradition of uninspired imitation when compared with Figure 3 for instance, thought to have Byzantine lineage. An analysis of the entire corpus of medieval manuscripts serves to confirm the helpless tradition of shameless imitation that produced no examples of original discovery in the nervous system, or for that matter, in any other area of human anatomical illustration. Where schematic representation varied from the set postural stance of the frog-like form, the results were no less grotesque and similarly devoid of any redeeming originality. Exemplifying the utter crudity of skeletal drawings in general which deviate from the squatting mode, Figure 6 from a fourteenth-century Latin Munich

13. Reproduced from Sudhoff, *Anatomie im Mittelalter*, p. xvi.

14. Choulant, *Anatomic Illustration*, p. 63.

15. Choulant, *Anatomic Illustration*, p. 69.

Ms[15] offers an interesting point of reference for comparison with da Vinci drawings discussed in later chapters.

Anatomical Illustration in Surgical Manuscripts

The early Middle Ages following the fall of Rome were truly dark, sterile, and regressive years for medicine. Crushed and devastated beneath succeeding ravages of war, famine, plagues, and economic chaos, the human spirit sank to unaccustomed depths of despair, mirroring the desolation of European civilization. Christianity was the rallying force that restored some promise of salvation but its triumph was largely a defeat for medicine. Nature could not be questioned for her secrets. Medieval thinkers were restricted under the ban of authority to seek truth through logical deduction. The library rather than the experimental laboratory was the source of discovery, and it was in the monasteries where monk scribes laboriously ground out acceptable copy that medieval illustration gradually emerged in primitive form from a forgotten and traceless past.[16] Vestiges of medical involvement remained from an earlier period when monastery medicine dominated but actual anatomical illustration was never important. Although pervaded by ecclesiastical art, profane elements such as the "five figure series," but including crude surgical themes, began to appear in manuscripts of the twelfth century. A revival of interest in purely anatomical matters was heralded by the *Anathomia Mundini* published in 1316, without illustrations as was consistent with its Arabic derivations.[17] The movement gained impetus as a more adventurous and innovative breed of surgeons with academic credentials and anatomical backgrounds began to publish at this time.[18] For a brief but abortive period surgical illustration emerged from anonymity in the manuscripts of Henri de Mondeville and Guido da Vigevano.

16. Edwin M. Todd, "Pain: Historical Perspectives," chap. 4, *Chronic Pain*, ed. Benjamin L. Crue, Jr. (New York and London, 1978), pp. 39-56.

17. Mondino de Luzzi (ca. 1270-1326), studied and taught at Bologna. His *Anathomia*, 1316, was the first pure anatomy text. Although his dissections were performed in person his vision was obscured by the blinds of authority; the Arabic versions of Galen prevailed intact.

18. Albert S. Lyons and R. Joseph Petrucelli II, *Medicine An Illustrated History* (New York, 1978), p. 331.

19. Choulant, *Anatomic Illustration*, p. 59.

20. Lyons and Petrucelli, *Illustrated History*, p. 331.

The anatomical miniatures of Figure 7 are from a French Ms of de Mondeville (2030), 1314, in the Bibliothèque Nationale, Paris.[19] Henri de Mondeville (1260-1320), body physician to Philip the Fair, was a Bologna graduate who helped popularize anatomy at Montpellier and gained enduring fame for his opposition to the notions of "coction" and "laudable pus."[20] He was one of the first to challenge the infallability of Galen. His miniatures which represent a break from Alexandrian models are the only survivors

Figure 7.

from a teaching series used to illustrate his lectures at Montpellier, a revival, in effect, of the tradition ascribed to Aristotle.

Anatomical dissection gathered momentum from the pioneer efforts of Mundinus, especially in Italy where the Papal Bull of Boniface VIII, *De Sepulturis*, issued 1300, was taken in its proper context as a proscription against the Crusader's practice of boiling down bodies to facilitate shipment home of the bones for burial.[21] In France the clergy extended their interpretation of the Bull to include a ban on anatomies. This notwithstanding, the works of de Mondeville and da Vigevano indicate that the prohibition was subject to differing local interpretation. Guido's medical education was probably at Bologna where more liberal attitudes prevailed. Figure 8 portrays seven of the eighteen illustrations from his *Anathomia* of 1345, Ms 334 (ex569), now at the Musée Condé at Château Chantilly, as redrawn by Wolfgang Vater of Kiel.[22] This work was compiled for King Philip the Fair, which possibly explains how it escaped censorship. The artist obviously worked from earlier designs, mostly diagrammatical in the medieval

21. O'Malley and Saunders, *On the Human Body*, p. 13.

22. Herrlinger, *Medical Illustration*, p. 40.

Figure 8.

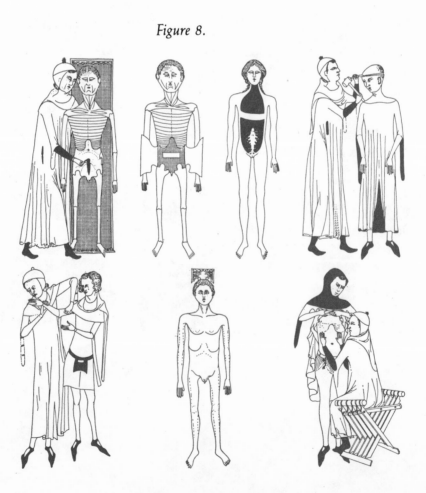

tradition, but a touch of realism is apparent in the examiner's demonstrations. Unfortunately, the fresh breath of anatomical creativity introduced by Henri and Guido was outside of the mainstream of medical teaching. Ridiculed by Guy de Chauliac and rejected by intransigent medical faculties the works became a forgotten oasis in an unimaginative, fruitless era.[23]

23. Herrlinger, *Medical Illustration*, p. 41.

Fugitive Plates with Anatomical Themes

By far the most popular form of anatomical illustration in vogue in the pre-da Vinci period was an assortment of fugitive plates exposed to the popular gaze in bath houses, barber shops, guild halls, billwalls, print shops, and in manuscripts mainly prepared for a lay public. Lacking in intellectual subtlety but occasionally acquiring an awkward polish in the figure outlines of some of the better woodcuts and engravings, they had mixed purposes of serving as home remedy guides as well as instructional aids for apprentice bloodletters, barber surgeons, astrologers, and midwives. Disdained by physicians and ignored by anatomists these plates took the form of labeled skeletons, in-situ organ figures, bloodletting man, cautery man, wound man, zodiac man, sickness man, and various combination designs. All are traceable to earlier manuscript prototypes, presumably deriving from Alexandrian didactic graphic arts. With the advent of printing these figures began to appear in more sophisticated patterns and a modicum of respectability was gained from the publication of Ketham's *Fasciculus medicinae* in 1491, reissued in Italian in 1493 with new woodcuts less scholastic and more realistic in design, marking a turning point between medieval and more modern illustrative techniques in quasimedical matters.[24]

24. Herrlinger, *Medical Illustration*, p. 66.

Drawings of skeletal figures enjoyed a wide circulation during the Middle Ages owing to iconological rather than anatomical factors. A medieval mentality preoccupied with death and the hereafter used these icons for conventional religious images. Gradually, the symbolic representations of death began to merge with paramedical interests and acquired more realistic anatomical features.[25] Figure 9 typifies the best examples decorating Renaissance surgeries during the life of Leonardo. This print made by Grüninger in Nuremberg about 1497 was attributed to a French physician, Richard Hilain, thought to have lived in Paris earlier in

25. Choulant, *Anatomic Illustration*, pp. 42-43.

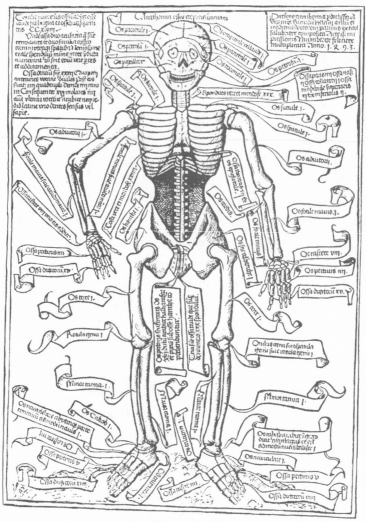

Figure 9.

26. Sudhoff, *Anatomie in Mittelalter*, p. 48

27. Title page of *Buch der Cirurgia* by Hieronymus Brunschwig (Strassburg, 1497), as reproduced by McMurrich, *The Anatomist*, p. 40.

28. Herrlinger, *Medical Illustration*, p. 30.

29. Ibid., pp. 26-29. Herrlinger reproduced the bloodletting man from Heinrich Louffenberg, *Verschung des Leibs* (Augsburg, 1491), the zodiac man from a venesection plate, circa 1480, Munich, Kupferslichkabinett, Schr. 1925, and the sickness man from *Fasciculus medicinae* of Ketham (Venice, 1493).

the fourteenth century, but the origins have not been confirmed although Sudhoff did establish its etiology within a French tradition.[26]

The wound man in Figure 10 is a popular graphic figure that awed and titillated the masses.[27] Sudhoff presumes a surgical derivation from paintings of the martyrdom of St. Sebastian.[28] It was sometimes accompanied by a text, listing the wounds from head to toe in terms of healing probabilities, curiously reminiscent of protocol in the Edwin Smith Papyrus.

The bloodletting man, Figure 11, closely related to the cautery man, the zodiac man, Figure 12, and the sickness man, Figure 13 were stock figures, equally crude and rudimentary in design, and categorically related as didactic graphic art figures used to illustrate therapeutic texts.[29]

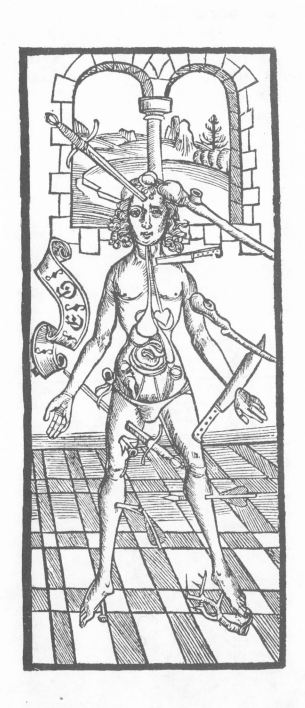

Figure 11.

Figure 12.

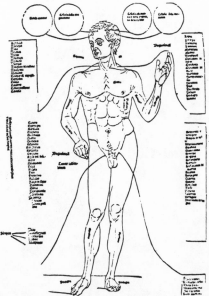

Figure 13.

Traditional crude, schematic demonstration of internal organs in medieval manuscripts showed little progress until the period of Leonardo's creative activities between 1489 and 1517 when a dramatic transition from scholastic to realistic portrayal occurred. His influence remains inferential from the fact, but no other sources exist to explain the gross stylistic and pictorial improvements in the rash of situ figures by German copyists without anatomical credentials. Well illustrated texts were pouring forth from German presses with ever improving illustrative technology but human dissection was not practiced in Germany and the anatomical works were all derivative, never the result of independent observation.[30] Figure 14 from the 1491 edition of Ketham is purely medieval in design and postural stance, quite arbitrary in outline, and entirely schematic in visceral relations.[31] Examination of other in-situ woodcuts of later publications such as Peyligk's (1499), Figure 15,[32] and Hundt's (1501), Figure 16, discloses somewhat better organ definition but clear reliance on ancient models without any relation to nature.[33] These in-situ figures are fairly representative of the true state of the art of anatomical illustration around A.D. 1500.

30. McMurrich, *The Anatomist,* pp. 36-46.

31. Choulant, *Anatomic Illustration,* p. 85.

32. Diagram of the thoracic and abdominal viscera from Hans Peyligk, *Philosophie naturalis compendium* (Leipzig, 1499). After McMurrich, *The Anatomist,* p. 42.

33. Visceral situs figure from Magnus Hundt, *Anthropologium* (Leipzig, 1501). After Choulant, *Anatomic Illustration,* p. 125.

Figure 14.

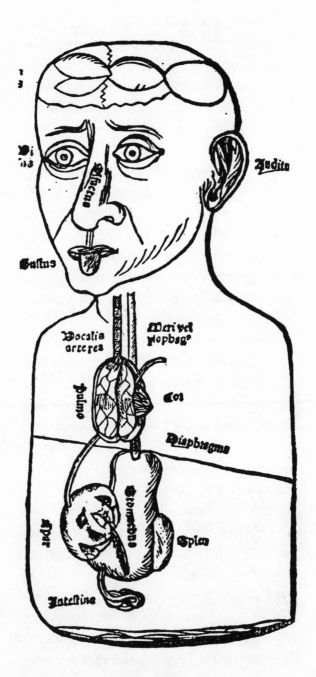

Figure 15.

34. Streeter, *Role of Certain Florentines*, pp. 113-118. Cf. O'Malley and Saunders, *On the Human Body*, p. 14.

Realistic Anatomical Representation in Art

At a time when the intellectual outlook of the medical community was dominated by a constipating dependence upon authority, a freer spirit of anatomical inquiry was gaining momentum in artistic endeavors. Streeter[34] traces a virtually unbroken genealogy of realistic anatomical portrayal from Andrea del Castagno, through Domenico Venegiano to Baldovinetti, who with Donatello taught Verrocchio, who in turn was the master of Leonardo. The scientific spirit that had awakened with Brunelleschi, Ghiberti, and Alberti was stimulated and enhanced by Piero della Francesca, Uccello, and Pollaiuolo to burn brightest in the Bottega of Verrocchio where the youthful genius of Leonardo was shaped and inspired. Away from Florence but caught in her spell, Luca Signorelli and Andrea Montegna also participated in the movement toward naturalism in the representation of the human form that eventually reached maturity with da Vinci, Michelangelo, Dürer, and Raphael.

It was a time when church patronage was a powerful factor in artistic subject matter decision. The church also ran the hospitals and if it is true that painters and sculptors had limited access to medical anatomies there is abundant evidence to support a claim that favored artists found convenient models for dissection experience in the charnel houses and autopsy chambers of the church hospitals where they worked. We do not really know the extent of autopsy practice but from the writings of Antonio Benivieni, we are informed that autopsy requests were seldom refused.[35] It is possible but unlikely that his case was unique. Judging from the intensity of the artists' curiosity in these matters it is only reasonable to presume that they were avid observers in any case where this means of exposition was available. A common affiliation that existed for artists and physicians in the Guild of Physicians and Apothecaries lends credence to speculation regarding a limited communication between the two professions in private dissections and autopsies.[36]

Whatever the source, a revolution was occurring in the realistic demonstration of the human form with a heightened awareness of proportions and mechanics that could not be conveyed without an intimate knowledge of deeper anatomical relationships. This

35. Antonio Benivieni, *De abditis nonnullis ac mirandis morborum et sanationum causis* (Florence, 1507).

36. Streeter, *Role of Certain Florentines*, p. 118.

movement toward better exposition of the human form that combined an intellectual awakening in scientific matters with topographical but intensive anatomical investigation was the proving ground where Leonardo acquired the insights that were to light his way from the dark and dreary morass of didactic medieval graphic arts.

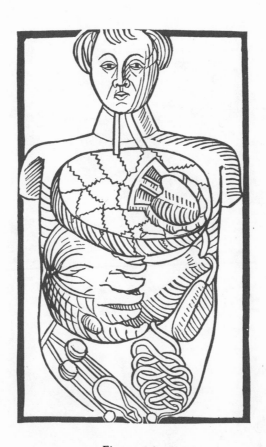

Figure 16.

CHAPTER FOUR

The Skull

AMONG THE MANY WONDERS OF FIFTEENTH-CENTURY ART THAT NEVER CEASE
to excite and inspire us, Leonardo's drawings of the human skull
endure and owe their timeless appeal to a superb marriage of art
and science. It has been said that Leonardo was an engineer who
painted a picture now and then when short of funds. In truth, he
was a scientist of protean interests and boundless curiosity who
happened to be a great artist as well.[1] Life is short and time simply
ran out on him as a painter.

He was architect, engineer, artist, and philosopher in turn. In
fact, all of these aspects of his enormous intellect both permeated,
and added dimension to, each field of study on which he focused
his attention. Subtle influences of his architectural and engineer-
ing talents combine with his artistic mastery of light and shade,
perspective and proportion, to endow these skulls with an excep-
tional depth and beauty, quite unique for anatomical demon-
stration of the period, and timeless as works of art.

Less subtle and somewhat disquieting are the philosophical
inferences in his explanatory notes which mark his commitment
to conventional themes in these early stages of his anatomical
development. Contrary to certain popular notions that for a time
labelled Leonardo as "omo sanza lettere,"[2] Martin Kemp has
convincingly revealed the curious role of traditional philosophical
dictates in the artist's thinking as Leonardo imaginatively in-
terpreted the contents of these magnificent drawings. Kemp
emphasizes the incongruity between the philosophical flights of
fancy that occupied Leonardo's mind and the exceedingly realistic
models of the natural objects wrought by Leonardo's hand and
eye—ultramodern housings for ancient clichés.[3]

The eye of the observer will quickly confirm experts' opinions
that Leonardo's early skull drawings are "masterpieces of model-

1. Ladislao Reti, "Elements of Ma-
chines," *The Unknown Leonardo*, ed. Ladis-
lao Reti (New York, 1974), p. 265. the
same sentiments are expressed in, Gas-
tone Lambertini, "Leonardo Anatomico,"
Studi Vinciani, ed. Leo S. Olschki (Flo-
rence, 1954), p. 68.

2. Giuseppina Fumagalli, *Leonardo Omo
Sanza Lettere* (Florence, 1970).

3. Martin Kemp, "'Il concetto dell'
animà' in Leonardo's early skull stud-
ies," *London Journal of Warburg and Courtland*
34 (1971):115-134.

4. A. E. Popham, *The Drawings of Leonardo da Vinci* (London, 1946), p. 85.

5. Kemp, "Leonardo's early skull studies," p. 117.

ling and texture"[4] and "supreme achievements of Renaissance naturalism,"[5] but the deeper purposes of our task demand an analysis, not only of the art, but of the artist's intent, as well as the intellectual context of his graphic representations, as indicated by the accompanying notes.

Bearing the date of 2 April 1489, which places this drawing among his earliest anatomical endeavors, Figure 17 lends credence to the concept of the artist as an essentially empirical observer with a skillfully cultivated faculty for accurate representation of the visual image. Leonardo's own description of the vascular ramifications attests to the scrupulous attention to detail that characterized his habits of observation as a visual scientist.

> The vein *m* (Maxillary) ascends upward and enters under the bone of the cheek and through the hole in the eye-socket (infraorbital foramen), it passes between the under side of the eyeball and the bone supporting it (maxilla), and in the middle of the said passage the said vein pierces the bone and drops down for half a finger's (breadth) and having perforated the surface of the bone under the margin of the above-mentioned socket at *n* there begins to ascend and having marked out for some distance the margin of the eye, it passes from the lachrymal

Figure 17

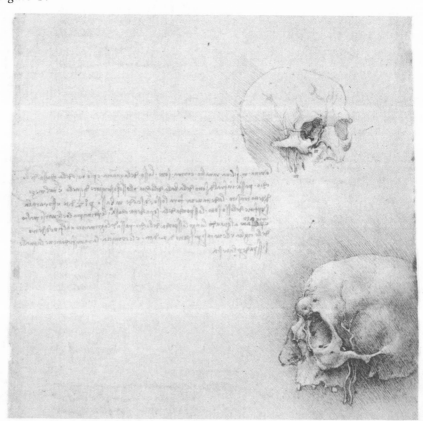

duct and finally, inside the eyelids after rising through a distance of two fingers, it there commences the ramification that extends over the head.[6]

6. Kenneth D. Keele and Carlo Pedretti, *Leonardo da Vinci Corpus of the Anatomical Studies in the Collection of Her Majesty The Queen at Windsor Castle*, 3 vols. (New York, 1979), I:94.

The difficulty in following these precise descriptions arises from the lack of established nomenclature, confusion of artery with vein, and the tendency of aged vessels to acquire rambling circuitous routes. In this particular skull, its kinky vessels, sparse, fragmented teeth, and osteomatous nodularity mark it as quite old.

Mastery of light and shade is exhibited with exquisite delicacy and finesse in Figure 18, an anterior view of the skull with brilliant innovative exposure of maxillary and frontal sinuses. Note the left-hander's subtle diagonal stroking from upper left to lower right for shadowing and highlighting the effects of an off-center light source above and to the left. By splitting the skull in the sagittal plane and then sawing through the facial structures on the right in the coronal plane an effective comparison of topographic landmarks with internal cavities is made and described:

Figure 18

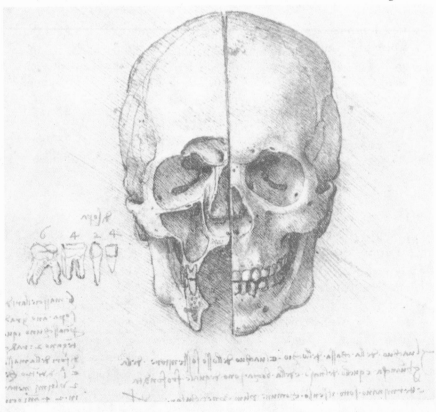

7. Keele and Pedretti, *Anatomical Studies*, I:104.

8. Kemp, "Leonardo's early skull studies," p. 129.

9. McMurrich, *The Anatomist*, p. 122.

10. O'Malley and Saunders, *On the Human Body*, p. 122.

The cavity of the eye-socket and the cavity in the bone that supports the cheek and that of the nose and mouth are of equal depth and terminate in a perpendicular line below the 'senso comune.'[7]

As Kemp has stressed, the *senso comune* as the dwelling place or "seat of the soul," became Leonardo's preoccupation and point of reference.[8] The artist's "perennial interest in the eye as 'the window of the soul' is shown by his attention to the orbits,"[9] which come under closer scrutiny in Figure 19, where the facial cavities are again very imaginatively exposed.

The same figure also shows the teeth, on the function of which Leonardo's views show an interesting course of development. The cut through the right facial cavities exposes the roots of a premolar tooth set in the floor of the maxillary sinus. Beneath a sketch of the teeth, to the left of the skull, Leonardo provides a discussion of the shape and relationships of the teeth, but as noted by O'Malley and Saunders, "The information here provided is derived almost word for word from Galen through Avicenna."[10] Several years later, however, as a mature anatomist, Leonardo articulated a thoughtful and highly original concept of structure and function based upon mechanical principles, an analysis that deserves our attention:

> That tooth has less power in its bite which is more distant from the centre of its movement. Thus if the centre of the movement of the teeth is at *a*, the fulcrum of the jaw, I say that the more distant such teeth are from that centre, *a*, so much the less is their power of biting. Therefore *d e* is less powerful in its bite than the teeth at *b c*.

> From this the corollary follows which says, that tooth is the more powerful the nearer it is to the centre of its movement or axis (or fulcrum) of its movement; that is the bite of *b c* is more powerful than the teeth *d e*. Nature makes those teeth less capable of penetrating food, and with blunter points, which are of greater power. Therefore the teeth *b c* will have their points so much the more obtuse as they are moved by greater power; and for this reason the teeth *b c* will be more obtuse than the teeth *d e* in the proportion they are nearer to the fulcrum or axis, *a*, of the jaws *a d* and *a e*. And for this reason Nature has made the molars with large crowns suitable for masticating the food and not for penetrating or cutting it; and in front she has made

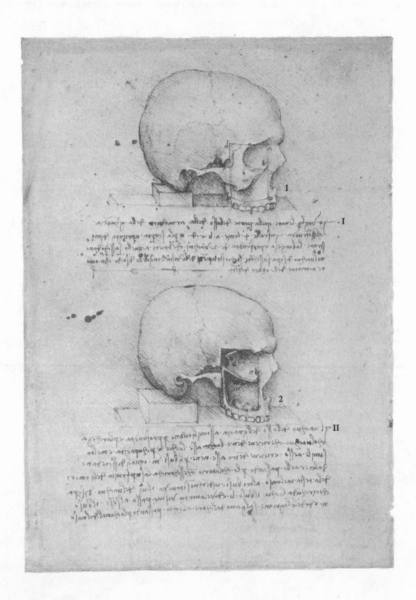

Figure 19.

the cutting and penetrating teeth which are not suitable for masti-
cating the food; and she has made the canine teeth between the molars
and the incisors.[11]

11. Keele and Pedretti, *Anatomical Studies*,
I:110.

An excellent demonstration of the boney nasolacrimal duct is
exemplified in Figure 18, despite a completely erroneous inter-
pretation of its purpose. "The lacrimal glands were unknown to
Leonardo and his contemporaries. The tears were supposed to
well up through the lacrimator or lacrimal duct from the heart
which was the seat of the emotions."[12] In this instance Leonardo
was no less under the spell of Aristotelian physiology than William
Harvey a century and a half later.

12. O'Malley and Saunders, *On the
Human Body*, p. 48.

In the upper skull of Figure 19, da Vinci announces his
intention:

> . . . to lift off the part of the bone, armour of the cheek, which is found
> between the four lines *a b c d* and through the exposed opening to
> demonstrate the width and depth of the two empty cavities which are
> concealed behind that (bone). In the upper cavity the eye is hidden, the
> instrument of the vision, and in that below is the humour which
> nourishes the roots of the teeth.[13]

13. Keele and Pedretti, *Anatomical Studies*,
I:108.

The orbit and maxillary sinus were thus skillfully revealed in the
lower skull with such fidelity that Keele felt compelled to
comment, "It is ironic that this sinus is called the antrum of
Highmore, who described it in 1651."[14] Leonardo's description,
though richly interlaced with distracting Galenic, Platonic, and
Aristotelian fantasies, does accurately transmit the revealed
anatomy:

14. Ibid., I:108.

> The empty cavity of the bone of the cheek is similar in depth and width
> to the cavity which lodges within it the eye, and in capacity it is very
> similar to it. And it receives veins into it through the holes *m* which
> descend from the brain passing through the sieve (cribriform plate of
> the ethmoid) which discharges the superfluous humours of the head
> into the nose. No other holes are evident in the cavity above which
> surrounds the eye. The hole *b* (optic foramen) is where the visual
> power passes to the 'senso comune'; the hole *n* is the place from which
> the tears rise up from the heart to the eye, passing through the canal of
> the nose.[15]

15. Keele and Pedretti, *Anatomical Studies*,
I:108.

Cranial sutures are faithfully represented in the drawings of
the skull but no effort is ever made to designate the individual
bones; cranial fossae are accorded the same fate.

Having rendered the topographical features of the skull in a manner consistent with his artistic heritage of objective examination, and having penetrated the facial structures with new and imaginative anatomical techniques, Leonardo reached deeper into his architectural and engineering experience to explore the inner chambers of the skull itself. In Figures 20 and 21 we find the cranial cavity revealed with the same care and imaginative representation that appealed to our esthetic and creative tastes in the surface drawings. The artistic quality and consummate draftsmanship of these beautiful works are matters that survive our critical appraisal of the confused medieval psychology which occupied the mind of Leonardo as he sought a site for the immortal soul in the mortal receptacle he was constructing for it. Leonardo's changing concepts of the mind's functions and the location of soul will be considered in later chapters. At this point it suffices to mention Kemp's contention that the brilliantly inventive skull osteology of his early anatomical period was conceived under

Figure 20

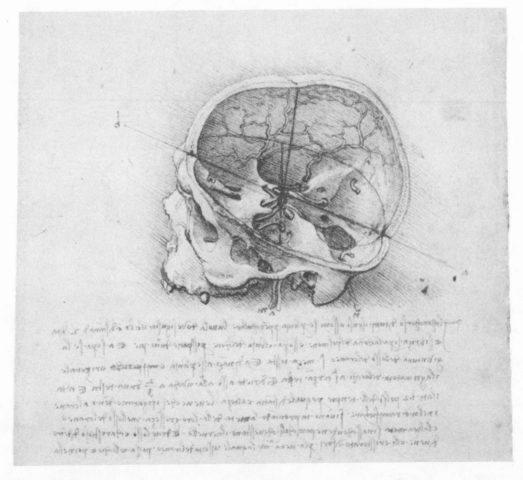

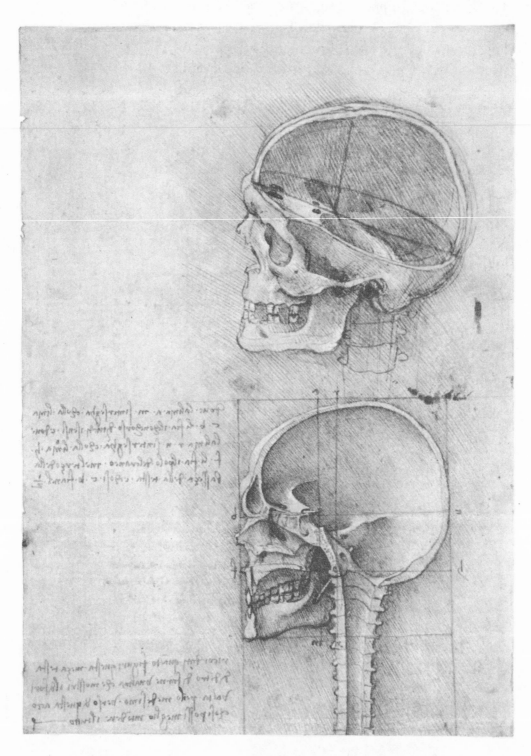

Figure 21

a cloud of conventional dogma which he understood and accepted. Accordingly, if Kemp is correct, and he presents his evidence rather convincingly:

> ...it is impossible to accept Castiglione's affirmation of Leonardo's independence from the mainstream of anatomical tradition: 'Leonardo began his studies without bothering about Galen and Mondino, and this was the secret of his greatness.' And Sarton's opinion voiced in his introduction to McMurrich's book, is little less tenable: 'Leonardo's originality was due not only to his inherent genius, to the penetration and comprehensiveness of his mind, but also to his ignorance.'[16]

16. Kemp, "Leonardo's early skull studies," p. 134.

A cursory perusal of the notes meant to illuminate the skull studies of Figures 20 and 21 will disclose some measure of the growing concern of Renaissance artists with what they regarded as a science of proportions. This interest was channeled off into art circles as part of the humanistic revival of ancient texts which included the ten books of Vitruvius, resurrected from the first

Figure 22.

17. Manuscript copies of Vitruvius' *De Architura* were certainly available to Leonardo in his early years as an artist. Marco Rosci, *The Hidden Leonardo* (Chicago, 1977) p. 76, mentions the presence of this work in his later lists of books; specifically, in Manuscript F (1508) and Manuscript K (1509-1512).

century B.C.[17] Leonardo's consuming involvement with these principles is best exemplified in his version of the Vitruvian man, Figure 22, now a prized possession of the Gallerie dell' Accademia in Venice. In the skull studies, especially the intracranial demonstrations, his passion for proportions extended beyond the boundaries of visual reality into the imaginery realm of medieval psychology whereby he sought to establish the elusive situs of the "soul" in the *senso comune*. These esoteric ventures indicate his belief in a precise organic dwelling for such abstractions as the *senso comune*, reasoning, judgment, memory, and imagination which shifted about somewhat as his anatomic ideas matured, but remained the basic tenets of his integrated philosophy of neurological function. Beneath the drawing in Figure 20, we are informed:

> The confluence of all the senses has below it in a perpendicular line the uvula where one tastes food at a distance of two fingers and it is directly above the wind-pipe of the lung and above the orifice of the heart by the space of one foot. And it has the junction of the bones of the head (bregma) half a head above it; and in front of it in a horizontal line is the lacrimator of the eye (nasolacrimal duct) at one-third of a head. And at the sides the two temporal pulses at equal distance and height. The veins which are drawn with the cranium in their ramification proceed imprinting half their thickness into the bone of the cranium and the other half is hidden in the membranes which cover the brain. And where the bone is deficient in veins inside it is replenished from outside by the vein *a m* (meningeal vessels) which having emerged from them into (probably the complex branches of the ophthalmic vessels).[18]

18. Keele and Pedretti, *Anatomical Studies,* I:102.

The terms "vein" and "artery" are used loosely, almost interchangeably at times. Tree-like ramifications of the meningeal arteries are illustrated for the first time in Figure 21, and accurately described in the text. Reference to "membranes which cover the brain" denotes the dura mater, a dense fibrous outer sheath, and the arachnoid, a delicate, filmy, loose inner membrane which contains the cerebrospinal fluid. The arachnoid is invariably misnamed "pia" by Leonardo, a term which properly applies to the layer of tissues that closely invests the brain and spinal cord and has a common embryological derivation with the arachnoid from the leptomeninx.[19] Identification of the pia requires microdissection techniques unavailable to the Renaissance anatomist.

19. Raymond C. Truex, *Strong and Elwyn's Human Neuroanatomy* (Baltimore, 1959), pp. 26-27.

Figure 23.

Figure 24.

It is not hard to imagine the awe of the rare connoisseur or anatomist fortunate enough to have glimpsed the skull drawings at any time during their long and varied imprisonments, for time has scarcely dimmed the delicacy of line and shading that continues to stir the emotions of the viewer. For the anatomist there is still much of interest in the layout itself which was entirely new when conceived. As an engineer, Leonardo had removed wedge sections from shells and machine casings to expose the inner workings (Figure 23); as an architect he had opened cathedrals to segmental inspection by similar devices (Figure 24).[20] For him it was only natural to extend these techniques to his anatomical studies. In Figure 20 and in the upper drawing of Figure 21, the dome of the calvarium is split sagitally and in a horizontal plane from the left so that the light source over the left shoulder of the viewer bathes the cranial fossae with a breath-taking play of lights and shadows previously reserved for lovely cloisters and selective architectural delights. Anterior, middle, and posterior fossae are portrayed with astute perceptiveness and accuracy, providing an elegant foundation for speculative reflections on brain-soul relationships. A complete sagittal section of skull and spine, designed to conform to his theories of proportions in the lower drawing of Figure 21,

20. *Leonardo da Vinci Anatomical Drawings from the Royal Collection*, published under the auspices of the Royal Academy of Arts (London, 1977), p. 48. The pen and dark brown ink over metalpoint sketch on blue prepared paper seen in Figure 24 has been rescued from virtual obscurity by special ultra-violet light optical aids. For an exploration of the techniques, see Jane Roberts and Carlo Pedretti, "Drawings by Leonardo da Vinci at the Windsor Newly Revealed by Ultra-Violet Light." *Burlington Magazine* 119 (June, 1977):396-408.

demonstrates the passageway for continuity of brain and spinal cord with careful representation of skull base and facial structure. Rather shoddy diagrammatic rendering of the spine in this transection was to be amply atoned in redeeming works of incomparable finesse at a later date.

In Leonardo's hands, perspective, proportions, and subtle utilization of light and shade become indispensable instruments for depicting the inner recesses of the body's cavities on two-dimensional surfaces—like looking through a window on the wonders of creation. Preoccupation of the mind with fanciful notions of how the mind worked and precisely where the soul resided did not interfere with the innovative processes of structural composition that endow these forms with enduring beauty and spontaneity. Leonardo never attempted to enlarge upon the early skull series which, in effect, implies an unexpressed satisfaction with the product, but then; who has ever seen their equal?

CHAPTER FIVE

The Senses

STUDIES OF THE NERVOUS SYSTEM APPEAR AMONG THE EARLIEST ENTRIES IN
Leonardo's notebooks. He had already acquired great technical
proficiency in drawing and an incipient concept of the human body
as a miniature reflection of the universe—a microcosm within the
macrocosm. Within the microcosm Leonardo now sought to
arrange the details of structure and function into a coherent
explanation for the human predicament.[1]

From the start it was more than a mere anatomical exploration,
particularly as he applied his thinking to the nervous system, for at
a philosophical level Leonardo was seeking to explicate the function
of man's mind as an instrument for logical revelation of nature's
laws.[2]

As a painter, the initial direction of his investigations naturally
focused on the seeing eye—the window of the soul for an artist—
and in a very personal way he was seeking to understand the
mechanisms of his own perception, interpretation, and re-creation
of the external world on a two-dimensional surface. An analysis of
his study of the senses, however, must not fail to heed Keele's
astute reference to the "triple aspect of his genius" which compre-
hends his viewpoint as a subtle integration of interests in mechan-
ics as well as in painting and in anatomy. Keele, in fact, develops a
brilliantly documented argument that reveals the thoroughly
mechanistic character of Leonardo's physiology of the senses
operating in accordance with his pyramidal law. This law quantifies
the movement and percussion implicit in sensory phenomena in
terms of intensity proportional to stimulus as affected by distance.[3]

Before proceeding with our study of the senses—a study which
naturally flows from the essential visual orientation and acute
perceptual sensitivity of the artist—it is necessary to dispel a
popular myth that deals with the notion of Leonardo as a unique

1. MacCurdy, The Notebooks, p. 19; see also Filippo Botazzi, "Leonardo as Physiologist," Leonardo da Vinci (New York, 1957), pp. 384-5.

2. Keele, "da Vinci's research on the nervous system," p. 28.

3. Kenneth D. Keele, "Leonardo da Vinci's Physiology of the Senses," Leonardo's Legacy. An International Symposium, ed. C. D. O'Malley (Berkeley and Los Angeles, 1969), pp. 35, 54-5.

individualist unfettered by the dogma of contemporary science. We will find this mind that treasured astonishment and wonder rather than authority was still a prisoner of time and place. A review of his debt to ancient precepts should provide a proper perspective for evaluating Leonardo's true contribution.

Medieval scientific inquiry into the metaphysics of light, optics, and vision derived from a profusion of ancient works lately transported from ancient sources over the Islam bridge of culture.[4]

In the *Timaeus* of Plato, a theory of vision emerged as a synthesis of prevailing concepts, whereby vision was regarded as a virtue passing from the eye to meet, mix, and combine with emanations from the object perceived to form the image carried back to the eye. This theory was superseded by an alternative theory of Aristotle's which featured a translucent medium for transport of images. Objects radiated "simulacra" or "species" of themselves through the media (air, water, glass, etc.), and these images were impressed upon the observing eye. Penetration of the eye was facilitated by the translucent character of cornea, pupil, and constituent humors. Concepts of intromission with a transport medium and extramission featuring emanations from the eye itself furnished material for scholastic debate that took theological, astrological, and scientific twists under the impetus of a steady stream of Arabic and Patristic influences.[5]

Optics became an important tradition in the Medieval curriculum as the works of Al-kindi (800-873),[6] Avicenna (989-1037),[7] Averroës (1126-1198),[8] and Alhazen (965-1038)[9] became familiar to medieval scholars. Popular support shifted back and forth between spiritual and physical interpretations concerning the nature of the "images" of objects, and the ideas of both Plato and Aristotle continued to capture the fancy of succeeding generations.

Gradually, over the centuries, an authoritative body of treatises emerged in which light and vision were subjected to geometrical analysis and theorizing. The early works of Grosseteste (1168-1253)[10] were amplified by Roger Bacon (1220-1292),[11] John Peckham (1225-1292),[12] Witelo (1230-1270),[13] and a host of others as scholarship scrutinized the questions of light transmission, eye mechanisms, the nature of light, vision, and "species," the rainbow and color spectrum, spectacles, and the application of mathematics to their solution. Jean Buridan (1328-1340), Nicholas Oresme

4. Otto Von Simson, *The Gothic Cathedral* (New York, 1962), pp. 50-5, 102-5. The legacy of the Christian tradition of the metaphysics of light is traced through the Patristic writings. See also, P. O. Kristeller, *The Philosophy of Marsilio Ficino* (New York, 1943), pp. 94-5, 253 and 384.

5. McMurrich, *The Anatomist*, p. 219.

6. Frederic Graziella Vescovini, *Studi sulla Prospectiva Medievale* (Turin, 1965), pp. 33-52.

7. Ibid., pp. 77-90.

8. Ibid., pp. 160-162.

9. Ibid., pp. 89-93. See also Edward J. Dijksterhuis, *The Mechanization of the World Picture* (Oxford, 1961), p. 112.

10. Alistair C. Crombie, "Early Concepts of the Senses and the Mind," *Scientific American*, May, 1964, pp. 2-10.

11. Vescovini, *Prospectiva Medievale*, pp. 131-134.

12. Alistair C. Crombie, *Robert Grosseteste and the Origins of Experimental Science* (Oxford, 1953), pp. 165-67.

13. Vescovini, *Prospectiva Medievale*, pp. 131-134.

(1320-1382), William of Ockham (1280-1349), among others, were instrumental in the development of a more physical approach to these problems.[14]

In the fifteenth century, the polemics took a more practical twist away from qualitative theorizing to accommodate the newly aroused concern of the art community with visual perspective. The writings of Alberti and Piero della Francesca best articulate what Brunelleschi, Ghiberti, Uccello, and other artists were trying to express in their works. Basically, these writers were attempting to rationalize the visual experience in geometrical terms. Alberti's background in humanistic scholarship included a learned aware-ness of the medieval traditions in optics that served as precursors for the newer concepts of perspective, and this information became a vital component of the training program in Verrocchio's workshop where Leonardo served his apprenticeship. Considering the unquenchable inquisitiveness of his nature, there is compelling circumstantial evidence to suspect that Leonardo had some famili-arity with available medieval manuscripts and with Latin trans-lations of Arabic works on optics. The cultural milieu of the Sforza court included a rich sprinkling of scientists and scholars from whom he could have drawn this type of information,[15] and Kemp has shown how pervasively certain of these traditional doctrines controlled his thinking in the early anatomical studies.[16] Individual opinions continue to favor one or another primary source for Leonardo's background knowledge of optics and sensory phe-nomena, yet most scholars—especially those familiar with the Madrid manuscripts and later transcriptions of the notebooks—concede a broad eclectic derivation.

In Figure 25, however, we are confronted with some of the dubious fruits of such confusing erudition. In this sagittal transection of the head, flashes of innovative brilliance are partially obscured by a slavish representation of Galen by way of Avicenna and as modified by Albertus Magnus, Mondino, and Guy de Chauliac.[17] Since this illustration will later serve as a baseline for tracing the development of Leonardo's conceptualization of cerebral function, it is worthy of examination in some detail. Note how the membranes of the brain form a sheath for the optic nerve which in turn forms the layers of the eyeball to surround the vitreous humor. In the center is the crystalline humor—a fictitious counterpart of the lens with an ancient pedigree and a bewildering

14. Donald Sanderson Strong, *Leonardo da Vinci On The Eye: The Ms D In The Bibliotheque De L'Institut De France, Paris Translated Into English And Annotated With A Study of Leonardo's Theories of Optics* (Ann Arbor, 1967), pp. 291-93.

15. Eugenio Garin, *La Cultura Filosofica del Rinascimento* (Florence, 1961), pp. 388-401.

16. Kemp, "Early Skull Studies," pp. 116-134.

17. O'Malley and Saunders, *On the Human Body*, p. 330.

62

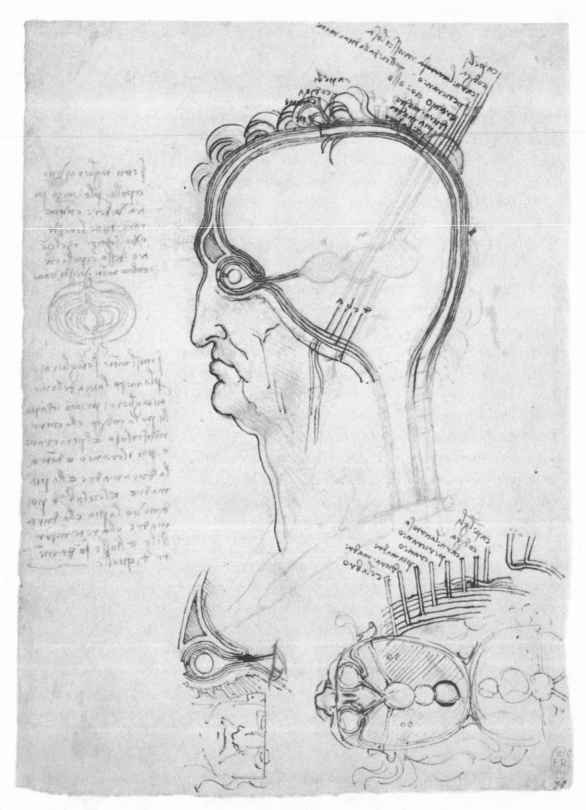

Figure 25.

propensity for avoiding proper identity until recognized in its true form and function by Felix Platter in 1583.[18] Leonardo was never to solve the puzzle of the crystalline humor, nor did he ever approach an accurate depiction of its anatomical relationships, although he did propose a method of fixation with heated egg white, and apparently performed dissection of the organ.[19] Unfortunately, this method of investigation may have backfired, for the lens probably became detached in the process, and when detached it assumes a spheroid shape. Moreover, while the lens is always attached to the iris in the living eye, in the anatomy of the dead it is usually separate. These misleading findings may explain why Leonardo always retains the ball shape of the lens in his drawings.[20] In any case, the mental picture retained from Avicenna's description caused a mental block that remained a barrier in his optical analyses, and at least in part, the foster child of despairing theories of visual image transport. Consistent with conventional ideas, the optic nerve spreads out into a net-like lining for the vitreous humor (retina) to terminate in the tela aranea (iris). In the main drawing, a tube-like canal pierces the iris to reach the crystalline humor, whereas in the lower left figure, a continuation of the retina separates the anterior and posterior chambers. This confusion anticipates a series of varying sketches of the eye that reflect his changing viewpoints and frustrating attempts to conduct an upright image to the *senso comune*.

Blind repetition of blatant errors in this early work should not discredit its merits as manifest in the clever "onion" analogy, the newly discovered frontal sinus, and the original techniques for portraying a horizontal sectioning of the imaginary brain.

> If you will cut an onion through the middle you will be able to see and enumerate all the coats or rinds which circularly clothe the center of this onion. Similarly if you cut through the middle of the head of a man you will first cut the hairs, then the scalp, then the muscular flesh and the pericranium; and inside, the dura mater, the pia mater and the brain; then again the pia mater and dura mater and the rete mirabile and then the bone, their foundation.[21]

An overriding concern about the principles of image transmission probably caused him to neglect his own stern attitudes regarding the priority of observation over authority, and so he failed to obtain an accurate knowledge of the instrument of vision

18. McMurrich, *The Anatomist*, p. 218.

19. Ibid., pp. 87-88.

20. Domenico Argentieri, "Leonardo's Optics," *Leonardo da Vinci* (New York, 1957), p. 426.

21. Keele and Pedretti, *Anatomical Studies*, I:70.

itself while diverted by the erroneous ideas of earlier scholars who themselves had never looked.

Aristotle established a hierarchy of the senses varying in importance according to how more or less perfectly each could perceive the form of objects as apart from their matter. Thus, the scale of perfection descended from vision to hearing to smell to taste and finally to touch which required physical contact with the object. Judging from the extent and intensity of his studies, Leonardo made vision the undisputed master of his sensory world. Taste was merely mentioned; smell was dealt with very lighlty; hearing more from the standpoint of the physics of sound; and touch was never treated as a composite subject. Forgotten or ignored were the perceptual qualities of fluidity and solidity, heat and cold, as well as the additional discriminatory concepts of dryness and wetness, hardness and softness, and roughness and smoothness proposed by Avicenna.[22]

22. McMurrich, *The Anatomist*, p. 216.

Vision

In his early statements regarding the nervous system, it was primarily as an artist that he was seeking to determine how the eye sees the world. For a while, he wrestled with the conflicting theories of extramission and intromission, eventually discarding the former, but not without reservations.

> I say that sight is exercised by all animals through the medium of light, and if against this any one should instance the sight of nocturnal animals, I would say that these in exactly the same way are subject to the same law of nature. For, as one may readily understand, the senses, when they receive the images of things do not send forth from themselves any actual power, but on the contrary the air which is between the object and its senses, serving as a medium, incorporates within itself the images of things, and by its own contact with the sense presents them to it...[23]

23. MacCurdy, *Notebooks*, p. 231.

In these words, Leonardo clearly embraces the intromission thesis, yet a tantalizing deference to medieval superstition persists in other writings dealing with extrasensory emanations from the eye as in:

> Is not that snake called lamia seen daily by the rustics attracting to itself with fixed gaze, as the magnet attracts iron, the nightingale, which with mournful song hastens to her death?

It is said also that the wolf has power by its look to cause men to have hoarse voices.

The basilisk is said to have the power by its glance to deprive of life every living thing.

The ostrich and the spider are said to hatch their eggs by looking at them.

Maidens are said to have power in their eyes to attract to themselves the love of men.

The fish called linno, which some name after St. Elmo, which is found off the coasts of Sardinia, is it not seen at night by the fishermen, shedding light with its eyes over a great quantity of water, as though they were two candles? And all those fishes which come within the compass of this radiance, immediately come up to the surface of the water and turn over, dead.[24]

24. MacCurdy, *Notebooks*, p. 236.

This penchant for mysticism, so disturbing and untidy to modern scientific thought, was a duality quite commonplace in Renaissance philosophical discussion. It became less frequent in Leonardo's notes as his methodology became more controlled and consciously rational. As he managed to strip his optical physics of spirits, emanations, and other creatures of the netherworld, a firmer mechanical set of explanations gradually evolved. From observing the spreading waves of two stones thrown simultaneously into a pond with the waves unbroken as they intersected (Figure 26), Leonardo went on to extrapolate a principle of wave motion from water to sound and—*para passus*—to light.

Figure 26.

Just as a stone thrown into water becomes the center and cause of
various circles, sound spreads in circles in the air. Thus every body
placed in the luminous air spreads out in circles and fills the sur-
rounding space with infinite likenesses of itself and appears all in all in
every part (CA, 9v).[25]

Accordingly, this wave transmission of light as of sound,

...is caused by a shock which may be described as a tremor rather than
movement...its parts transmit the tremor to one another without
change of position (CA, 61r).[26]

Thus the luminous air is filled with an infinity of images,
interchangeably designated by Leonardo as "species," "simulacra,"
"eidola," or "similitudes" of objects which impress upon the eye
along perspectival pyramids with lines intersecting without
interference.[27]

To ascertain the manner of arrival of these spaciotemporal
pyramids of images, Leonardo resorted to experimental models,
the function of which he endowed with a great deal of speculative
significance. In Figure 27, he constructs a model whereby he
reasons on how the objects are seen by the eye.

Figure 27.

Suppose that the ball figured above is the ball of the eye: and let the
small portion of the ball which is cut off by the line s.t. be the pupil, and
all the objects mirrored on the centre of the surface of the eye by
means of the pupil pass on at once through the crystalline humour
(lens)...which does not interfere with the things seen by the light.
And this pupil having received the objects by means of the light
immediately refers and transmits them to the intellect except when the
objects presented to it through the light reach it by the line a.b. as if
from the line c.a. For although the lines m, n, f and g may be seen by
the pupil, they are not considered because they do not coincide with the
line a.b. And the proof is this: if the eye shown above wants to count

25. Argentieri, "Leonardo's Optics," p.
405.

26. Ibid., p. 406.

27. Anna Maria Brizio, "Correlations
and Correspondences between Folios
of the Codex Atlanticus and Folios of
Anatomical MsB and Mss A and C on
the Eye, Perspective, the Pyramid of
Light Rays, and Shadows," XVII *Raccolta
Vinciana*, pp. 81-89.

the letters placed in front of it, the eye will be obliged to turn from letter to letter because it cannot discern them unless they lie in the line a.b. or c.a. All visible objects reach the eye by the lines of a pyramid and the point of the pyramid ends in the centre of the pupil as figured above (CA, 85v).[28]

28. Keele, "Physiology of the Senses," p. 44.

In distinguishing between the acuity of central and peripheral vision, Leonardo devises a shunt system that mainlines the image back to the *imprensiva* via a central chute, analogous to the preferential route for an arrow intended to negotiate a hollow tubing.[29]

29. Ibid., p. 44.

Exemplifying the pains he took to discover the true dioptrics of the eye are the experiments with the camera obscura (an invention of Levi ben Gerson in the early fourteenth century) where Leonardo compared the eye with this instrument (Figure 28). Ironically, his ingenuity was fatally misdirected by a fundamental assumption that the inverted image of the camera obscura had to be righted on reaching the optic nerve. A great mass of intellectual energy was exhausted in efforts to right the image, as in the glass and metal model, (Figure 29), where his own eye became the optic nerve.[30] Among the various schemes devised to arrange an acceptable image righting system, the cornea became a collector and refractor of rays from enormous visual fields (Figure 30). Whereas all visual images conveniently converged to a common pyramidal point in the pupil of Figure 27, further insights from observation of birds and animals gave the pupil a vastly more responsible role in lighting the way to central cognition:

30. Argentieri, "Leonardo's Optics," p. 428.

The nocturnal animal can see better during the night than during the day. This happens because there is a greater difference between the enlargement and contraction of their pupils than in diurnal animals; for while the pupil of man doubles itself, the diameter of the pupil of the owl widens 10 times from its size during the day. Furthermore the ventricle in the human brain referred to as the imprensiva is more than 10 times the size of the whole human eye, and the pupil less than a thousandth part of the eye itself; while in the owl the pupil at night is much larger than the ventricle of its imprensiva in the brain. The proportion between the imprensiva and the size of the human pupil, the imprensiva being 10,000 times larger than the pupil, is far greater in man than in the owl where they are almost equal. The man's imprensiva compared with that of the owl is like a great hall receiving light through a small hole compared with a small room entirely open. Indeed in the great hall there will be darkness at noonday, while in the small open one there will be brightness at midnight (MsD, 5v).[31]

31. Keele, "Physiology of the Senses," pp. 46-47.

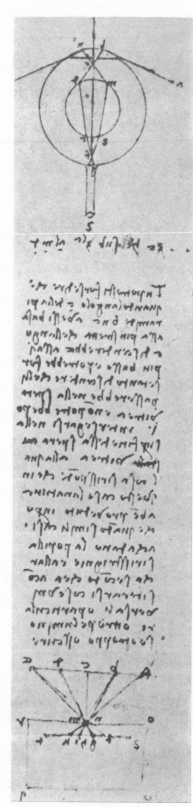

Figure 28.

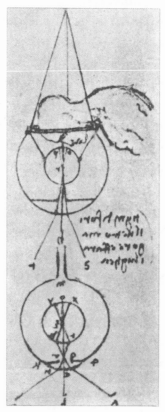

Figure 29.

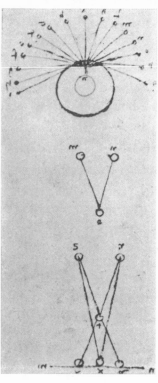

Figure 30.

Keele sees the pupil functioning, in part, as the shade in Leonardo's completely mechanistic two-stage visual system consisting of (1) perspective from the object to the pupil, and (2) from the pupil through the optic nerve to the *imprensiva* in the brain.[32]

Beyond the pupil, Leonardo's real problem began. Committed to reinvert the image of the camera obscura, he never considered the decussation of the optic nerve fibers or central mechanisms in the role; instead he continued to vent his frustrations on various combinations of reflections between the spheroid crystalline humor and retina, as in Figures 31 and 32. Although he did refer to changes in the lens in one statement;

> The crystalline humor which is internal to the pupil condenses to meet the things that shine and rarifies to meet obscure things (D, 5v).

he never related these changes to accommodation for near and far vision.[33]

"Leonardo was the first to decompose a beam of sunlight, producing and receiving the solar system on a screen." However as Argentieri qualifies this statement, Leonardo specifically denies the eye an integral part in the process:

> If you place a glass full of water on the windowsill so that the sun's rays will strike it from the other side, you will see the aforesaid colors formed in the impression made by the sun's rays that have penetrated through the glass and fallen on the pavement in the dark at the foot of the window, and since the eye is not used here, we may with full certainty say that these colors are not in any way due to the eye.[34]

Again, in his explanations for the blue color of the sky, Leonardo was not concerned with color vision, or the physiology of color perception, but rather, with optical illusion, for color was simply an aspect of form, from Aristotle's categorization, which was inherent in the simulacra of configuration that passed from the object to the eye:[35]

> I say that the blue which is seen in the atmosphere is not its own color, but is caused by the heated moisture having evaporated into the most minute and inperceptible particles, which the beams of the solar rays attract and cause to seem luminous against the deep, intense darkness of the region of fire that forms a covering among them (Ms L, 4r).[36]

32. Ibid., p. 47.

33. McMurrich, *The Anatomist*, p. 225.

34. Argentieri, "Leonardo's Optics," p. 412.

35. McMurrich, *The Anatomist*, p. 227.

36. Argentieri, "Leonardo's Optics," p. 413.

Leonardo was intrigued by the glowing circle produced by a whirling firebrand which, "...passes through an infinite number of adjacent lines and therefore this circle appears united in the air" (QIV, 12r). At one point he seemed to regard visual after-images as counterparts of auditory impressions from the lingering resonance of a bell. He reconsidered when he noted how the resonance ceased when the bell was touched, and finally concluded that the auditory impressions were merely vibrations of the bell, whereas the visual after-image was truly within the eye (CA, 332).[37]

Finally, as to the question of binocular vision, McMurrich cites two avant-garde passages that presage the theory of stereoscopic vision conceived by Wheatstone in 1830. In the *Trattato della Pittura*, Leonardo observes that when the right eye is fixed on an object, other objects obscured from the right eye may be seen by the left, and on H 49, the observation is made that objects seen with both eyes will appear rounder than when seen with only one.[38]

A poetic evocation of the wonder and excitement he felt for the divine gift of vision is eloquently expressed in the following passage: "...the eye is the window of the human body through which the soul views and enjoys the beauties of the world." (CA, 345v)[39]

Hearing

Just as Leonardo the artist perceived the eye as the window of the soul, so Leonardo the musician viewed the ear as an esthetic instrument to delight the soul with the sounds of the world.

The major thrust of his concern with hearing was into the mechanical principles of acoustics. Structural anatomy never progressed beyond the crudely represented cord-like extension from external ear to the archaic tripartite ventricles of his early drawings. These cords were transferred from anterior ventricle, as in the lower right sketch in Figure 25, to the middle ventricle, as his concepts of mental function relocated the *senso comune* in the latter situs. When wax casting techniques provided a more realistic likeness of the brain, the acoustic nerves were completely ignored in the reorientation of cranial nerve relationships.[40]

Alcmaeon of Croton is believed to have dissected the brains of animals and to have commented on the function of cranial nerves about 500 B.C. We are informed in the writings of Theophrastus

37. McMurrich, *The Anatomist*, p. 226.

38. Ibid., p. 227.

39. Strong, *Leonardo da Vinci On the Eye*, p. 120.

40. See Weimar Sheet, verso, K/P, p. 167, designated, "Leonardo's finest drawing of the brain, cerebral ventricles and cranial nerves," by Keele, in which the acoustic nerves are not included; again in Rli2602, K/P 103r and in 19090v, K/P 113r where brain, ventricles and cranial nerves are carefully drawn, the acoustics are conspicuously absent.

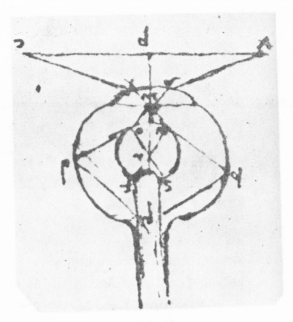

Figure 31.

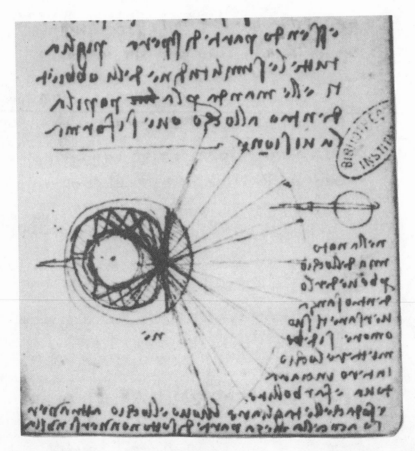

Figure 32.

(ca. 372-287 B.C.), pupil of Aristotle and successor as master of the Lyceum at Athens, that Alcmaeon:

> ...tells us that we hear by means of the ears and that sound is heard because of the empty space in them; he says that the (internal) air resounds by means of the hollow space. (He asserts that) we smell by means of the nostrils when in respiration the air has been carried to the brain; and that we distinguish flavors by the tongue, for since it is warm and soft it melts (substances) by its heat, and because of its yielding fineness it receives and passes on (the flavors).[41]

41. Edwin Clarke and C. D. O'Malley, *The Human Brain and Spinal Cord* (Berkeley and Los Angeles, 1968), p. 3, quoting from a passage in *Theophrasti Eresii opera, quae supersunt, omnia*, ed. Fredericus Wimmer (Paris, 1866).

These precious pearls on sensory function are transmitted as hearsay relics of an advanced culture that has no surviving documents. The complicated petrous porosity retained its secrets over the centuries, apparently ignored or undeciphered during the enlightened agencies of Aristotle, Herophilus, Erasistratus, and Galen. In this area, Arabic and Medieval transcribers really had little to debase.[42]

42. McMurrich, *The Anatomist*, p. 217.

In lieu of dissection, Leonardo resorted to speculation regarding the hearing apparatus. In this endeavor, his use of experimental models and analogies fell far short of the true working order, but they did serve to satisfy his limited curiosity about the inner workings, and in some ways he came remarkably close to meaningful discovery. Keele cites several examples that attest to the fertility of his thinking on the matter. A teasing analogue of eardrum and middle ear ossicle function is apparent in an illustrative drawing and description of a mine-detecting device:

> If you wish to find out where the mine runs, set a drum over all the places where you suspect the mine is being made, and on this drum set a pair of dice, and when you are near the place where the mining is the dice will jump a little on the drum through the percussion given underground in digging out the earth (Ms 2037, 14r, Bibl. Nat.)

To explain his idea of how sound resonates in the deep porosity of the petrous bone he diagramed the principle of large caves in the mountain of Romagna, evidently observed during his travels as Engineer General with Cesare Borgia, used by the peasants to amplify broadcasted signals.

> ...on one side they fasten a horn, and this little horn becomes one and the same with the concavity already made, whence is made a great sound (Ms K, 2r).

In another model intended as an extension of the external ear canal he came perilously close to anticipating Laënnec's invention of the stethoscope.

> If you place the head of a long tube in the water and the other end in your ear, you will hear ships at a great distance from you. You can do the same by placing the head of the tube on the ground, and you will then hear anyone passing at a distance (Ms B, 6r).[43]

43. Keele, "Physiology of the Senses," p. 50.

Galen added little to the earlier remarks of Alcmaeon about hearing, and Leonardo more or less reiterated in writing that the sound of a voice to be heard must "resound in the concave porosity of the petrous bone, which is the inner side of the ear," but he then elaborated on the process by conveying the sound through to the *senso comune* via the acoustic nerves (AnB, 2).[44] He was quite clear and emphatic in refuting the multiple receptive souls of Plato and the cardio-centric course of sensory input advanced by Aristotle.[45]

44. McMurrich, *The Anatomist*, p. 217.

45. Keele, "Physiology of the Senses," p. 49.

> The soul apparently resides in the seat of the judgment, and the judgment apparently resides in the place where all the senses meet, which is called the common sense; and it is not in the whole body as many have believed, but it is all in this part; for if it were all in the whole, and all in every part, it would not have been necessary for the instruments of the senses to come together in concourse to one particular spot...with the sense of hearing it would be sufficient merely for the voice to resound in the arched recesses of the rock-like bone which is within the ear, without there being another passage (acoustic nerve) from this bone to the common sense (B, 2r).[46]

46. MacCurdy, *Notebooks*, p. 110.

In contrast to the capricious judgments from faulty or inadequate dissection of sensory organs, Leonardo was better able to apply his knowledge of physics to the acoustics of the hearing process. His concepts of sound and its transmission are entirely mechanistic, shorn of all spirits and virtues, as admirably explicated by Keele. Sound originates in percussion. Propagation is by a wave motion, "the wave of the voice goes through the air as the images of objects pass to the eye" (Ms A, 27v). Far in advance of his time, he was dealing with a temporospacial transmission explicitly involving a "tremor" or vibration, "...a shock which may be described as a tremor rather than movement...its parts transmit the tremor to one another without change of position" (CA, 61r).

These waves of sound bounce off surfaces in accordance with the same laws of incidence and reflection as light. "I say that the sound of the echo is reflected by percussion to the ear, just as the percussions made in mirrors by the images of objects are to the eye" (Ms C, 16r). Hammers are used to emphasize the percussion points in Figure 33 (Ms C, 16r), and it is notable that delivery of sound to the ear itself is by percussion. The mechanics of multiple echo production is graphically illustrated in Figure 34 (Ms B, 90v). As Keele stresses, Leonardo applies his pyramidal law to the diminishing intensity of sensory stimuli as functions of distance. It is interesting to compare Figure 35 (R L 12351) which studies the problem of variation in intensity of light with Figure 36 (L, 79v), wherein the pyramidal dissipation of sound is disclosed:

> In the distance $a\,b$, the 2 voices m and n diminish by a half.... In the same distance the voice f, being twice m or n, has lost a quarter of its power. Here it surpasses by three times the power of the voice at g, which is equal to the voices m and n, at the distance $a\,b$ (L, 70v).[47]

47. Keele, "Physiology of the Senses," pp. 48-9.

Leonardo attempted to extend the similarities of visual and hearing phenomena to include the after-sound of a bell as a counterpart of after-image. On impulse, he first thought that the sound was a captured resonance perpetuating in the ear, then later rejected the idea, for "if it were true, the sound of the bell would not cease abruptly if the bell is touched by the hand—but it does." (CA, 322).[48]

48. McMurrich, *The Anatomist*, p. 217.

Figure 33.

Figure 34.

Figure 35.

Figure 36.

Smell

Traditional sources, including Galen, neglected to include the olfactory nerves among the cranial nerves, and this omission may explain some of the confusion in his mind while shifting these nerves back and forth between the anterior and middle ventricles in early sketches. His reference to these nerves as "caruncular nerves" probably derives from a fragmentary mention by Mundino of "two carunculae, like nipples" at the fore-end of the brain as cited by O'Malley and Saunders.[49] The inconsistency in the sketches is not reduplicated in the text, however, where smell is conveyed to the common sense the same way as all sensory images:

49. O'Malley and Saunders, *On the Human Body*, p. 342; see also K/P, *Anatomical Studies*, I:166.

> And this name, common sense, they use simply because it is the common judge of the five senses, namely seeing, hearing, touch, taste and smell. The common sense is set in movement by means of the organ of perception (imprensiva) which is situated in the centre between it and the senses. The organ of perception acts by means of the images of things presented to it by the superficial instruments, that is, the senses, which are placed in the middle between the external things and the organ of perception; and the senses act in the same way through the medium of objects. The images of the surrounding things are transmitted to the senses, and the senses transmit them to the organ of perception, and the organ of perception transmits them to the common sense (CA, 90r).[50]

50. MacCurdy, *Notebooks*, p. 200.

Thus he affirms the common mechanism of all the senses as a process of image impact by percussive forces. From the same text, Keele remarks upon the striking similarity of sight, sound, and smell image transmission to the senses expressed in the lines:

> ...the atmospheric medium which exists between the object and the sense incorporates in itself the image of things, and by its contact with the sense transmits the image of it; and if the object consists of either sound or odour, they send their spiritual power to the ear or the nose (CA, 90r).[51]

51. Keele, "Physiology of the Senses," p. 51.

Among the diverse entertainments of the cosmopolitan Florentinians during Leonardo's lifetime was a rather well-stocked zoo located not far from the seat of government at the Palazzo Vecchia. Evidently, Leonardo was afforded opportunity at some

time to investigate the cranial contents of one of the lions, for he comments on the relative insignificance of the human olfactory apparatus compared with the lion in whom,

> ...the sense organ of smell, forming part of the substance of the brain, descends into a large receptacle to meet the sense of smell which enters among a great number of cartilaginous cells or spaces with many foramina which go to meet the above-mentioned brain (B, 13v).[52]

52. Ibid., p. 51.

In spite of this awareness of a greater faculty in animals, he was still disposed to marvel at the sensitivity of the human organ, capable of sniffing scents from great distances. These odoriferous images or particles, carried on the air medium, reach the organ by mechanical contact, as in the case of the musk,

> ...which keeps a large quantity of air loaded with its odour, and which, if it is carried a thousand miles, will occupy the atmosphere without any diminuition of itself (CA, 27v).[53]

53. Keele, "Physiology of the Senses," p. 51; see also McMurrich, *The Anatomist*, p. 217.

Taste

It seems inconceivable that Leonardo would virtually ignore the sense of taste except to mention it as one of the senses. No connoisseur of food, he was in fact a vegetarian with somewhat ascetic views regarding gourmet pleasures, which may have blunted his curiosity in this area. Somewhere out there in the vast wasteland of lost works there may be something pertinent. Let us hope that the Madrid manuscripts are not the last instance of fortuitous reclaim.

A rare passage carries some humorous inferences about taste:

> The potencies are four: memory and intellect, appetite, and concupiscence. The two first are of the reason, the others of the senses.

> Of the five senses, seeing, hearing, smelling may be partially withheld—touch and taste, not.

> The sense of smell leads that of taste with it, in the dog and other greedy animals (Tr, 12a).[54]

54. MacCurdy, *Notebooks*, p. 202.

Touch

It is only proper that we pause now and then to recall that Leonardo was a lonely explorer in anatomy, ranging ever in a vast unknown without much of a compass. He was a seeker and a finder, but seldom a systematizer. Uncertainty and arbitrariness were his frequent companions. New findings led to renewed speculation which left conflicts and loose ends that never were resolved as time ran out on him. His thinking about the sensation of touch was such an instance. In earlier works, the metaphor envisioned the five senses as the ministers of the soul (B, 2r), committing their intelligence to its receptionist, the *imprensiva*, for deliverance to the *senso comune* wherein the soul was said to dwell. Less fanciful and more direct was the statement:

> The sense of touch clothes all the skin of man. Touch passes through the perforated nerves and is transmitted to the senso comune; nerves spread out with infinite ramifications into the skin which encloses the limbs and viscera of the body...and being distributed over the tips of all the fingers they transmit to the senso comune the impression of what they touch (B, 1v and 1r).

Elsewhere he informs, "For as soon as the finger tips have touched the object, the *senso comune* is immediately made aware of whether it is hot, cold, hard or soft, pointed or smooth" (CA, 270v).[55] The composite nature of touch that came down from the ancients was never questioned; however, it became increasingly difficult to reconcile his earlier notions of sensory pathways with the re-orientation of brain relationships demanded by new information about ventricular conformation (wax castings), and from a better awareness of spinal cord function. It was when he had traced the course of peripheral nerves to the spinal marrow and thence to the brain that he marked the position of the fourth ventricle at the confluence of all these sensory pathways:

> Since we have clearly seen that the ventricle *a* (fourth ventricle) is at the end of the spinal cord where all the nerves which give the sense of touch come together, we can judge that the sense of touch passes into this ventricle, since Nature operates in all things in the shortest time and way possible (RL 19127r).[56]

He did not develop a relay system from fourth ventricle to *imprensiva*, nor did he elaborate on how the short-circuiting would

55. Keele, "Physiology of the Senses," p. 52-53.

56. Keele and Pedretti, *Anatomical Studies*, I:332.

relate to other sensory paradigms. Despite this notable gap in transmission of touch, his physiology of the senses remained uncompromisingly mechanical.

Pain and temperature, apparently because they share the same receptor organ, i.e., the entire investment of body and viscera, are regarded as modalities of touch with variable sensitivity thresholds related to intensity of percussive stimuli, according to the pyramidal law:

> Just as the many rays of a concave mirror united in a point make extreme heat, so do the many puffs of air blowing on a point make extreme cold (Ms A, 20r).[57]

He describes pain as the twin and opposite of pleasure (Oxford drawings, Part II, No. 7), but recognizes its ambivalence and vital function in the preservation of the species:

> Though nature has given sensibility to pain to such living organisms as have the power of movement,—in order thereby to preserve the members which in this movement are liable to diminish and be destroyed—the living organisms which have no power of movement do not have to encounter opposing objects, and plants consequently do not need to have sensibility to pain (H, 60r).[58]

Possibly from dissection or animal experimentation, but more likely from observation on a wounded limb (perhaps his own as suggested by McMurrich), he noted that when the nerve to the finger is cut sensation of the member is lost, "even if it be placed in the fire," but movement may persist. At least peripherally, in the distal ramifications of fibers, an exclusive sensory function was known to exist; and in order that such nerves be protected from injury they were positioned between fingers (AnA, 10v).[59]

Leonardo's study of anatomy was a very personal, highly speculative inquiry into the nature of man and his place in a harmonious universe. It was only by the senses that man was able to provide a reasoning soul with the kind of information it needed to interpret nature's laws. It has been claimed that Leonardo's physiology of the senses suited the viewpoint of the painter better than the anatomist, but one might argue that in the context of his times only a painter or an anatomist who was also a philosopher and a scientist could have appreciated its merits.

57. Keele, "Physiology of the Senses," p. 53.

58. MacCurdy, *Notebooks*, p. 71.

59. McMurrich, *The Anatomist*, p. 216.

CHAPTER SIX

The Brain and Cranial Nerves

THE NEED TO KNOW IS A FORCEFUL DRIVE IN ALL INTELLIGENT CREATURES; IN
Leonardo da Vinci it was an obsession. Facts revealed to him by
topographical tinkering with anatomy, which suited the needs of
the botegas, only created an itch that could not be assuaged by
superficial scratching. The secrets of human movement and
emotional expression in which he had so great an interest lay
deeper, and it was into these depths that he was drawn inexorably
by a powerful, unremitting curiosity. His initial handicap as he
sought the answers in the brain and cranial nerves was not so
much his ignorance as his knowledge,[1] for his early works clearly
demonstrate the crippling effects of the scholastic dogma he was
attempting to explicate by pictorial representation. Philosophical
phantasies of brain function conjured by medieval scholars from
the debased texts of the ancients were never really disputed by
Leonardo. At best he was only able to improve the housing in
which he allowed this phantasmagoria to dwell, but his search and
find techniques eventually provided a more empirical methodology
for rendering structural relationships that transcended the rude
concepts he had inherited.

1. Kemp, "Early skull series," p. 134.

Of Leonardo's sources we have little direct knowledge. They
must be inferred and presumed from very scanty references in the
notebooks—usually not more than a name in isolation, a list, or an
occasional sentence traceable to a known work that he might have
seen or heard of. There is nothing so specific as a citation.

The extent to which he was able to go beyond authority and to
develop a method of realistic portrayal, can only be revealed by the
drawings themselves, and by the accompanying texts which
reflect the maturation of his vision. To the extent that he failed,
and in many areas this is considerable, we must temper judgment
with an appreciation of the miserable state of his medieval

2. G. Reisch, *Margarita philosophiae* (Strossburg, 1504), Liber. X. Trac. II.

heritage. The absurdity of this heritage is cogently displayed in the string of three sausages meant to illustrate the ventricles in Figure 25. This is a concept that Leonardo lifted intact and unchallenged at the time from a popular notion of cerebral localization circulating freely since Albertus Magnus in the thirteenth century, and depicted in Figure 37 from Reisch's *Margarita philosophiae*.[2] For all its crudeness and servile mimicry of ridiculous tradition, flashes of brilliant inventiveness; e.g., the onion analogy, exposure of frontal sinus, and horizontal sectioning techniques are redeeming features of the Figure 25 drawings that presage an awakening anatomical awareness.

To better understand his predicament and the mental obstacles obstructing and distorting visual impressions, it is appropriate at this point to briefly recapitulate the curious derivations of medieval brain concepts.

Leonardo would have recognized a kindred spirit in Alcmaeon of Croton (ca. 500 B.C.) who, from the writings of Theophrastus,

Figure 37.

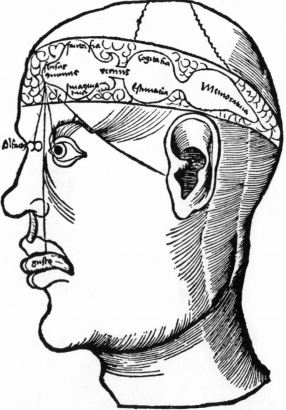

we are able to establish as the first great medical figure to deal intelligently with the brain in the modern sense. Relying upon the findings of animal dissection, Alcmaeon elaborated a theory of sensory appreciation that comprehended the brain as the center for sensation. His nervous system consisted of a network of ducts and vessels carrying sensation in the form of particles of elements that invaded the body through various sensory organs and were conveyed to the sensorium in the brain. He postulated a mechanism of consciousness dependent upon variations in cerebral circulation for sleep and wakefulness. The views of Alcmaeon, the lonely empiricist, fell on the deaf ears of a rationalist society that eschewed vulgar dissection for more noble mental gymnastics in physiological matters.[3]

By the time of the Hippocratic Corpus (ca. 430-360 B.C.), dissection was no longer practiced. Medicine was practical and rational, stressing an expectant attitude while trusting in the marvelous healing power of nature. Physiology was based upon a proper balance of the four elements (air, fire, earth, and water), the four qualities (hot, cold, moist, dry), and the four humors that were supposed to inhabit the body. References to the brain were contradictory, for in certain writings it was regarded as merely a gland of sorts, excreting mucus matter that played a part in regulating body heat. In one striking exception, *The Sacred Disease*, believed by some to be authored by Hippocrates himself, the role of the brain as the seat of the mental processes is clearly delineated:

> Il faut savois que, d'une part, les plaisirs, les joies, les ris et les jeux, d'autre part, les chagrins, les peines, les mécontentements et les plaintes ne nous proviennent que de là (le cerveau). C'est par là surtout que nous pensons, comprenons, voyons, entendons, que nous connaissons le laid et le beau, le mal et le bien, l'agreable et le desgreable...[4]

Thereafter, Hellenic Greek interpretations of brain function deteriorated. The astonishing physiological inaccuracies of Plato (ca. 429-347 B.C.) and Aristotle (384-322 B.C.) stem from a common ignorance of human anatomy, a tragic deficiency Leonardo would have deplored. The magnitude of their minds stunned subsequent generations of men to the extent that their gross errors became indistinguishable from their magnificent triumphs.

3. B. Seman, *Man Against Pain* (Philadelphia, 1962), p. 59. Cf. Clarke and O'Malley, *The Human Brain*, p. 3.

4. Émile Littré, *Oeuvres Complètes d'Hippocrate* (Paris, 1839-61), VI, pp. 350-397. Translated to English, it reads, "One ought to know that on the one hand pleasure, joy, laughter and play, on the other, sorrow, pain, discontent and dissatisfaction derive only from the brain. It is above all by it that we think, comprehend, see and hear, that we become acquainted with and distinguish the ugly from the beautiful, the bad from the good, the agreeable from the disagreeable..."

5. George Sarton, *A History of Science: Ancient Science Through the Golden Age of Greece* (New York, 1952), Vol. I, pp. 420-423. Also, Kenneth Keele, *Anatomies of Pain* (Springfield, 1957), pp. 20-29.

Lacking a necessary substratum of anatomy, the speculative physiology of Plato frequently becomes unintelligible to the modern reader. In *Timaeus*, Plato aspires to present a comprehensive account of the nature of man. A fundamental blending of mortal body with immortal soul entailed a rather complicated commotion of atoms and elements in relation to a percipient soul scattered among a multiplicity of organs. The heart became the receiving and distributing center for sensory input. In deference to Alcmaeon, perhaps, the brain was allotted reasoning and memory. Lust and other lower level appetites found refuge in the liver.[5] These speculative misconceptions reverberated through history, blurring the gaze of the most penetrating empiricists, even when confronted with facts in anatomical dissection, as in the case of Leonardo.

There is no reference to human dissection in the works of Aristotle; they deal exclusively with animal anatomy. A teleological point of view permeates his thinking on structure and function. *De Partibus Animalius*, his major physiological treatise, reiterates the premise that everything has a design or purpose, as "nature never makes anything that is superfluous." It is difficult to reconcile the exquisitely detailed differentiations of form and function in his comparative anatomy with his completely erroneous ideas concerning the brain and heart of man. For Aristotle, the heart was the seat of intelligence, emotion, and sensation; the brain was relegated to the specious role of thermostatic sponge for cooling the heart to prevent overheating. The irony of mistaken identification is compounded by the fact that it was Aristotle who coined the term *sensorium commune*, and the awesome effects of his prodigious outpourings in all fields of knowledge gave his works a force of dogma that misdirected physiological research in this area for 2000 years.[6] Leonardo remained under the spell of this persuasive genius, particularly in his espousal of a teleological approach to homologous organ analyses, although he did selectively reject Aristotle's cardiocentric theories.

6. Seman, *Man Against Pain*, p. 60. Cf. Keele, *Pain*, p. 31, Sarton, *Ancient Science*, I:532-545, and Clarke and O'Malley, *The Human Brain*, pp. 7-10.

With the death of Aristotle in 322 B.C., the glorious era of Hellenic science faded from the center stage of history. The scene casually shifted to Alexandria where for a brief interlude restraints imposed by dogma and tabu on scientific investigation were lifted to allow a freer spirit of inquiry in human anatomy. It was an ambience in which Leonardo would have thrived.

Drawn to Alexandria by the inviting intellectual climate, Herophilus of Chalcedon (315-280 B.C.) made extensive anatomical dissections on human cadavers. From fragmentary references in Celsus (first century A.D.), Pliny the Elder (A.D. 23-79), Rufus of Ephesus (ca. A.D. 98-117), Galen of Pergamon (ca. A.D. 130-200), and others, we are advised that Herophilus identified the brain as the seat of motor and sensory function. He clearly distinguished between nerves and arteries, and traced the course of nerves to and from the brain and spinal cord. Familiarity with the ventricles led to speculation on the site of the soul which he chose to ensconce in the fourth ventricle.[7]

7. Keele, *Pain*, pp. 41-42; Sarton, *A History of Science: Hellenistic Science and Culture in the Last Three Centuries B.C.* (New York, 1959), II:129-131; Charles Singer, *Greek Biology and Greek Medicine* (London, 1922), pp. 116-119.

The original observations of Herophilus were first challenged, then brilliantly expanded by a second generation of Alexandrian anatomists, most outstanding of whom was Erasistratus of Cheos (310-250 B.C.). He elaborated on the structure of the cerebrum and cerebellum with the deep-lying system of ventricles and connecting foramina. Curiously, he chose to differ with Herophilus on the proper dwelling for the soul, placing it somewhere in the cerebellum. Erasistratus commented on the rich convolutional development of the human brain, and hypothesized an association with intellectual capacity. He identified the heart as a central pump propelling blood and air to all parts of the body, and discredited it as a sensory organ.[8]

8. Isaac Asimov, *A Short History of Biology* (Garden City, 1964), p. 9; Keele, *Pain*, pp. 42-48; Sarton, *History of Science*, II:131-133.

The original texts of the great Alexandrian investigators have all disappeared in the quagmires of wasteful wars, fires, and cultural dissolutions, but their contributions survive in loosely documented comments of Byzantine, Greek, and Arabic compilers, perhaps most authoritatively by Rufus and Galen whom we know to have studied at Alexandria when the legends were still circulating. Herophilus and Erasistratus, with Alcmaeon and Aristotle, are vital links in a chain of actual dissectors—as distinguished from pure anatomical and physiological speculators—later to include Galen and lesser figures such as Mondino, eventually Leonardo da Vinci.

Rufus of Ephesus (fl. A.D. 90-120) remains an obscure figure in medical history; however, his writings survive as valuable confirmation of the high level of Alexandrian achievement, and as a standard of reference for assessing medieval opinion. Describing monkey dissection material, apparently from personal observation,

he freely acknowledges his debt to his Alexandrian predecessors. His observations are practical and reasonably accurate:

> The brain is located inside the skull; it is covered by meninges; one denser and more resistant, is attached to the bone (dura mater); the other, thinner but also resistant, although to a lesser extent, stretches over the brain (pia mater). The upper surface of the brain is called varicose (convoluted), its inner and posterior surface is called the base; the extension from the base is the parencephalon (cerebellum); the cavities of the brain have been designated hollows (ventricles). The membrane which lines the ventricles is called the choroid membrane. Herophilus also calls it the choroid meninges. The processes springing from the brain are the sensory and motor nerves with the help of which we are able to feel and to move voluntarily, and which are responsible for all the activities of the body. There are also those nerves which issue from the spinal marrow, and from the meninges that surround it. One may designate indifferently all of the marrow which descends through the vertebrae either as dorsal or spinal.[9]

It remained for Galen (ca. A.D. 130-200), however, to rescue the great advances of the Alexandrians, and to restore a central nervous system to explain the physiology of motor and sensory function. He attacked Aristotle head-on to thoroughly discredit the heart as a neurological entity, while retaining a high respect otherwise for his authority as a biologist. Animal dissection and experimentation, supplemented by practical observations in his role as a surgeon to the gladiators, led Galen to much personal theorizing about physiological mechanisms. It is not possible to fractionate his own opinions from the knowledge he acquired of Herophilus and Erasistratus, but his systematized organization of data had a compelling ring of authority that appealed to the church fathers, who later attached the stamp of dogma to his work.[10]

Unfortunately, Galen's Arabic transcribers failed to emphasize the exclusive animal content of his comparative anatomy, and Galen himself was somewhat derelict in this regard. On the whole, Galen did feel that mental function had its situs in brain substance generally. In one passage there is a rather oblique inference of ventricular participation in these processes:

> If the anterior part of the brain is injured, its upper ventricle (lateral ventricles) is necessarily also affected by sympathy, and the intellectual functions are damaged.[11]

9. C. Daremberg and C. E. Ruelle, *Ouvres de Rufus d'Ephèse* (Paris, 1879), 2 vols., pp. 169-171. The French translation from the Greek is in turn translated into English in Clarke and O'Malley, *The Human Brain*, pp. 12-13.

10. Charles G. Cumston, *An Introduction to the History of Medicine* (London, 1968), pp. 153-168; also Benjamin L. Gordon, *Medicine Throughout Antiquity* (Philadelphia, 1949), pp. 704-713, and Keele, *Pain*, pp. 46-53.

11. Clarke and O'Malley, *The Human Brain*, pp. 460-461, as excerpted and translated from C. Daremberg, *The Sites of Diseases*, IV, 3(1854-1856), II:590.

Galen's proclivity for decisive statement failed to materialize in this instance, and his avid followers were left with only vague ideas of brain localization for psychophysiological matters.

Sadly, Greek enterprise in medical matters died with Galen. A decline in anatomical interest preceded the fall of Rome by two centuries. Whereas in some areas of science a creative light waxed and waned with occasional flashes of brilliance during the early Middle Ages, these were dark and sterile times for anatomy in Europe. The mind of man was too preoccupied with the next world to pay much attention to the wonders of its own world. Experimentation could only lead to heretical conclusion, so the safe way to truth around the road blocks of church dogma was by disputation and logical deduction, circuitous routes which went nowhere. It was a tedious period of scientific stagnation and intellectual decadence for medicine in general and anatomy in particular.[12] A da Vinci would have suffered neonatal extinction in this atmosphere.

Meanwhile, a fresh spring of intellectual inspiration was flooding the arid lands of distant Persia. To Jundishapur and other Persian centers fled refugee scholars attracted by an unprejudiced climate for learning and a generous patronage of the ruling class. Hindu, Chinese, and native Persian influences blended with surviving vestiges of ancient Near Eastern cultures gathered by Jewish and Syrian scholars. Far from the chaos and desolation of decadent Europe, a desert oasis had collected a colony of learned exiles who in their meager baggage but retentive minds had preserved the major sources of our vision of the ancient worlds.[13]

In this conducive ambience, Nemesius, (fl. ca. 400) Bishop of Emesa in Syria, a Christian philosopher whose life and sources remain obscure, revitalized Greek concepts of the soul and its psychological implications in relationship to the human body, proposing a ventricular situs doctrine more detailed and specific than anything advocated by Galen. His influence profoundly affected Albertus Magnus and Thomas Aquinas, and indirectly from their writings, Leonardo da Vinci. It is regrettable that speculations of Nemesius rather than the more practical observations of Rufus captured the fancy of Medieval commentators. One notes that historical vagaries of dissection opportunity strongly colored the language of anatomical description. Speculative excesses flourished when the opportunity was withheld;

12. D. Reisman, *The Story of Medicine in the Middle Ages* (New York, 1935), pp. 83-88, J. J. Walsh, *Medieval Medicine* (New York, 1920), pp. 1-20, and Erwin Ackerknecht, *A Short History of Medicine* (New York, 1968), pp. 81-94.

13. E. G. Brown, *Arabian Medicine* (Cambridge, 1921), pp. 66-74, and M. W. H. Simpson, *Arab Medicine and Surgery* (London, 1922), pp. 1-2.

conversely, a more sober and accurate account emerged when the times were favorable. We see some of the roots of Leonardo's early confusion in a passage of Nemesius' book, *On Human Nature:*

> Now, if we make this assertion, that the senses have their sources and roots in the front ventricles of the brain, that those of the faculty of intellect are in the middle part of the brain, and that those of the memory are in the hinder brain, we are bound to offer demonstration that this is how these things work, lest we should appear to credit such an assertion without rational grounds. The most convincing proof is that derived from studying the activities of the various parts of the brain. If the front ventricles have suffered any kind of lesion, the senses are impaired, but the faculty of intellect continues as before. It is when the middle of the brain is affected that the mind is deranged, but then the senses are left in possession of their natural functions. If the front ventricles and the middle of the brain are affected together, both thought and sensation break down. If it is the cerebellum that is damaged, only loss of memory follows, while sensation and thought take no harm. But if the middle of the brain and the cerebellum share in the damage, in addition to the front ventricles, sensation, thought, and memory all founder together, with the result that the living subject is in danger of death.[14]

14. William Telfer, ed., *Cyril of Jerusalem and Nemesius of Emesa* (Philadelphia, 1955), pp. 341-342.

The doctrine of ventricular autonomy in mental functions is clearly articulated; however, this basic idea was much distorted and rearranged to fit the variable requirements of later Arabic şcholars in accordance with their particular philosophical and scientific biases.

Following the death of Mohammed, Arab prophet and founder of Islam, in 632, Muslim troops poured out of the Saudi Arabian desert conquering all before them, and proclaiming that "there is no god but God, and Mohammed is the messenger of God." These fanatical warriors carried their message triumphantly into Persia advancing as far as India, and in one of the great paradoxes of all history, exhibited a tender and merciful regard for preserving the culture and properties of the conquered in deference to the veneration for knowledge and learning preached by their prophet. The true greatness of Mohammed is best exemplified in the Islamic doctrine stated in the Koran, "Science lights the path to paradise. Take ye knowledge even from the lips of the infidel. The ink of the scholar is more holy than the blood of the martyr." For these words we are profoundly grateful—it was the guiding precept in the preservation of antiquity. Islamic centers of learning

gathered scholars of all faiths and ethnic backgrounds. Ancient Greek and Latin texts were translated by Jewish and Syrian philologists into Syriac and Hebrew, later into Arabic.[15]

Persian centers dominated in the early years of Islam, and science flourished. Unfortunately, anatomical dissection was proscribed by religious edict. The most influential physician was a Persian, Avicenna or ibn-Sina (980-1063). His medical textbook, the *Canon*, exercised a persuasive influence over all medically related matters for centuries. Avicenna's notions of anatomy were drawn from an encyclopedic knowledge of Hippocrates, Aristotle, Galen, and lesser figures such as Nemesius, from which eclectic sources he extracted freely what suited his fancy. Not satisfied with the vague cerebral centers of Galen, he followed the lead of Herophilus who advocated a fourth ventricle seat for the soul, but distributed the sites more generously through the ventricles as suggested by Nemesius. Some of his ideas suffered sadly in translation, but his own high regard for Aristotle caused him to vacillate most ambiguously on the cardiocentric vs. cerebrocentric dominance controversy. Thus his powerful influence had negative as well as positive features to distract the impressionable medieval mind and mislead scientific debate long after Leonardo. A selection from Book I of the *Canon* on the subject of movement, sensation, and the rational faculty communicates the compelling authority of his statements, bearing in mind that he was quite as decisive when expressing contrary opinions elsewhere in his works:

> Now the great philosopher Aristotle believes that the heart is the source of all these functions, though they are manifested in the several principal organs. But physicians still keep to the opinion that the brain is the chief seat of sentient life, and that each sense has its own distinct member whereby it manifests function. But if physicians thought over the whole matter as thoroughly as they should, they would take Aristotle's view instead. They would find that they have been only regarding appearances instead of realities, taking non-essentials for essentials. The establishment of this truth is for the philosopher and natural scientist, and not for the doctor as doctor. But the latter, looking on members as being initiators of the faculties instead of as their manifestation—thus despising or ignoring philosophy—fails to see which things are prior...[16]

To his credit, Leonardo was never deceived by the mental gymnastics of scholastic debate on the brain-heart question of

15. Albert S. Lyons and R. Joseph Petrucelli, *Medicine An Illustrated History* (New York, 1978), pp. 295-310.

16. O. C. Gruner, "Commentary on the Canon of Medicine of Avicenna," *Hamdard*, Vol. XI, 7-9, July-Sept., (Karachi, Pakistan, 1967):25.

neurological function, but some of his uneasiness about brain localization undoubtedly stemmed from other Avicenna sources such as a passage on the situs of the common sense. It serves to explain some of his early difficulties:

> One of the animal internal faculties of perception is the faculty of fantasy, i.e., sensus communis, located in the forepart of the front ventricle of the brain. It receives all the forms which are imprinted on the five senses and transmitted to it from them. Next is the faculty of representation located in the rear part of the front ventricle of the brain, which preserves what the sensus communis has received from the individual five senses even in the absence of the sensed object.[17]

Medieval scholars considered questions involving the soul the exclusive domain of philosophy, resolvable only by disputations; consequently, the experimental data compiled by Galen and available in the writings of Avicenna were largely ignored. A lingering penchant for the ventricular arrangement of Nemesius colored the views of Albertus Magnus from which a series of crude pictorial representations sprang as depicted in Figure 37.

Other than these medico-philosophical concepts inherited from antiquity, as modified by the sages of the Middle Ages, Leonardo had a source of ideas about the brain and nervous system that was closer in both time and space. Fortuitous medico-legal requirements for autopsy material in the late-thirteenth century sparked a renewed interest in human dissection in northern Italy, and Bologna became the center for an anatomical movement where more practical attitudes contrasted with the ivy-towered disputations of the philosophers.[18] Mondino de'Luzzi (ca. 1275-1326) emerged as the most distinguished exponent of the movement. His *Anathomia*, written in 1316, survives as the classic expression of the revival. It took the form of a dissection manual, reproducing Galen and Aristotle as portrayed by Arabic authorities. It was for the most part, a humble imitation, but he did some of his own dissections, and the work has merit for its brevity and systematic arrangement. Despite the paucity of truly original observation, Mondino's contribution is most notable for the enormous potential of the dissection methods advocated. Unfortunately, his followers disdained the knife for the more prestigious reader's rostrum, and failed to capitalize on Mondino's initiatives. The book enjoyed enduring popularity, passing through several editions, and pre-

17. F. Rahman, *Avicenna's Psychology. An English translation of Kitab al-Najat, Book II, Chapter VI, with historico-philosophical notes and textual improvements on the Cairo edition* (London, 1952), p. 31.

18. Ackerkneckt, *History of Medicine*, pp. 88-91.

senting a laboratory alternative to scholastic speculative anatomy. Some notion of the contrasting viewpoints and erroneous assumptions upon which Leonardo was to launch his career as an anatomist may be apparent in the following excerpts from the *Anathomia*:

> The anatomy of the cerebral marrow and of those things contained in it. When the membranes have been seen, the brain will appear, larger in quantity in man than in any other animal of the same size because he has a hotter brain than they, and because he requires more animal spirits for the operation of his intellect.

An uneasy juxtaposition of fact and fancy characterizes this entire work, but it is a derivative fancy repeating the authoritative physiology of Galen via Avicenna:

> This brain has two parts, anterior and posterior, and the anterior part (cerebrum) is divided into right and left; this division appears clearly in the substance of the brain and consequently in the ventricles.

Leonardo missed this point in his early brain drawings wherein the influence of Albertus Magnus is more apparent:

> Its substance is a cold and humid marrow, different from other marrows (as in the long bones, for instance); it is not contained to nourish the cranium, but rather the cranium is nourished that it may contain the brain of which the purpose is to temper by its complexion the vital spirit (from the heart) so that it may become animal spirit.

Later, we will see how Leonardo endorses this Aristotelian principle when defining the function of the nasolacrimal duct:

> Then cut lighty through the middle until you reach the greater anterior (lateral) ventricle. Before you reach the depth of the lacuna (infundibulum) note that the ventricle is divided into right and left, as I said; also that there are walls on this side descending as far as the base, dividing right from left; then you will immediately see the size of each ventricle.

Mundino was preparing a dissection manual as the wording will attest, and clearly, he did see much of what he was describing, some of it quite original observation; however, he was a man of his time, bound to reiterate inherited dogma which inevitably must cloud the vision of Leonardo as in the following:

Phantasy, which retains the appearance received by particular senses, is located in the anterior angle. Imagination, which apprehends those appearances received by phantasy, is in the posterior angle; it apprehends them by composing and dividing, not be perceiving that this thing is this. In the middle is the 'sensus communis' which apprehends appearances carried from the particular senses, and so, as you will see, the sensitive parts end at this place like rivers in a fountain.

Soberly conscious of the conflicts that theory imposes upon the observed facts, Mundino almost apologetically adds:

All these things are in accordance with the opinion of Avicenna, *De vertutibus animalibus*, although as I declare elsewhere, according to the opinion of Aristotle and Galen, there is only the 'sensus communis' which is variously called phantasy and imagination.[19]

19. Clarke and O'Malley, *The Human Brain*, pp. 22-23, translated from Berengario da Carpi, *Commentaria cum amplissimis additionibus super anatomis Mundini* (Bologna, 1521).

Numerous references in the notebooks indicate Leonardo's familiarity with the *Anathomia*, first published at Pavia and Bologna in 1478, but also quite available in manuscript form. While he was quick to condemn reliance upon authority, he was never able to escape from it. The anatomical drawings reveal the on-going struggle to seek the truth, and the glory of the occasional triumph.

Figure 38.

As we see in Figure 25, one of his earliest brain figures, the study of the brain and cranial nerves commences with a background knowledge of utter nonsense, but clearly not ignorance, for even in the accurate designation of external and internal layers, he was following traditional texts. Interesting for the insights these sketches give of Leonardo's versatility at devising new means of diagrammatic portrayal, Figure 38, repeats the structural stations of Figure 25 from different perspectives. A curious three-dimensional effect is produced above the horizontal section of the brain in the upper right drawing by preserving a frame of meningeal vessels. Additional horizontal sections of the head in the two central drawings add little, but notable as a demonstration of the technique of "transformation" or "parallel projection" is the lower right cluster of three heads, whereby the middle projection is derived from the parallel frontal and lateral figures. Leonardo was introducing an established architectural device to anatomical illustration.

In Figures 39 and 40 we get some idea of the confusion and contradiction he was trying to sort out and clarify without benefit of actual brain dissection as yet. The vacillating state of his

Figure 39.

Figure 40.

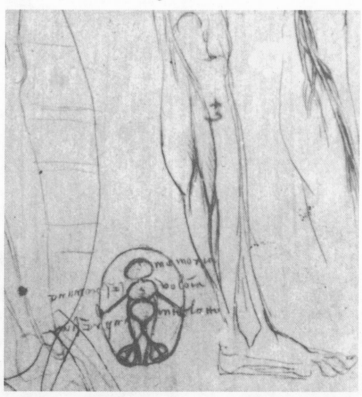

thinking is apparent when these drawings are compared with Figure 25 where the *senso comune* is still in the anterior ventricle. Shifting patterns of cranial nerve-ventricle attachment reflect the mounting tension between theory and observed facts.

The attempt to precisely locate a percipient soul as a center for ingress and egress of all neurological phenomena continued to dominate Leonardo's studies of the nervous system. It was a quest that has the appearance of absurdity in the modern sense only because of its ineradicable roots in antiquity, for although the ventricles no longer excite interest, man still aspires indecisively to define and locate the elusive site.[20] As previously noted in chapter III, this preoccupation with fictional physiology did not interfere with the achievement of superbly naturalistic skull drawings. In fact, the realistic representation of the skull in Figures 20 and 21 must have fostered an uneasiness about traditional notions of ventricular placement which Leonardo subjected to geometrical analysis by resorting to a system of proportions. Thus in Figure 21 he reasons:

> Where the line *a m* is intersected by the line *b c* there the meeting of all the senses is made, and where the line *r n* is intersected by the line *h f* there the fulcrum of the cranium is located, at one-third from the base line of the head; and so *c b* is halfway.[21]

Having accurately presented the housing, he was trying to develop a scheme for geometrical as well as practical localization of *senso comune* to accommodate cranial nerve pathways and foramina newly revealed to him. His calculations created a dilemma that could not be resolved satisfactorily with the traditional brain models. Up to this point Leonardo had been serenely content to theorize without objective knowledge of brain structure. How to reconcile the observed facts to theoretical concepts required a proper understanding of the ventricular environment. This he accomplished in a most brilliantly innovative fashion. By making wax castings of the ventricles in the intact brain, he discovered that the third ventricle did indeed lie within the purview of the site for a *senso comune* inductively derived from his observations. Despite formidable technical difficulties imposed by an unfixed brain, the cast impression was a reasonable similitude of reality. In Figure 41, the injection technique is carefully illustrated and described, employing the brain of an ox as subject. Species differences,

20. Wilder Penfield, *The Mystery of the Mind* (Princeton, 1975), p. 110.

21. Keele and Pedretti, *Anatomical Studies*, I:106.

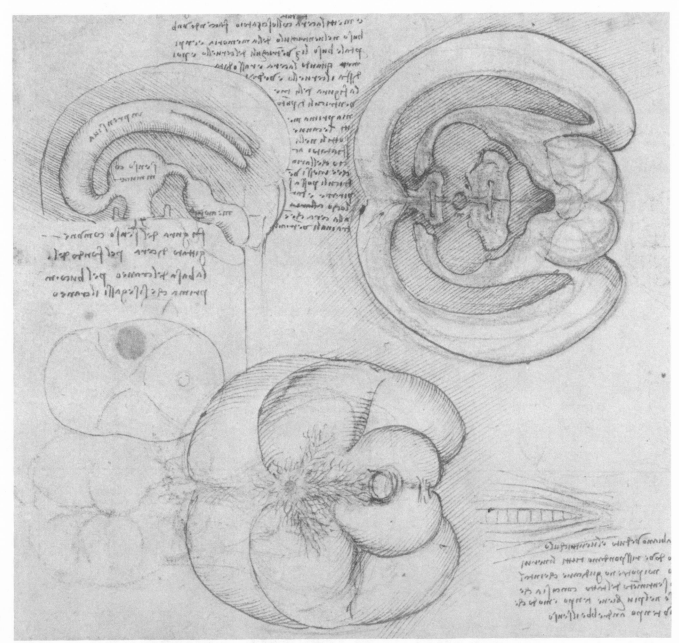

Figure 41.

unnatural molding distortion of the unfixed brain, and lack of filling of temporal horns account for the failure to produce an exact likeness of the human ventricular casting exhibited in Figure 42.[22] Wax casting was no accidental discovery. It was an extraordinarily inventive problem-solving response to a very real need at the time. Below the upper left drawing he writes: "Shape of the 'senso comune.' Cast in wax through the bottom of the base of the cranium through the hole *m* before the cranium is sawn through."[23]

22. R. J. Last and D. H. Thompsett, "Casts of the cerebral ventricles," By permission of the President and Council of the Royal College of Surgeons of England. *British Journal of Surgery* 40 (London, 1953):525.

23. Keele and Pedretti, *Anatomical Studies*, I:332.

Figure 42. In this lateral view of the ventricular system, the anterior portion of the lateral ventricle becomes the *impresiva*, sensory receiving center. Lateral ventricular division is well posterior. *Senso comune* is now lodged in the third ventricle and *memoria* in the fourth. The tip of the injection syringe enters the infundibulum of the third ventricle. To the right of the lateral projection he instructs:

Make two vent-holes in the horns of the greater ventricles and insert melted wax with a syringe, making a hole in the ventricle of memory; and through such a hole fill the three ventricles of the brain. Then when the wax has set, dissect off the brain and you will see the shape of the three ventricles exactly. But first put fine tubes into the vent-holes so that the air which is in these ventricles is blown out and makes room for the wax which enters into the ventricles.[24]

24. Keele and Pedretti, *Anatomical Studies*, I:332.

In the drawing to the right of the lateral projection, the ventricular arrangement can only be comprehended as a split down the middle from above, opened like a book, revealing the foramina of Monro, the two halves of the longitudinally divided aqueduct of Sylvius lying laterally, the fourth ventricle, and the injection site *m* from inside. Immediately adjacent to the right margin of the hinged-open view of the ventricles is a faint drawing of cortical convolutions as seen from above. Recalling Leonardo's natural inclination to work from right to left, it is entirely conceivable that the convolutional sketch was intended to set the scene for the sagittal-hemispheric split of the open ventricles. Temporal horns are missing in all drawings owing to a failure to employ additional drainage vents in these areas. There is no indication that he ever suspected the presence of these extensions. The large basal study below left is interesting for its legendary *rete mirabile* dispersed about the injection site, a normal anatomical accoutrement of the ox and other animals, but only a figment of the imagination for deluded Medieval and Renaissance anatomists who failed to recognize species differences in Galen's animal anatomy. To the far right, a crude sketch denotes the convergence of nerves on the *senso comune*. Directly below is another lateral projection with a more normal anterior split of lateral ventricles, and a hint of communication between fourth ventricle and the central canal of the spinal cord. The injection site is again illustrated in the floor of the third ventricle. Beneath this drawing he suggests a short-circuiting of afferent sensory messages into the fourth ventricle:

Since we have clearly seen that the ventricle *a* (fourth ventricle) is at the end of the spinal cord where all the nerves which give the sense of touch come together, we can judge that the sense of touch passes into this ventricle, since Nature operates in all things in the shortest time and way possible.[25]

25. Keele and Pedretti, *Anatomical Studies*, I:332.

Demonstration of a more realistic ventricular system marked a turning point that was apparent in more natural and more sophisticated drawings of intracranial structures, which curiously and inexplicably become evident in the works of Leonardo's immediate successors as well, lending additional credence to speculation that his anatomical discoveries were not unknown to his contemporaries.

Provided with new and more accurate information about the brain's internal environment from the wax castings, Leonardo was freshly stimulated to sort out the complex interrelationships of brain and cranial nerves. Groping efforts to integrate motor and sensory activity through a common center were contradicted by the observed facts as his study of the nerve pathways progressed. A significant tendency of nerves to converge on the third ventricle led to the conviction, which bucked tradition, that the *senso comune* did indeed lay in the third ventricle, and there he placed it in all subsequent drawings. However, pathways of the sense of touch which he traced through lateral ancillaries of the cervical cord appeared to end in the fourth ventricle. This was one of the hitches in the unified system he was attempting to formulate. There is no explanation in existing manuscripts as to how touch was relayed to the *senso comune* from this auxiliary

Figure 43.

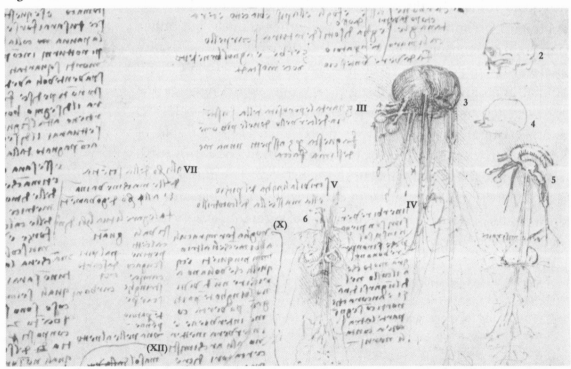

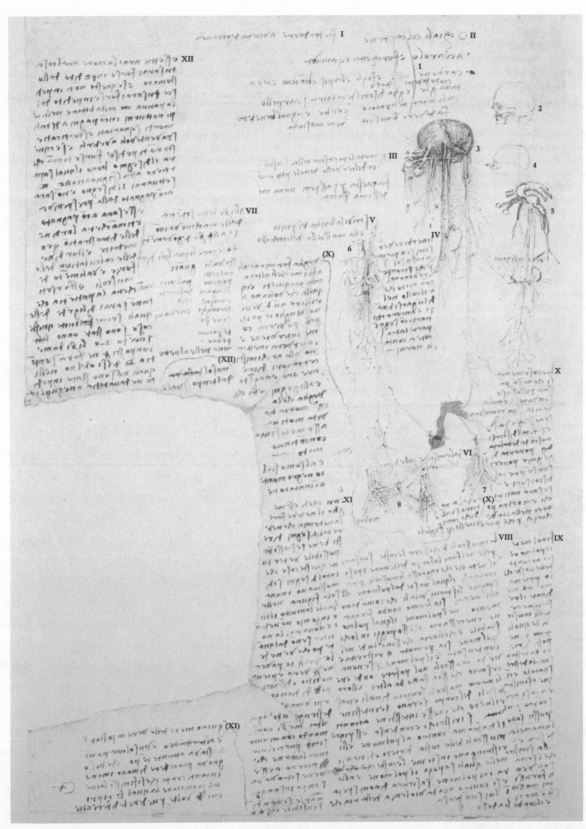

Figure 44.

26. Amongst the miscellaneous jottings of this page (RL19070v, K/P113r) are several statements that give important subjective insights into his personal approach to anatomy. For a translation of the paragraph in the upper left corner of the page see fn. 16 in Chapter I. Along the right edge of the cut-out and continued directly below, he writes:

"And you who say that it is better to see an anatomy made than to see these drawings would be right if it were possible to see all these things which are demonstrated in such drawings in a single figure. In this with all your ability you will not see nor obtain knowledge of more than a few vessels, to obtain a true and full knowledge of which I have dissected more than ten human bodies, destroying all other organs, and taking away in its minutest particles all the flesh which was to be found around the vessels without causing them to bleed, except for the imperceptible bleeding of capillary vessels. And one single body was not sufficient for enough time, so that it was necessary to proceed little by little with as many bodies as would render a complete knowledge. This I repeated twice in order to observe the differences." (K/P, p. 360).

Jammed tightly against the right margin below the trailing vague ramifications is a paragraph in which Leonardo casts aspersions upon speculative reasoners who shun objective evidence, and upon the charlatans and montebanks of science who seek miracles rather than the obvious laws of nature:

"Mental matters, which have not passed through the 'senso comune' are vain and they beget nothing but prejudiced truth. And because such discourses arise from poverty of wits, such reasoners are always poor, and if they are born rich they will die poor in old age because it seems that Nature revenges herself on those who want to work miracles, so that they have less than other quieter men. And those who want to grow rich in a day live for a long time in great poverty, as happens, and will happen to eternity, to the alchemists, searchers after the creation of gold and silver; and to those engineers who want dead water to give itself

receptive center, otherwise always designated as the lodging of memory, and apparently the matter was never resolved.

An interesting collection of small sketches shown in Figure 43 reflects some of the difficulties he was encountering as he tried to develop his central nervous system. These drawings were squeezed almost in miniature into an available corner of a page of assorted, unrelated, but extremely revealing statements on his activities and philosophic judgments, particularly pertinent where they dealt with anatomical matters. A scaled-down version of the page is reproduced in Figure 44 as a typical example of Leonardo's common propensity for eclectic representation on a single sheet.[26] The careful manner in which the writing is sculptured about the cut-out on the left indicates that the defect preexisted. Vague outlines of a skull in the right upper corner may be construed as a mere reminder to locate a skull from the note beside it, "try to get a skull." The drawings of the brain and cranial nerves below and to the left of the skull, and of the ventricular system with attached nerves directly below, are intermediary or transitional phases between Figure 41 and the more detailed and accurate drawings in Figures 45, 46 and 47.

It was only in the basal and superior topographical views in Figure 41 that Leonardo ever achieved a semblance of reality in shaping the brain. His lateral perspectives, as in Figure 43, always resembled the Portuguese man-of-war. The olfactory tracts, a and n, are shown above the eyeballs and chiasm, but in rather odd relationship to the optic tracts, unless the viewer's angle is from below and m is the right eyeball. This crudely drawn chiasm must vie with the depictions in Figures 45 and 46 for the honor of being the earliest illustrations in existence; all probably were drawn at about the same time. The relationships of these nerves are better exhibited in the later figures where they converge more distinctly on the third ventricle rather than anterior aspect of the lateral ventricles, which is more consistent with his maturing opinions. Note the high-lying position of the olfactory tracts, optic tracts, and third divisions of the trigeminal nerve in the ventricle sketch. These findings suggest an earlier stage in his changing thoughts about *senso comune* localization. Behind the trigeminal nerves are the vagus nerves, originating from the third ventricle, with the right descending to the stomach and the left to the heart. Below these organs the vagi appear to continue as the branching splanchnic

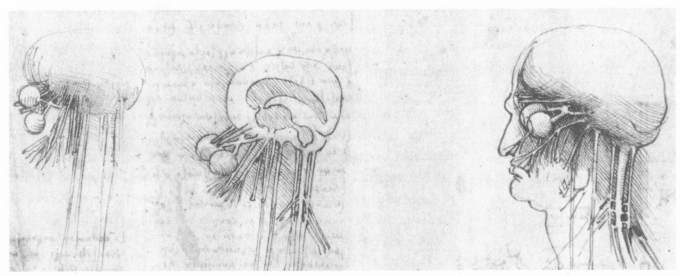

Figure 45.

nerves of the autonomic nervous system. How interesting to reflect that both Vesalius[27] and Eustachius[28] were similarly deceived more than a half century later. Only in Leonardo's case can the trailing strands be permitted an alternative interpretation as the true parasympathetic extensions that pass through the coeliac and its subsidiary plexuses to end in the terminal ganglia of the intestine, liver, pancreas, and kidneys.

Dangling inappropriately at a 90° angle to the posterior tip of the brain is the spinal cord with its misconceived lateral auxiliaries in the cervical region, a fiction that is perpetuated in all subsequent drawings.

Certain features of the drawings in Figure 45 mark these studies as a progressive stage in his struggle to reconcile the confused statements of available texts regarding brain-cranial nerve relationships with the facts as observed in his dissections. Provided with a more accurate knowledge of ventricular distribution by the wax castings, he felt compelled to move the *senso comune* to the third ventricle. This move seemed to conform with the basilar course of the nerves. He was exploring uncharted anatomical areas and dealing with a mushy, unfixed brain, disposed to fall apart in his hands as he lifted it from the cranial fossae, trying to retain a visual picture of proper relationships while meningeal investments and mooring nerves were cut away. Medical students have always encountered great difficulty reconstructing proper associations with a fixed brain and precise

moving life with perpetual motion. And to the supreme fool, the necromancer and enchanter." (K/P, I:360).

27. Andreae Vesalii, *De Humani corporis fabrica Libri septem* (Basel, 1543), p. 319.

28. Bartholomaei Eustachii, *Tabulae anatomicae* (Amsterdam, 1722), Tab. XVIII, between pp. 44 and 45.

drawings in this situation. Leonardo's realignment is deplorably incomplete and almost comical in outline, but nevertheless, a giant step in anatomical exposition. From left to right, the three sketches in Figure 45 deal in turn with orientation of cranial nerve to brain, cranial nerve to ventricle, and cranial nerve to brain, head, and neck. The relative placement of olfactory tracts and visual pathways in the middle and right figures is quite true to nature, but distorted in the left figure unless the arrangement can be construed as a deliberate rotation of right eyeball and optic nerve counter clockwise over the olfactory tracts. Convergence of five pairs of nerves on the third ventricle in the middle figure epitomizes his concept of third ventricle as seat of *senso comune*, and designates a final assumption from which he never retreats. Nerve pairings posterior to the optic tracts are somewhat confusing. If the branching pair behind the optic tracts are to be interpreted as maxillary divisions of the trigeminal nerve as clearly shown in the right figure, then the short vertical pair immediately posterior probably represent the mandibular divisions. However, the pair with terminal branching in the left and middle figures have the appearance of mandibular divisions. In such case, the short vertical nerves could be facial nerves, or, less likely, the efferent motor tracts of the trigeminal nerves. It is more consistent with medieval anatomical tradition to assume the trigeminal label for the entire complex. There is no mystery about the long vertical nerves (vagi) which are elsewhere described and discussed in detail. At the posterior-inferior aspect of these drawings, the spinal cord emerges in the form of the tripartite misconception that Leonardo never corrected. The cord invariably appears to be emerging from a sack-like brain, undivested of its meningeal envelopes. Lateral auxiliary ducts extend down to the cervical nerves forming the brachial plexuses.

Leonardo's finest representation of brain, cerebral ventricles and cranial nerves is found on the verso of an anatomical sheet in the Schlossmuseum at Weimar. Pedretti assigns a date of 1506-8, by which time his special interest in the nervous system was virtually completed.[29] The verso of the Weimar sheet, reproduced in Figure 46, exhibits two important technical innovations in anatomical illustration that add special interest to the excellent drawings. In the large center figure above, cranial nerve relationships are shown by the method of "transparency," and in the

29. Pedretti, *Richter Commentary*, II:110.

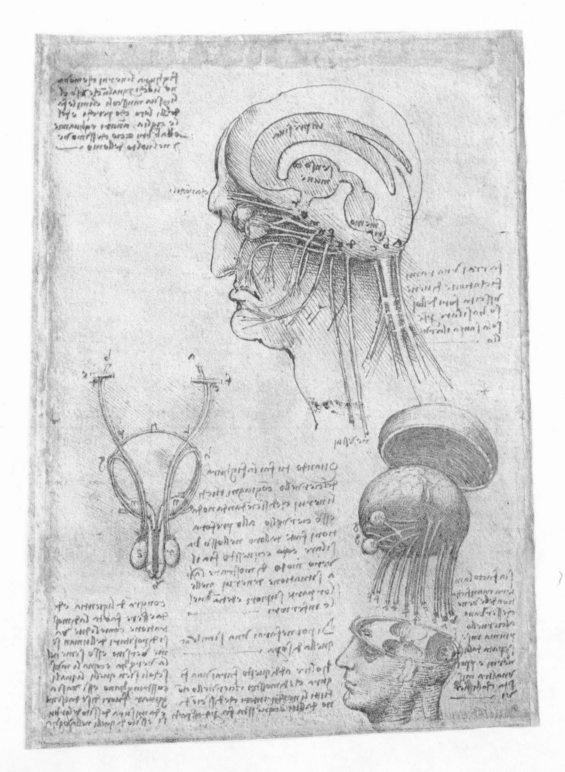

Figure 46.

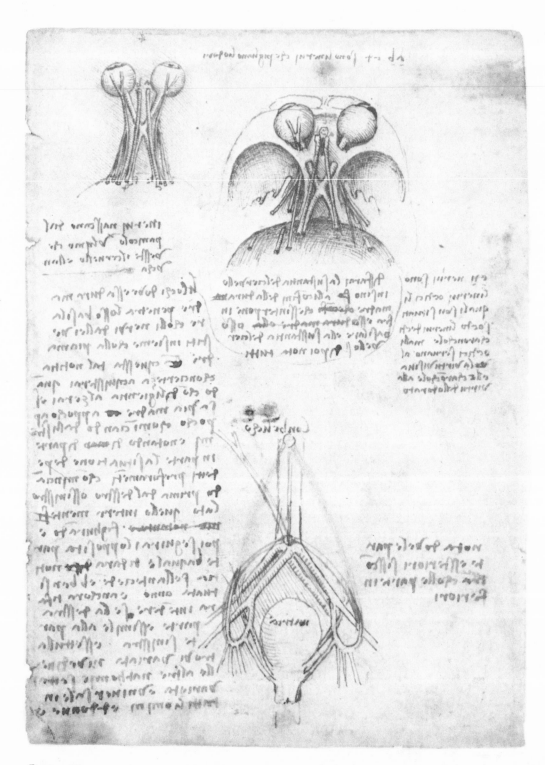

Figure 47.

lower right corner, calvarium, brain with emerging cranial nerves, and basal fossae are "exploded" to add a new dimension to the art of visual demonstration of these complicated structures.

The true value of the Weimar sheet is not limited to its drawings, for from its writings we gain some idea of how far Leonardo's knowledge of brain anatomy outstripped his efforts to record the information in his drawings. An ambitious program is described, designed to include the cerebrovascular system in a multi-perspective rendering of the intra and extracranial environment. That he intended to explore function as well as form is manifest in the lines in the upper left corner of the page:

> Draw the nerves which move the eyes in any direction, and its muscles;
> and do the same with their eyelids, and with the eyebrows, nostrils,
> cheeks, and lips, and everything that moves in man's face.[30]

30. Keele and Pedretti, *Anatomical Studies*, I:166.

It can be inferred from the remarkable study of cranial nerves in Figure 47 that he did indeed acquire some insight into extra-ocular movements, but in none of the drawings is there any indication that he discovered the facial nerve.

In both of the brain drawings of the Weimar sheet, the olfactory tracts, optic nerves, chiasms and optic tracts are exceedingly well rendered. The nerve with forking branches over the eyeballs is regarded by most interpreters as the ophthalmic or first division of the trigeminal nerve.[31] This assumption can be debated, and a case can be made for the oculomotor nerve, based upon the drawings in Figure 47. Owing to his failure to ever expose the gasserian ganglion in its tight little meningeal envelope, the divisions of the trigeminal nerves are always treated as separate nerves with confused origins from the brain. This confusion is compounded in the "transparency" version, and made ridiculous in the "exploded" composite, where in both instances the divisions are properly paired, but as separate nerves. Maxillary divisions of the trigeminal nerves are readily ascertainable arising from the brain at *e* and curving downward beneath the eyes to terminate in the upper lips, with alveolar branching only distinguishable on the left. Curiously, the mandibular or third divisions of the trigeminal nerves originate from the brain more anteriorly at *f* at approximately the same take-off as the nerves that fork above the eyes. The posterior-superior alveolar branches appear to have independent origins near the point where the optic tracts merge into

31. O'Malley and Saunders, *On the Human Body*, p. 342, and Keele and Pedretti, *Anatomical Studies*, I:166 and also I:168.

the substance of the brain. Leonardo's lettering does not help matters for he never elaborated on its meaning, and the dangling pairs in the "exploded" view of Figure 46 offer no enlightenment. The confusion of pathway details should not detract from the ultimate brilliance and originality of the pictorial conceptionalizations in these two drawings.

The vagus nerves arising at *d* in the upper drawing of Figure 46 are called "reversivi" and so labelled inferiorly at the cut ends, in accordance with Mundino and medieval custom. Vagi and spinal cord are precisely patterned after the representations in Figure 45, so nothing is added other than superior draftsmanship.

There is clear evidence of the struggle to shake off the bonds of tradition which held that the cranial nerves consisted of seven pairs. In the paragraph to the left of the lower drawings he states:

> When you make a drawing of the brain join all the nerves which descend from the brain to the perforations made by them in the basilar bone. And this is the true way of showing the true situation of the nerves in their upper parts as well as in their lower parts.
>
> Then you will make a similar one to that from above.
>
> Besides this you will make a drawing which demonstrates the brain with all its nerves descending from it, complete; and do this from four aspects.[32]

32. Keele and Pedretti, *Anatomical Studies*, I:166.

To the right of the lower figure is a statement that confirms his awareness of the cerebral circulation, but this knowledge does not materialize in any of the extant drawings:

> Let the whole ramification of the vessels which serve the brain be made first by itself, separated from the nerves, and then another combined with the nerves.[33]

33. Keele and Pedretti, *Anatomical Studies*, I:166.

If we are to fault Leonardo for failure to achieve the enterprising objectives proposed in the Weimar sheet, we must nevertheless marvel at some of the remarkable products of these investigations that followed. The exciting consequences are revealed in the upper two drawings of Figure 47, whereby we may appraise and acknowledge the astonishing extent of his success. How to explain the hidden springs of genius under the depressing circumstances in which these secretive dissections were conducted

is beyond the scope of any analysis from the available facts. Without benefit of a coherent physiological substratum, his dissection protocol, nevertheless, was designed with a refreshing touch of modern sophistication, and followed meticulously with the astute observant eye of the master artist. Beneath these remarkable drawings of the cranial nerves in Figure 47 he directs:

> Ease away the brain substance from the borders of the dura mater which is interposed between the basilar bone and the brain substance. Then note all the places where the dura mater penetrates the basilar bone with nerves ensheathed in it together with the pia mater. And you will acquire such knowledge with certainty when you diligently raise the pia mater, little by little commencing from the edges and noting bit by bit the situation of the aforesaid perforations, commencing first from the right or left side, and drawing this in its entirety; then you will follow the opposite side which will give you knowledge as to whether the previous one was correctly situated or not. Furthermore, you will come to understand whether the right side is the same as the left. And if you find differences, review the other anatomies to see whether such a variation is universal in all men and women, etc.[34]

34. Keele and Pedretti, *Anatomical Studies*, I:168.

These careful instructions took recognizable form in the Figure 47 sketches. Here the observant eye masters a scene that transcends the functional understanding of the artist. Having removed the brain and peeled away the arachnoid membranes, the peripheral extensions of the first six cranial nerves were clearly disclosed. Unfortunately, the terminal attachments of the three nerves governing eye movements were disengaged from the extrinsic muscles of the eyes in the process of unroofing the orbits and stripping away the soft tissues to expose the eyeballs. Had he undertaken the dissection of these tissues with greater care he would have discovered their innervation and possibly their manner of turning the eyes. In the upper left figure, the olfactory tracts *a b c d* overlay the optic tracts, chiasm, and optic nerves *e n*. Terminal olfactory bulbs are less obvious than in the more inclusive drawing to the right. From his comparative anatomy, Leonardo was aware of the much larger bulbs in animals, termed "caruncles," and it is to his credit that, unlike Mundino, who was describing the animal anatomy of Galen, Leonardo rejected tradition and drew what he saw.[35] The perforated cribriform plate of the ethmoid bone *c* in the right sketch provides the holes through which odors were believed

35. Filippo Bottazzi, "Leonardo as Physiologist" *Leonardo da Vinci* (New York, 1956), pp. 373-388. Bottazzi

discusses Leonardo's awareness of sense acuity between species, including a direct quotation, translated from MS B, 13v:

"I have found in the constitution of the human body that, among all the animal constitutions, it is of more obtuse and blunt sensibilities, so it is formed as an instrument less ingenious, of parts less capable of receiving the power of the senses. I have seen in the leonine species how the olfactory nerve, forming part of the substance of the brain, descends in a very large receptacle to meet the sense of smell, which enters among a great number of cartilaginous cells with many passages that go to meet the above-mentioned brain."

See also, Gastone Lambertini, "Leonardo Anatomico," *Studi Vinciani* (Florence, 1954), ed. by Leo S. Olschki, pp. 66-67.

36. Keele and Pedretti, *Anatomical Studies*, I:168.

37. McMurrich, *The Anatomist*, p. 211. McMurrich concedes that Leonardo observed at least one of the nerves supplying the eye muscles that Galen had overlooked. In O'Malley and Saunders, *On the Human Body*, p. 342, and Keele and Pedretti, *Anatomical Studies*, I:168, the ophthalomic division of the trigeminal nerve is described as one of the three nerves passing to the orbit, and the tripartite forking of the trigeminal nerves in the middle fossae is not mentioned in any of these works.

to ascend to the olfactory "nerves" for conveyance to the brain. In the paragraph to the right of the larger drawing he explains:

e n are nerves, the optic nerves which are situated beneath the nerves called caruncular; but the optic nerves serve visual power and the caruncles the olfactory power.[36]

Lateral to the olfactory tracts and optic complex are bundles of three nerves which, contrary to most authorities,[37] can only be the oculomotor, trochlear, and abducens nerves, and the cluster of three is consistently explicit in all four representations. Moreover, the nerve with forking branches over the left eyeball is most medial in the cluster, and the branching is best interpreted as the loose ends of the oculomotor nerve from the extirpated muscles. Branching of the ophthalamic division of the trigeminal nerve normally occurs more distally. This impression is substantiated in the right drawing by an unequivocal, well defined, tripartite forking of the trigeminal nerves in both middle fossae, with the ophthalmic divisions directed toward the orbits quite apart from the more mesial cluster of three nerves. Leonardo's failure to delineate more precisely by size differential makes it impossible to distinguish between abducens and trochlear nerves, but the trochlear nerves, having a more lateral and serpentine course, are probably the shorter pair with lateral flaring ends.

In these beautiful drawings of cranial nerve relationships, Leonardo is revealed as a consummate anatomist, capable of exploring the unknown in a careful systematic manner, and of recording quite objectively the new vistas disclosed. The disclosure in this case is uncommonly accurate, but also quite beautifully rendered.

Our study of the brain and cranial nerves draws to a close with a superb, timeless example of the illustrator's art in Figure 48 which shows the course, and attempts to define the function, of the right vagus nerve.

Medieval anatomists called the vagus nerve, "nervo reversivo," in deference to Galen who had resected a branch of it, the recurrent laryngeal nerve, and discovered that a pig could no longer squeal. In the upper paragraph on the left, Leonardo states:

The reversive nerves (vagus) arise at *a b*; and *b f* is the reversive nerve descending to the pylorus of the stomach; and the left nerve, its companion, descends to the capsule of the heart, and I believe that this nerve enters the heart.

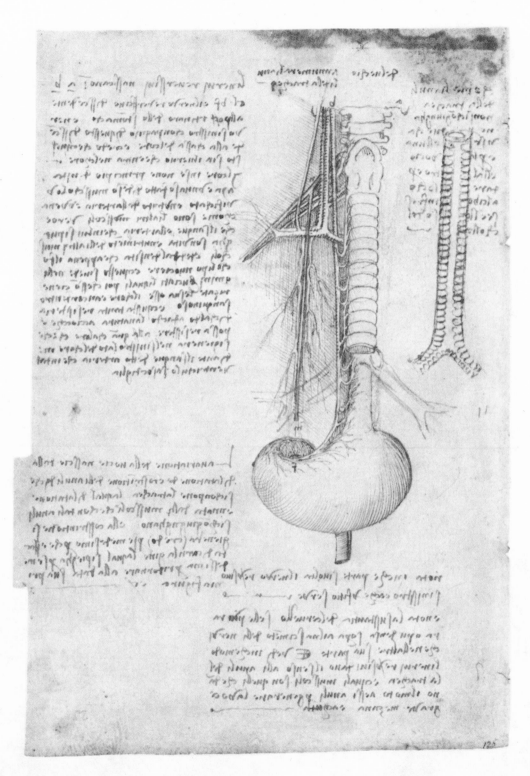

Figure 48.

Figure 49.

At the lower right corner of the page he expresses his investigative intentions:

> Note in what part the left reversive nerve turns round and what function it serves.

> And note whether the substance of the brain is rarer or denser at the origin of these nerves than in other parts. Observe in what ways the reversive nerves give sensation to the rings of the trachea, and what muscles give movement to these rings in order to produce a deep, medium or high-pitched voice.[38]

38. Keele and Pedretti, *Anatomical Studies*, I:184.

There is no record that he pursued all these inquiries to a satisfactory resolution in his own mind, but it is clear from the notes on this page that he was convinced that alterations in the pitch of the voice related directly to variations in caliber of the trachea. It is reasonably safe to conclude that he regarded the vagus nerve as regulator of this function. The crude posterior aspect of the trachea on the right is meant to show how the unjoined tracheal rings in back allow for change in diameter.

Despite numerous errors of commission as well as omission, the overall representation of the right vagus nerve merits our admiration as an original impression not to be exceeded for hundreds of years. The nerve descends from *b* along with the contents of the carotid sheath, passing anterior to the cervical nerves forming the brachial plexus. At this stage he was in the process of working out the details of plexus relations and this matter will be dealt with at greater length in a later chapter. Possibly because he had stripped away the vascular complex to expose the trachea, he brings the recurrent laryngeal nerve erroneously around anterior to the innominate vein instead of backward under the bifurcation of the innominate artery. Below the recurrent laryngeal branching he fails to provide any branching to the bronchial tree, but he does admirably depict the supply to lower trachea, esophagus, and stomach. The right phrenic nerve, accompanied by veins and arteries to heart and diaphragm, follows a parallel course to the left of the vagus. Some measure of the quality of this work can be gained from a comparison with Figure 49 from the *Fabrica* of Vesalius, which informs us of progress made in brain and cranial nerve illustration over the next fifty years, but greatly misrepresents the vagus nerves. Note especially how the

39. See footnote 26.

splanchnic nerves were thought to derive from the vagus nerves at *h* as discussed above.[39]

Leonardo's interest in the central nervous system was aborted by a variety of other activities with higher priorities on his time, particularly those concerned with making a living. Later, when his fortunes allowed a return to anatomical studies, his curiosity had shifted to the heart and vascular system where his substantial contributions must mitigate any poignant regrets about neglected neurological concerns.

CHAPTER SEVEN

The Spine and Spinal Cord

WHEN WE MARVEL AT THE EXQUISITE DETAIL AND ACCURATE REPRESENTATION
of the human spine exhibited in Figure 50, it becomes incumbent
upon us to inquire into the predisposing circumstances of time and
place that made such a realistic creation possible. What, indeed,
were the antecedents, ancient or contemporary, that spawned this
enduring work of incredibly modern sophistication? We may be
sure that a concern with the spine and spinal cord touches upon a
subject of very ancient lineage as strikingly revealed in the Edwin
Smith papyrus.[1] Unfortunately, these pertinent anatomical in-
sights shared the fate of much of da Vinci's work, lying unseen
and unappreciated well into the modern era.

We may presume, reasonably, that Leonardo had access to
manuscripts equivalent artistically to the medieval works brought
to light centuries later by Sudhoff and other resurrectionists of
the nineteenth century, as described and illustrated in Chapter
Two,[2] but those grotesque, diagrammatic absurdities were only
derivative curiosities with little inspirational content. Fugitive
sheets depicting the skeleton enjoyed wide popularity with barber
surgeons and other paramedical cults during Leonardo's lifetime.
A glimpse at the Hilain skeleton,[3] which perhaps exemplifies the
best of this class of materials, quickly reveals the gross inaccuracies
and artistic crudity of a poorly conceived spine, serving to dispel
any lingering notions that these works could have had much
influence on Leonardo. Invariably, the spine simply served to
connect the shoulder girdle with the pelvis. Little concern was
given to spine contour or to alignment with a properly tilted pelvis
essential for standing and walking. Ribs attached at angles in-
consistent with respiratory excursions and intervertebral artic-
ulations were unrecognizable.

Contemporary medical writers snobbishly disdained illustrative

1. James Henry Breasted, *The Edwin
Smith Surgical Papyrus Published in Facsimile
and Hieroglyphic Translations with Translations
and Commentary in Two Volumes* (Chicago,
1930), 1:xiii, 316-338. Some notion of
the vagaries affecting the transport of
knowledge through the course of hu-
man history is brought into perspective
when we consider the advanced clinical
acuity of Egyptian physicians of the
Pyramid Age in dealing with the spine
and cord. A broad spectrum of trau-
matic circumstances involving the cer-
vical spine was correctly diagnosed and
wisely administered as disclosed in the
Edwin Smith Papyrus. This papyrus,
dating from the seventeenth century
B.C., is reproduced from an earlier
manuscript thought to derive from
about 2500 to 3000 B.C. James Breasted
proposes a possible authorship to
Imhotep, architect-astronomer-physi-
cian, whose apotheosis served as the
prototype that inspired the Greek glori-
fication of Asclepius many centuries
later. As the scroll unravelled, the cases
were presented according to the loca-
tion of the pathological entity in a head
to foot order—a protocol that has sur-
vived as a popular arrangement into
modern times. Unfortunately, the scroll
broke off at the chest, and the lost

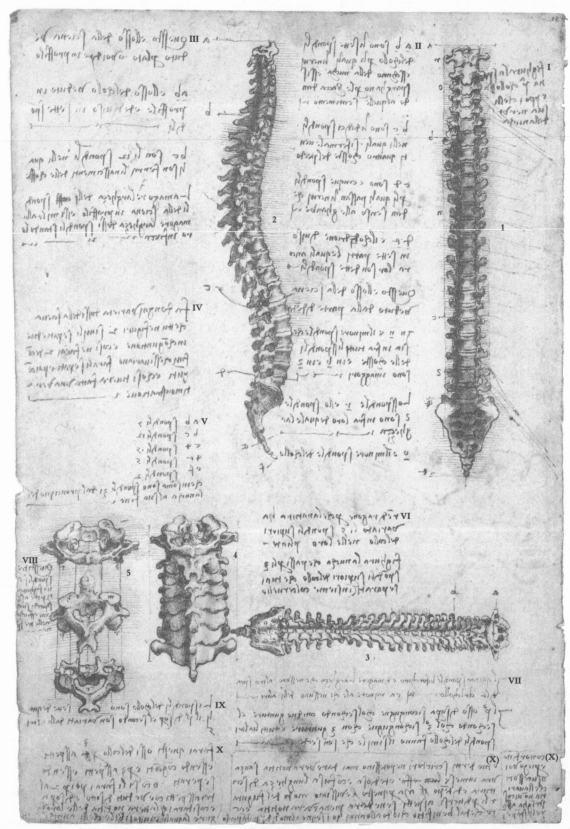

Figure 50.

exposition of their texts until the last decade of the fifteenth century, and the early exceptions, such as those found in the numerous editions of Ketham's works and in a plethora of German surgical manuals, merely reproduced copies of skeletons from popular fugitive sheets.[4]

A major virtue of the Renaissance artistic heritage was the tradition for accurate representation that traced its origins to the new standards of objectivity initiated by Giotto in the early Trecento.[5] It was to this artistic preoccupation for accuracy itself rather than to any tradition of illustrated anatomical manuscripts that we must ascribe the impetus for Leonardo's uniquely realistic anatomical models, as illustrated by his studies of the spine. Following Giotto's initiative, the faculty for depicting the world naturally was assiduously cultivated by painters and sculptors with demonstrable improvement in the portrayal of the human figure. Until Leonardo, this carefully nurtured "gift of visual penetration"[6] seldom pierced the superficial layers. There is no evidence that any previous artist had ever regarded the spinal cord as anything more than the marrow seen in other bones.

It is certainly reasonable to suppose that Leonardo had some familiarity with the few existing instances where known artists ventured beyond the surface structures. He lived in a time when sketches and even finished reproductions of distant masterpieces circulated freely among young artists who diligently copied those works in the natural process of developing and expanding their own incipient skills. Considering the popularity of this practice and Leonardo's consuming interest in anatomical matters, even lacking any documentation of personal exposure to the originals, we may yet reasonably surmise a knowledgeable awareness of the better known works of his day.

Donatello's "anatomy of the miser's heart," Figure 51, executed between 1445 and 1448, was the notable forerunner of anatomical dissection themes by a recognized master.[7] It provided a stimulus for deeper exploration of body structures by artists which, regrettably, was largely ignored before Leonardo, but it did serve to encourage the new interest in topographical anatomy.

Two exceptions to the topographical trend in anatomical representation warrant our attention. Both pertain to skeletal exposition. Signorelli's frescoes on the walls of the Cappella della Madonna de S. Brizio, in the Cathedral of Orvieto, amply display

fragment has never been found. Cases 29 to 33 record: (1) the appearance and manifestations of a gaping wound in the back of the neck which perforated the vertebra but did not injure the cord, (2) a sprain of cervical vertebrae, (3) a dislocation of a middle cervical vertebra that paralyzed the arms and legs and produced an erect phallus, (4) a displaced cervical vertebra that prevented motion but did not harm the cord, and (5) a crushed vertebra that caused quadriplegia and aphonia. Cord effects were recognized and preemptorily designated as not treatable. Spine injuries were regarded as within the purview of their therapeutic skills where the cord was not involved. Medical science never really exceeded these auspicious judgments before World War II, and the anatomical perceptiveness of this ancient work continues to impress and excite us.

2. See Figures 4, 6, and 8 in Chapter Two for typical examples of the illustrator's art with regards to the human spine in medieval manuscripts.

3. Refer to Figure 9, Chapter Two.

4. Johannes Ketham, *Fasciculus medicinae* (Venice, 1491, etc.). Best known among the German texts are Hieronymus Brunschwig's, *Buch Der Cirurgia* (Strasbourg, 1497), and Hans von Gersdorff's *Feldtbuch Der Wundlartzney* (Strasbourg, 1517).

5. McMurrich, *The Anatomist*, p. 249.

6. L. H. Heydenreich, *Leonardo da Vinci* (London, 1954), p. 129.

7. Maud Cruttwell, *Donatello* (London, 1911), pp. 102-110. Leonardo's familiarity with this bronze relief, one of the four miracles of St. Anthony in the predella of the High Altar at the Church of the Santo, can only be presumed. We can be sure, however, that Vesalius was quite well acquainted with this work during his stay in Padua, for more than a trace of the same compositional structuring and dramatic illustration is exhibited in the derivative frontispiece of the *Fabrica*.

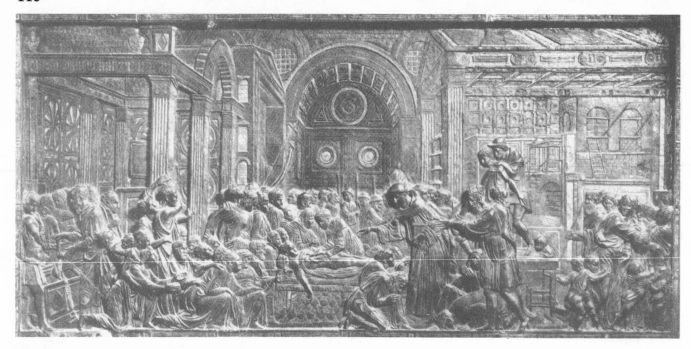

Figure 51.

Figure 52.

the influences of his apprenticeship with Antonio Pollaiuolo as well as his own mastery of human surface anatomy.[8] Skeletal figures in "La Rissurezione della carne," Figure 52, are grossly erroneous in detail, yet endowed with a graceful fluidity of movement and postural expressiveness so fitting to the theme of newly restored life. A blown-up section, Figure 53, exposes the anatomical crudity while delightfully exhibiting postural expressiveness in a skeleton that would appear at ease in the ambience of a modern cocktail party. The second exception reclines beneath the fresco of a Crucifix-Trinity painted by Masaccio in Santa

8. Enzo Carli, *Luca Signorelli, Gli affreschi nel Duomo di Orvieto* (Bergamo, 1946), pp. 14-15. These frescoes, painted between 1499 and 1502, were widely known and admired and, like the frescoes by Masaccio in the Carmine, a source of inspiration for other artists. We may presume with some assurance that Leonardo was well aware of them. He could have seen them in the making. See his reference to Orvieto in Ms L.c. 1502.

Figure 53.

Maria Novello about 1427 or 1428. It has been designated the skeleton of an "unknown warrior." The Trinity, Figure 54, has acquired fame from the appearance of reality lent to an imaginary chapel by a very early example of accurate perspectival alignment. Leonardo most certainly stopped to admire this illusory architectural setting in his many visits to Santa Maria Novella, and his eyes must have been drawn to the foreshortened profile of a skeleton at the base, Figure 55, meant to "symbolize death, the lower estate, and the transitory nature of man."[9] Despite the ravages of time and inadvertent separation of the base figure from

9. Luciano Berti, *Masaccio* (University Park and London, 1967) p.

Figure 54.

Figure 55.

the Trinity for hundreds of years when it barely survived beneath layers of whitewash, we can be sure that Leonardo appreciated the accurate lordotic curvature of the lumbar spine and the proper tilt of the pelvic girdle.

Clearly, Leonardo found little incentive for pictorial exposition of the deeper anatomical structures from the visible models of his day. Rather, his indebtedness to his colleagues and predecessors lay in the technical developments within the artist's trade—proportions, perspective, use of light and shade in the projection of geometrical forms—whereby drawing became the tool for transmission of his extraordinary perceptual innovations.

Leonardo's deeper motivations were self generated in anatomy as in painting, mechanics, and a vast spectrum of interests. His

ruling passion was curiosity, a curiosity fanned by a relentless desire to understand the physical world and to expose ultimate causes. In anatomy, as in all other fields where his curiosity strayed, drawing was his language of expression, and when he borrowed from his artistic heritage, it was to add refinements in new and provocative ways. These special skills are epitomized in Figure 50 where his scientific investigations materialize in an eloquent expression of this artistic heritage in a uniquely personal style. Here he has completely ignored the schematic and simplified tradition of anatomical illustration to reveal the axial skeleton for the first time with great detail and accuracy as the structural wonder it was meant to be. A modern x-ray study would scarcely improve upon the contour of vertebrae phasing from gentle cervical lordosis to dorsal convexity, then from a more prominent lumbar lordosis to a terminal sacrococcygeal convexity in the lateral view. Nor would the films provide the illusion of proper curvature as effected by skillful use of light and shade in anterior and posterior projections. It is a delicate and subtle illusion that devolves from a consummate mastery of the effects of reflected light on statuesque forms. These superb anatomical drawings are truly works of art for any age.

The representation of the spinal column also illustrates the way in which Leonardo hoped to use these artistic techniques for instructional purposes. That he intended to organize his scattered studies into an anatomical textbook, there can be no doubt; his notebooks are replete with expressions of this intention. Remarks on the vertebral column exemplify how he wished to carry this out. The spine should be disarticulated to be shown "separate and then joined together" not only from three aspects (front, back, and side), but also from above and below to reveal the functional propensities of the articulating surfaces, thus endowing the static with dynamic potentials: "...through this very short way of drawing then from different aspects one gives a full and true knowledge of them."[10]

While Figure 50 superbly exemplifies the designated protocol, the supplemental drawings necessary to complete the intention are missing, leading the scholar into wistful speculative visions and empty longings for lost works, forever merely conjectural. What we do have, however, is a human vertebral column, beautifully rendered in exquisite detail from the front, side, and back, with

10. Keele, *Leonardo da Vinci*, p. 80.

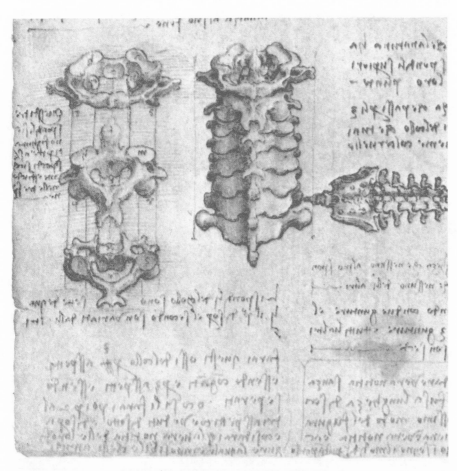

Figure 56.

proper perspectival alignment of segments, and accurate representation of curvature as never before portrayed.

Intrigued by the complicated mechanics of the upper three segments of the cervical spine, Leonardo maximizes exposure of relationships by introducing a startling new technique—the exploded view, Figure 56, effectively illustrating an area that must have held great interest for him, but about which he remains strangely silent in his notes. Nevertheless, the drawings of the spine remain impressive original works, the first to demonstrate accurately the curves, the articulating relationships, and the sacrum as a five unit segment. Avicenna and Mondinus had perpetuated Galen's erroneous claim that there were three vertebral units to the sacrum; much later, even Vesalius miscounted with six.[11] Leonardo's two-segment coccyx is an infrequent, but not unlikely, fusion variant of a highly variable three to five unit rudimentary extension of the spine.

In the swift movements of his pen Leonardo was not entirely without fault, as may be seen in the lateral view of the spine

where an extra spinous process is gently insinuated between the second and third thoracic processes, a conceivable anomaly but one that virtually never occurs in this form.

Whereas Figure 50 uniquely and dramatically illustrates the spine in isolation, in all the notebooks there is no drawing of the complete skeleton. A worn and torn folio in the Uffizi Gallery in Florence bears inscriptions on the recto and verso attributing its four skeletal drawings to Leonardo, a claim justified by the quality of execution and supported in the early years of this century by no less authorities than Holl and Sudhoff.[12] The attributions, however, are in an unknown hand, labels read from left to right, and the shading is right above to left below, all quite incongruous with his other works. It is a pity, indeed, that no intact skeleton has come down to us; however, we are provided with numerous instances where the spine is incorporated into more complete skeletal figures where proper alignment of the parts reveal a functional structure for a believable human form which, for the first time, could stand, walk, and breathe. This is a landmark in human anatomical illustration that remained unmatched for centuries. Allowing for a few Galenic ape features whereby Leonardo continued to pay lip service to traditional authority, notably in the elongated scapulae, the seven-segment sternum, and the separated ossicle between clavicle and acromion, in Figure 57 we have the set of drawings that come closest to furnishing a complete skeleton. Here the ribs are attached with the essential obliquity for the mechanics of respiratory function to operate. Of equal importance, the tilt and relationships of pelvic girdle with spine and limbs conform to the appropriate statics of posture, a necessary predisposition for standing and ambulation. These basic relationships are sadly lacking in the works of his predecessors.

Not content with a mastery of the statics of posture and of the dynamic potentials of the human form, Leonardo's curiosity expanded into comparative anatomy exploring the same principles, as in Figure 58 where the pelvic arrangement of man is compared with the hind quarters of the horse. This commitment to comparative anatomy reverberates through his notebooks in statements and drawings, mainly concerned with the horse, but quite broadly encompassing frogs, hares, oxen, bears, birds, monkeys, pigs, dogs, and even lions.

It was, in fact, while experimenting with the live frog specimen,

12. M. Holl and K. Sudhoff, "eine dem Leonardo da Vinci zugeschribene Skelettzeichnung in der Uffizien zu Florenz." *Arch. für Geschichte der Medizin*, Bd. VII (Leipzig, 1914), pp. 323-334.

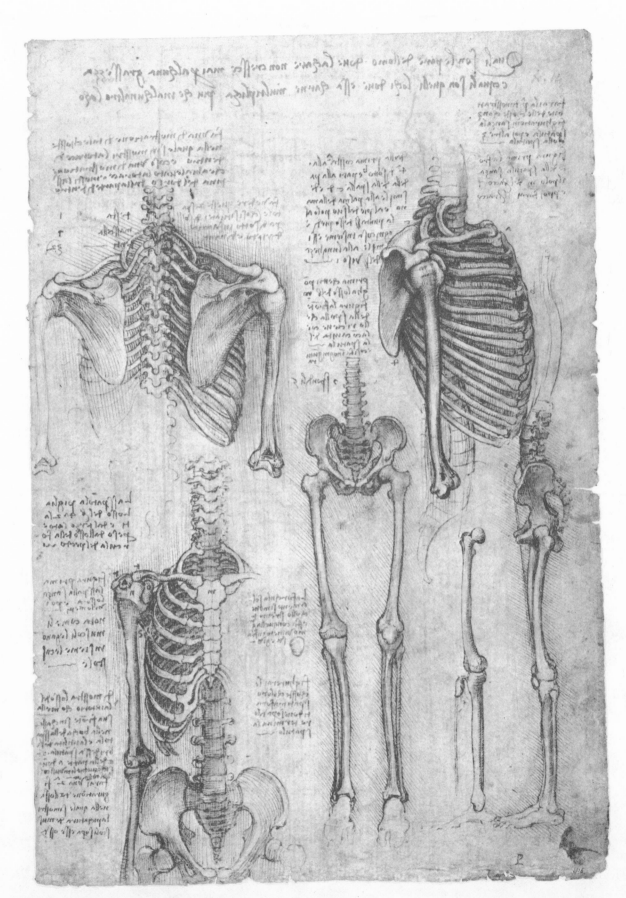

Figure 57.

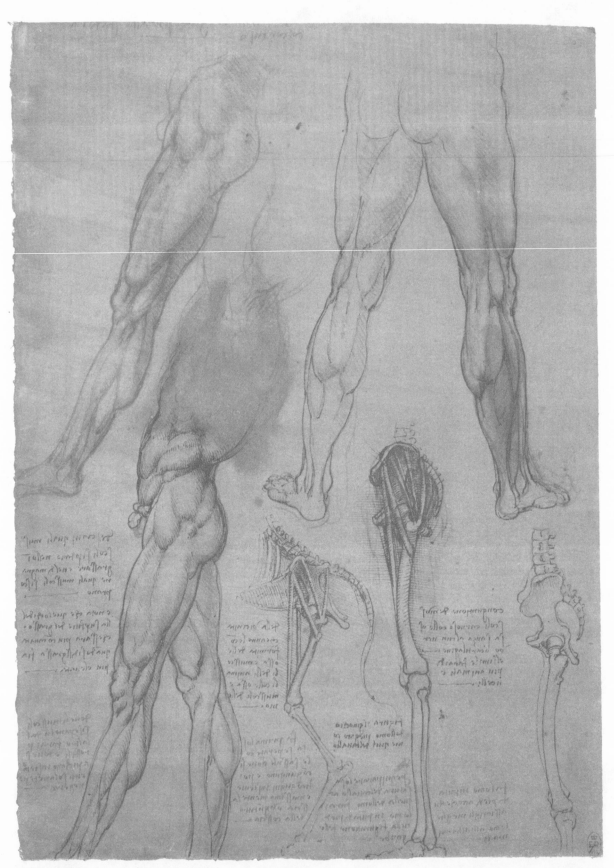

Figure 58.

the first genuine neurophysiological experimentation since Galen in the second century B.C.,[13] that Leonardo observed:

13. McMurrich, *The Anatomist*, p. 209.

> The frog retains life for some hours when deprived of its head and heart and all of its bowels. And if you puncture the said nerve (spinal Medulla) it immediately twitches and dies.[14]

14. Keele and Pedretti, *Anatomical Studies*, I:2.

From his frog experiments Leonardo was content to conclude that the seat of the soul was at the top of the spinal cord; i.e., in the medulla oblongata. After removing the brain, heart, and other internal organs wherein various ancients had seated the soul, the specimen still retained its capacities for motor and sensory activity. Indeed, he was unable to recognize the fact that he was dealing with the reflex arc when he removed the head and still observed responses to stimulation, but in effect this was precisely what he was describing.[15]

15. Kenneth D. Keele, *Anatomies of Pain* (Springfield, 1957), p. 60.

Quite aside from the fact that the statement about the pithed frog is extracted from the left upper paragraph in Figure 59, the drawings on this sheet are interesting for several other reasons. Not the least of these is the drawing just below, which serves as our introduction to some of Leonardo's gross misconceptions regarding the spinal cord, misconceptions bearing the weight of authority from such imposing sources as Hippocrates and Plato. These were authors whose influence was too powerful in this case to be overcome by the discriminating empiricism that characterized Leonardo's usual breaks from traditional errors, for in all his later works the same cord absurdities are perpetuated. It should be added that the timetable of dissection protocol was a culpable factor. Splitting the spine and long bones was always a terminal step, and indeed, the predisposing cause for the necrotic dissolution of structural relationships in the unfixed cord that confronted the dissector. The drawing in Figure 59 depicts a diagrammatic spinal cord with separate lateral columns to which fictions he assigned a major role in neurological functioning. What is most intriguing about these drawings and those on the verso of the same sheet is the diversity of animal parts assembled to form the anatomical figures illustrated. Animal parts exhibited include the dog, pig, and monkey, and the casual indifference with which he incorporated a simian hand or a dog's humerus in a human anatomical drawing belies the dearth of human cadavers available

126

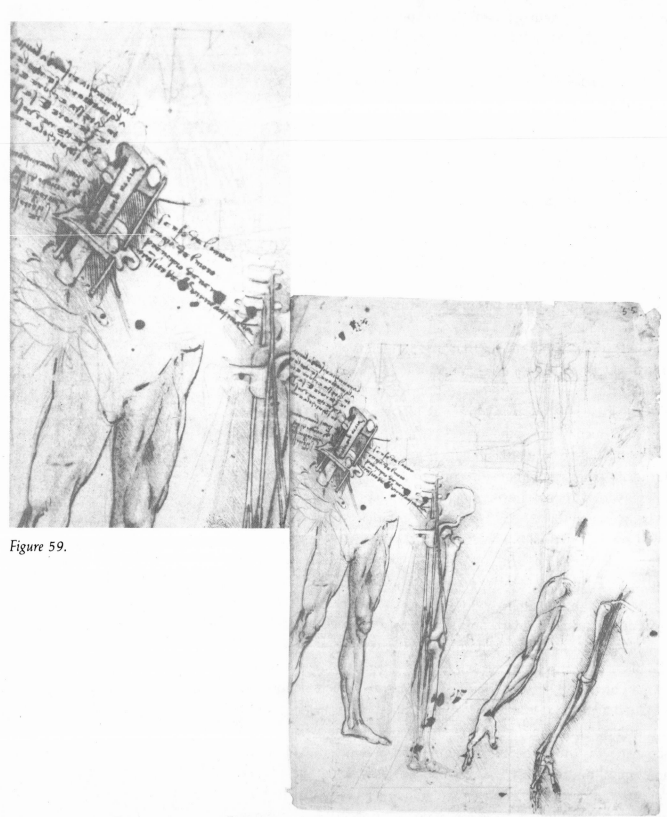

Figure 59.

Figure 60.

for dissection in those early works, dating from 1485 to 1489. It is evident that Leonardo had to range far and wide into the animal kingdom for homologous structures.

The very same folio also contains a hidden treasure. Special photographic techniques utilizing ultra-violet light have exposed drawings on Figure 59 that are invisible to the naked eye. Faintly outlined in the upper right area is a lower-half skeleton, remarkable for the accurate alignment of spine, pelvis, and femurs at such an early period in his anatomical development.

Intervertebral disk function was not discussed although the disks as entities are well illustrated in Figures 50 and 57. The best and, in fact, the earliest rendering of an intervertebral disk is seen in an exquisite little insert between AP and lateral views of animal abdominal organs of Figure 67, shown in Chapter Seven. Here Leonardo's purpose is to detail the emergence of a spinal nerve through the foramen formed by the articulating processes of adjacent vertebrae. Ultra-violet light enables photographic processes to reveal the disk, labelled "sponge," between the labelled vertebrae and spinal nerve.

When Leonardo drew from the actual dissection, combining the faculties of artistic ability and keen observation, the production was usually a thing of beauty and an advancement in anatomical understanding, as in the drawings of the spine. Conversely, his diagrammatical representations, while often artistic gems, could be utter flights of fancy, based on excerpts from his readings, or second-hand tales from the works of Hippocrates, Plato, Aristotle, Galen, Avicenna, Mondino, or Abertus Magnus, names all mentioned in the notebooks. In the context of these ancient illusory concepts the spinal cord is a cogent example of authority's worst influences. Marginal notes to the left of the conceptualized upper spinal cord, Figure 60, extracted from Figure 59, inform us that "all nerves of animals derive from here (spinal cord). When this is pricked the animal dies at once." To the right is the note, "Sense of touch; cause of motion; origin of the nerves; passage for the animal power (nerve power)." These remarkable insights at this early stage in his anatomic studies contrast with the drawing itself wherein "generative power" is inscribed on the spinal cord and imaginary lateral auxiliary columns are shown. His confusion about these separate lateral channels is an excusable error in the interpretation of complex, unchartered areas. The same can

hardly be claimed for his naive efforts to illustrate generative power, for as Keele points out, "The view that semen was derived from the spinal cord was old enough to be denied by Alcmaeon in the sixth century B.C."[16] Nevertheless, as seen in Figure 61, Leonardo allowed himself to be deceived by the popular allure of ancient myth, a visual evocation of pure Platonic fantasy which probably has greater appeal to prurient interests than to any serious anatomical analysis. Thus we observe that the spinal cord, as a continuation of the brain, extends the length of the spine, sending out three roots to form a cord that transports the semen along a separate lumen through the penis. Note the transected penis in the lower figure showing the double lumen.

16. Keele and Pedretti, *Anatomical Studies,* I:2.

Figure 61.

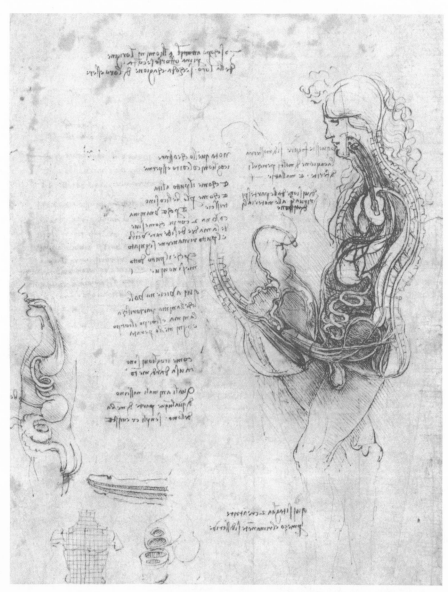

Some idea of the low priority afforded the cord in his dissections may be inferred from the fact that it is always drawn through the length of the spine; whereas in fact, it stops at the L 1-2 level, whence the cauda equina continues, distributing paired roots to lower vertebral foramina.

Further evidence that the spinal cord never inspired more intensive investigation is found in the nature of the drawings, which are always diagrammatic, never directly derived from observation. The classic example is a schematic series, Figures 62 to 64, illustrative marvels for original seriographic demonstration, but error-ridden and only important as early landmarks from which we can follow his later development as an anatomist. The first drawing in the series (the upper sketch in Figure 62) depicts the cervical spine and upper thoracic cage with emerging cervical nerves forming symmetrical but very primitive brachial plexuses. In the two lower sketches the base of the brain is shown with triplicate extensions through vertebral canals. These lateral pathways normally lie outside the spinal cord, piercing the lateral spinal processes and containing the vertebral arteries. Somehow in his early dissections he must have mistaken the empty arteries for hollow vessels thought to transport motor and sensory infor-

Figure 62.

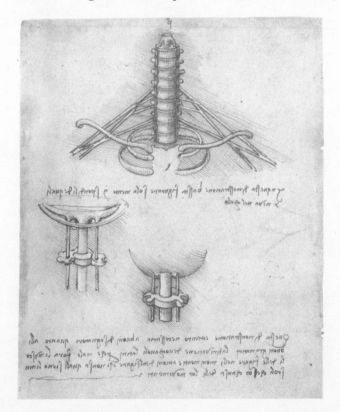

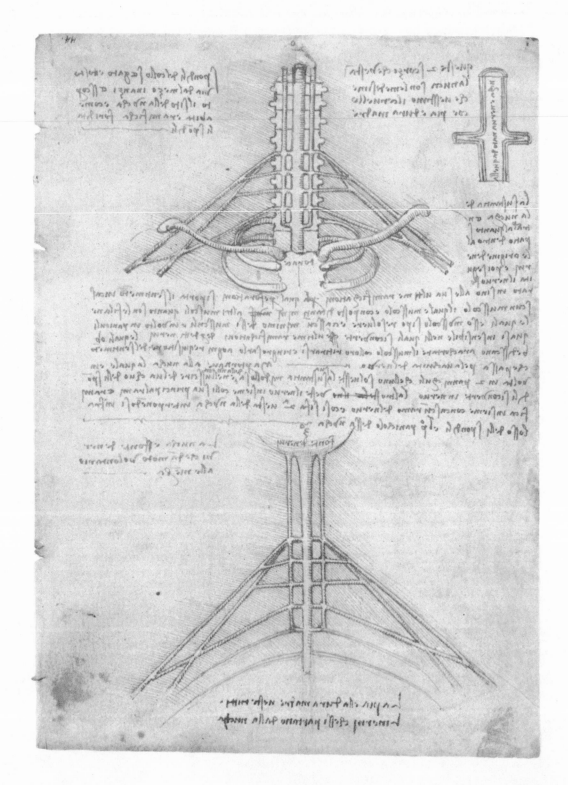

Figure 63.

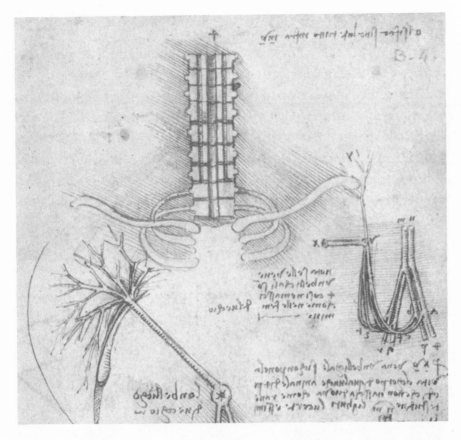

Figure 64.

mation between brain and upper extremities via the brachial plexuses. The sympathetic chains with their reflections to the emerging spinal nerves may have added to this difficulty. These drawings diagram the conducting pathways as he conceived them. Coronal sectioning of the spine exhibits the intact hypothetical system in the upper sketch of Figure 63, and the nervous system is isolated by extraction of boney structures in the lower sketch. To complete the series he sketches the boney encasement in Figure 64, but before leaving Figure 63, it is important to consider the small drawing in the right upper corner, a coronal section of a segment of spinal cord, meant to illustrate his notions about spinal nerve origins. Cord substance appears to dip a short way into the nerves which then take form as extensions of the two membranes. Explanatory notes below the sketch will bear closer scrutiny in the next chapter. Later studies of the brachial plexus and emerging spinal nerves will correct some of these rather blatant errors, but will perpetuate others. The seriographic technique, sadly presented in a fanciful and unfortunate circumstance in this case, was later recognized as an ingenious and most helpful tool for

anatomical exposition. Modern anatomical texts amply reflect an indebtedness to Leonardo's invention.

Spinal draftsmanship and attention to detail improved dramatically after Leonardo. This sudden unexplained change in the quality of drawing has spawned tantalizing speculative inferences regarding his influence that have not been documented. The fact that Berengarius, Estienne, Vesalius, and other anatomists continued to perpetuate the errors in contour, alignment with pelvis, and pelvic tilt of pre-da Vinci skeletal exposition has been cited as persuasive, if undecisive, refutation of any such claims. His influence, if any at all, remains a matter as enigmatic as Mona Lisa's wistful smile.

CHAPTER EIGHT

The Peripheral Nerves and Plexuses

LEONARDO'S STUDIES OF PERIPHERAL NERVES WERE SPREAD OUT OVER THE
entire span of his anatomical interests, and sprinkled irreverently
through his vast notebooks. Only in a relatively few instances in
the studies of peripheral nerves is it possible to arrange his
drawings into a series that shows a clear internal development of
insight and illustrative technique. Even so, it is necessary to bring
drawings together that are far removed in time. One such
especially good example occurs in the series of drawings of the
brachial plexus.

Had Leonardo succeeded in accomplishing his frequently
avowed intentions of organizing his scattered works into a unified
text, it is reasonable to suppose that he would have followed the
ancient protocol that treated subjects in a head to foot order as
arbitrarily chosen for purposes of simplicity in this chapter.

It should not be surprising if the descriptive terminology would
appear a little strange and a trifle ridiculous to the modern reader.
Accordingly, it would seem appropriate to pause briefly before
examining these works to mention some of the more esoteric
sources.

We are informed in fragments and transcripts from ancient
texts that pre-Socratic philosophers freely promulgated vague
notions of "spirits" or "anima" as messengers carrying sensory
impressions and motion instructions. These loose musings gained
a measure of physiological credibility from Aristotle who postu-
lated a host of sentient and locomotive "souls" acting in some
strange harmony as motor and sensory coordinators.[1] Apparently,
Leonardo found nothing unconscionable about the figment of
vague spirits conveying messages through hollow nerves as a
modus operandi for nerve function. Leonardo's anti-Aristotelian bias
was limited to the brain vs. heart debate, and it was enough that

1. George Sarton, *A History of Science:
Ancient Science Through the Golden Age of
Greece*, 2 vols. (New York, 1952), I:533.

2. Margaret Tallmadge May, *Galen on the Usefulness of the Parts of the Body*, 2 vols., a translation from the Greek, with an Introduction and Commentary by M. T. May (Ithaca, 1968), I:399 and II:491.

Galen had thoroughly rejected the Aristotelian doctrine of cardiocentric control; moreover, Galen himself had imprinted the stamp of authority on the Greek idea of subtle agents at work with his own "animal spirit," and it was through Galen that the Arabists learned how Herophilus and Erasistratus had regarded nerves as hollow.[2] The compelling authority of entrenched dogma was too powerful and Leonardo made little effort to dispel these ancient misconceptions. Tampering with accepted ideas about the functioning of "souls" and kindred spirits, even in a purely physiological context, could border on heresy, and one who dissected cadavers was already vulnerable under the stigma of necromancer. In some respects he merely added to the confused state of descriptive nomenclature on the nervous system with loose, ambiguous and sometimes contradictory language of his own. It was in his drawings that he distinguished himself and escaped to some extent from the mimicry of derivative errors.

Most of his early peripheral nerve sketches were tenuous accoutrements to musculo-skeletal studies made on animals. It was not until the fortuitous occasion when he witnessed the death of the centenarian at the hospital of Santa Maria Novella in Florence (ca. 1508) that drawings of the peripheral nerves and plexuses began to approach the quality of his other works.

3. Keele and Pedretti, *Anatomical Studies*, I:214.

> And I made an anatomy of him in order to see the cause of so sweet a death...the anatomy I described very diligently and with great ease because of the absence of fat and humours which greatly hinder the recognition of the parts.[3]

This dissection rekindled his neglected passion for anatomical discovery; moreover, it marked the period of transition to a more confident reliance on his own research methods. While it is quite clear that his renewed interest focused on other systems, a heightened mastery of illustrative techniques for rendering observed detail spilled over into his nerve studies, as will become apparent when we examine his progress with the brachial plexus.

Between the schematic drawings of the nervous system in Figure 65, he writes, "Tree of all the nerves; and it is shown how they all have their origin from the spinal cord, and the spinal cord from the brain." Elsewhere he exhibits similar compulsions to portray systems in isolation, preferably within a body outline as

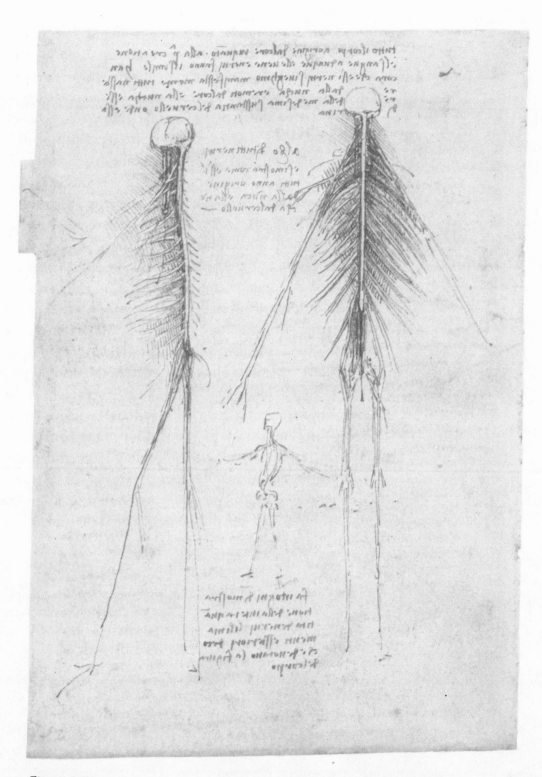

Figure 65.

signified by the lower figure; e.g., the cardiovascular tree (RL12592r and v and RL12597r). One might speculate that he was swayed in this practice by lingering medieval influences found in manuscripts with variations of the *fünfbilderserie*. These crude schemata in Figure 65 were intended to express his idea of the unity of the system as part of a greater whole; nothing more. Here again he gives lip service to Aristotelian ideas, possibly deriving from a mutual interest in the chick embryo, when at the top of the sheet he declares, "The whole body takes origin from the heart inasmuch as its primary creation is concerned, therefore the blood vessels and nerves do the same."[4] This is possibly a reluctant concession drawn from his embryological studies where he may have observed an early pulsating blood point *(punctum saliens)*,[5] for on second thought he adds, "however, all the nerves manifestly arise from the spinal cord remote from the heart, and the spinal cord consists of the same substance as the brain from which it is derived." One wonders why the inclination to depict systems, "Every part desires to unite with its whole...to escape imperfection" (CA, 59r), never materialized into a complete skeleton.[6]

In the course of his muscle dissections, Leonardo became aware of the finer networks of innervation, and he carefully traced individual nerves back to their origins from the spinal cord. A small diagrammatic hemisection of the spinal canal (Figure 63, right upper corner) pictures the formation of the spinal nerves from extensions of the dura and pia mater with elements of the cord itself dipping into the nerve for a short distance. Below the sketch he writes:

> The substance of the spinal cord enters for some distance inside the origin of the nerves and then follows the perforated nerve as far as its ultimate ramifications, through which perforations the stimulus to each muscle is carried; which muscle is composed of as many other very small muscles as there are fibers into which the muscle can be resolved. And each of these miminal muscles is ensheathed in an almost imperceptible membrane into which the ultimate ramifications of the above-mentioned nerve are converted.

Such a description is about as close as the naked eye can get to the motor endplate. He continues:

> These (muscle fibers) obey by shortening, the muscle being drawn back and enlarged at each order of the stimulus which passes along the void of the nerve.[7]

4. Keele and Pedretti, *Anatomical Studies*, I:254.

5. McMurrich, *The Anatomist*, p. 228.

6. Keele and Pedretti, *Anatomical Studies*, I:254.

7. Ibid., I:198.

Regrettably, Leonardo speaks of nerves as tubular structures (corde forata) and frequently confuses with descriptions of tendons, labelled *nervi*. An extract from the oft-quoted metaphorical rendering of how the five senses are the ministers of the soul can only be understood when *nervi* and *corde* are interchanged:

> The tendons (nervi) with their muscles obey the nerves (corde) as soldiers obey the officers, and the nerves (corde) obey the Common Sense as the officers obey the supreme commander (An. B, 2r).[8]

Leonardo persistently favors this species of metaphor for describing nerve action as evidenced in the following:

> The function of the nerve is to give a stimulus *(sentimento)*. They are the knights *(cavallari)* of the soul and have their origin from its seat, and command the muscles that move the members at the good pleasure of the soul (QII, 18v).[9]

Before leaving Figure 63, two statements deserve attention. To the left of the lower drawing he advises, "The spinal cord is the source of the nerves which give voluntary movement to the limbs," and at the bottom of the page he remarks, "The pia and dura mater clothe all the nerves which leave the spinal cord."[10]

When we wonder why he never recognized the nerve roots forming the spinal nerves, the explanation resides in the fact that the contents of the meningeal investments were little more than a slimy, necrotic morass by the time his dissections penetrated the spinal column of the unfixed specimen. Recognition came later in the work of Coiter, 1573,[11] and it was not until Bell[12] and Magendie,[13] three hundred years removed, that the proper delineation and functional explication of the anterior and posterior roots came to light.

With the pithing of the frog, the eye experiments, and a few other minor efforts to determine cause and effect, Leonardo's enquiry into physiological mechanisms of the nervous system virtually ceased. The monumental tasks he had set for himself in his early visionary propositions collapsed under the press of time although he did resort to productive experimental practice in other systems, notably the heart and circulation. As early as 1489, he declared his intention to investigate:

8. Richter, *Notebooks*, I:128. Translated into English with proper interchange from Richter's transcription of Leonardo's Italian. The passage makes no sense as Richter translates it.

9. McMurrich, *The Anatomist*, p. 210.

10. Keele and Pedretti, *Anatomical Studies*, I:198.

11. McMurrich, *The Anatomist*, p. 209. See also Keele, *Anatomies of Pain*, p. 64 and p. 108.

12. Charles Bell, *Ideas of a New Anatomy of the Brain Submitted for the Observations of His Friends* (London, 1811), pp. 21-24.

13. François Magendie, "Esperiences sur les fonctions des nerfs rachidiens," *J. Physiological esp. path.*, Paris, 1822, 2:276-9.

Cause of breathing, of the cause of the motion of the heart, of the cause of vomiting, of the cause of the descent of food from the stomach, of the cause of emptying the intestines.

Of the cause of the movement of superfluous matter through the intestines.

Of the cause of swallowing, of the cause of coughing, of the cause of yawning, of the cause of sneezing, of the cause of limbs getting asleep.

Of the cause of losing sensibility in any limb.

Of the cause of tickling.

Of the cause of lust and other appetites of the body, of the cause of urine and also of all the natural excretions of the body (An B, 1v).[14]

14. Richter, *Notebooks*, II:117.

The ineluctable fate of these noble aspirations was dictated by the practical reality of a situation that transcended genius and over which he had no control. They were foredoomed by the basic inadequacy of Renaissance physiological knowledge which, in fact, was totally lacking in a requisite substratum of chemistry. However futile these preoccupations with physiological mechanisms were in the scientific context of his time and place, they do exemplify the enormous range of his curiosity and give credence to the striking simile attributed by Freud to Merezhkovsky, "He was like a man who had awoken too early in the darkness, while everyone else was asleep."[15]

15. Sigmund Freud, *Eine Kindhertserinnerung des Leonardo da Vinci* as translated into English by Alan Tyson (New York, 1964), p. 72.

If we concede, then, that the high aims that he set for himself in physiological investigations were too advanced, and therefore inherently futile, how do we excuse the received errors in anatomical exposition which he perpetuated? How are we to understand the man who boldly asserted, "He who appeals to authority when there is a difference of opinion works with his memory rather than with his reason?"[16] Here we must fall back on the utter void of precedence in the art of illustrating these matters. Lacking a human specimen, he often resorted to animal dissection to substitute the missing part, unaware of species differences, assuming, like all others of his time, that the received descriptions of Galen, and even Aristotle, related to human anatomy. To some extent he corrected these errors as his studies of the peripheral nervous system progressed. It is possible to trace the tedious, groping process of shaping a realistic portrayal of a

16. CA, 76r. "Chi disputa allegando l'autorita non adopra l'ingegno ma piuttosto la memoria?"

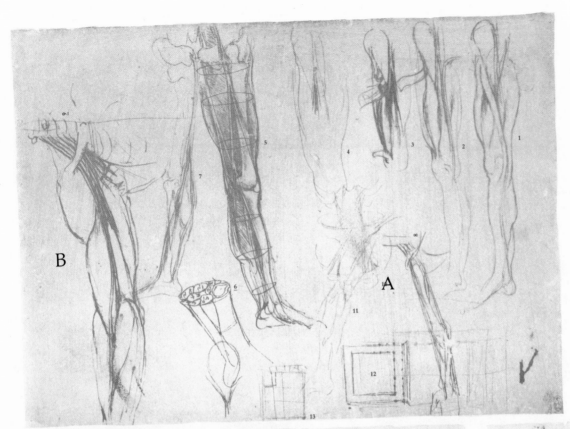

Figure 66.

Figure 67.

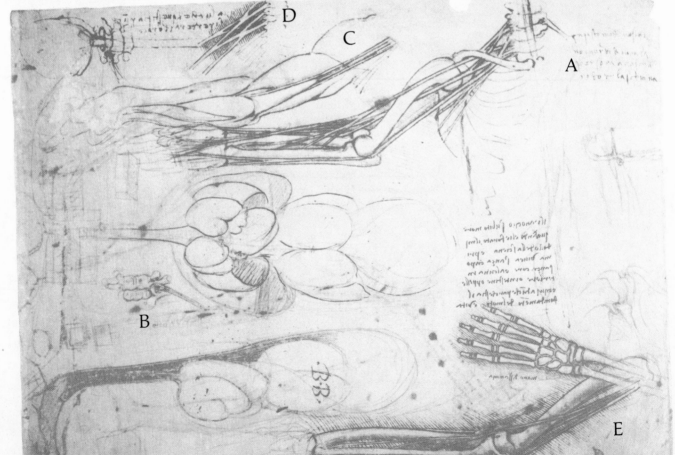

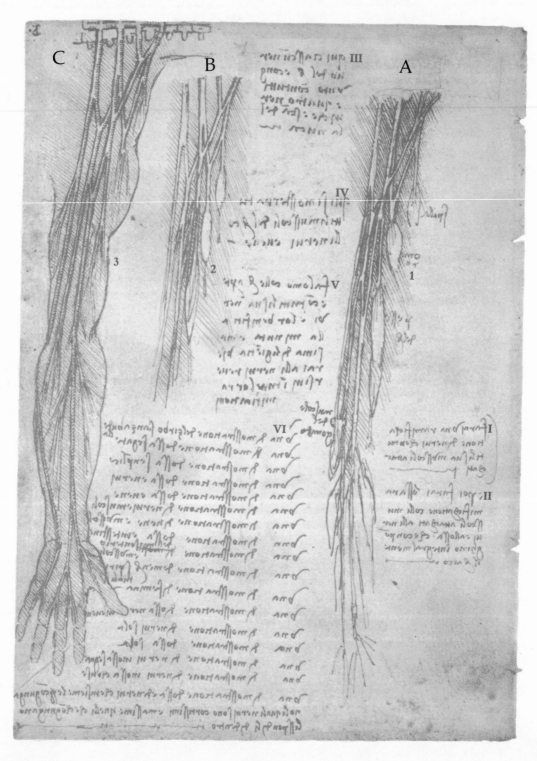

Figure 68.

complex structure (brachial plexus) by following the progressions in Figures 66 to 69, where the drawings evolve from crudity to sophistication in a truly modern sense. Ultra-violet lighting facilitates the evaluation of faded figures in these early works. To understand his problem and the manner in which he resolved it, note carefully the initial naive rendering of the emerging cervical nerves from only three roots that stream haphazardly under a clavicle to continue as peripheral nerves down the arm in sketch A of Figure 66, without benefit of intervening plexus. A better structured limb in sketch B recapitulates the abrupt transition from cervical nerve to peripheral nerve in the arm except for one indistinct confluence of nerves just below the clavicle; this is the first inkling that Leonardo was becoming aware of a plexus.

Not far removed in time and still within the early period of anatomical interest (1487-1492), the drawings in Figure 67 show definite improvement in nerve relationships. Note the canine humerus in all illustrations and the monkey hand in the right lower corner. Dürer astutely shortened the thumb when he copied this sketch. The main drawing of the sheet, sketch A, is illuminated by a note to the right explaining, "In this way the nerves of the whole person arise, between each joint of the spine."[17] The note leads off from the trailing extension of a single cervical nerve issuing from between two vertebrae on the left. Sketch B better details the same circumstance and warrants attention for the excellent delineation of an intervertebral disk as mentioned in Chapter Six. This sheet marks Leonardo's growing appreciation of the transitional structure between spinal and peripheral nerve. He traces four cervical nerves into this complex in sketch A, and repeats the design in isolation, sketch D. Radial, ulnar, and median nerves are well defined in A and C, and ulnar and median nerves are accurately followed between muscle bundles in C, attesting to the fact that his dissection techniques were already highly developed at this early stage.

Several years separate the drawings of Figures 67 and 68. During the interim his energies were concentrated on other subjects; anatomical investigation was confined to the occasional fortuitous animal specimen that came into his possession. Nevertheless, his artistic skills had matured and this is apparent in the neatness of design that characterizes Figure 68. His concept of the brachial plexus has advanced considerably. It takes shape in his

17. Keele and Pedretti, *Anatomical Studies* I:4.

mind with a consistency reflected in the rather precise reconstructions, building from A and B to C. He still perceives only a four-root derivation, which predisposes to an imperfect arrangement of trunk and cords, but these structures are beginning to assume recognizable form. The course through the limb and peripheral distributions of radial, median, and ulnar nerves are carefully and accurately detailed.

Finally, in Figure 69, the puzzle falls into place for him and the long struggle to represent the brachial plexus intelligently culminates in this splendid triumph. Thus from the anterior primary divisions of C5, C6, C7, C8, and D1 a proper representation of upper, middle, and lower trunk is formed. Somewhat less exact is the rearrangement into lateral, posterior, and medial cords, but most of the essential branchings are included. The rather casual dispersion of loose ends distal to the plexus merely signifies his lack of intention to consider peripheral relationships in this drawing. His accurate knowledge of radial, median, and ulnar nerve routing was admirably exhibited in his earliest drawings (Figures 66 and 67), and consistently maintained in subsequent

Figure 69.

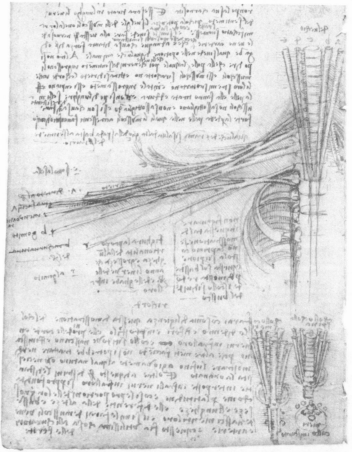

reconstructions of the limbs. Some notion of the deftness and delicacy of his dissection technique is evidenced in Figure 70 where he carefully distinguishes the areas of innervation served by median and ulnar nerves in the ring finger of a left hand. Further evidence of his superb dissection skills combined with purposeful attention to detail is seen in Figure 71 where the complicated frame of ligaments, tendons, and nerves of a finger is neatly delineated, and the separate components labelled for explanatory designation of function at a time when these structures were still unnamed. He writes, "...c is the nerve which gives sensation. This having been cut the finger no longer has sensation even when placed in the fire."[18] His awareness of the variable functions of different nerves is provided by the observation, "Following a cut in the hand, sometimes the sensation and not the motion of the finger is blocked, and sometimes the motion and not the sensation. Sometimes it is both motion and sensation." (QA. 13v)[19]

18. Keele and Pedretti, *Anatomical Studies,* II:536.

19. Keele, "Research on the central nervous system," p. 26.

Figure 70.

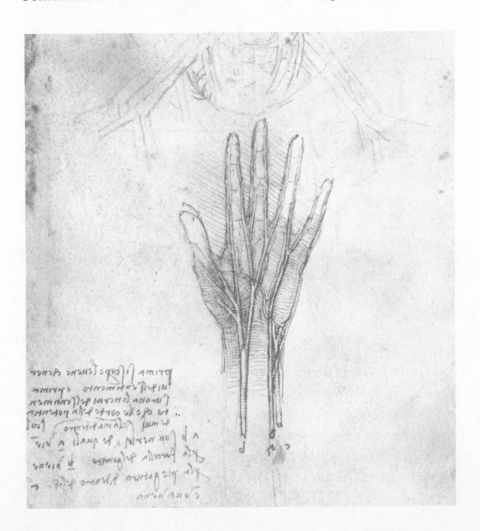

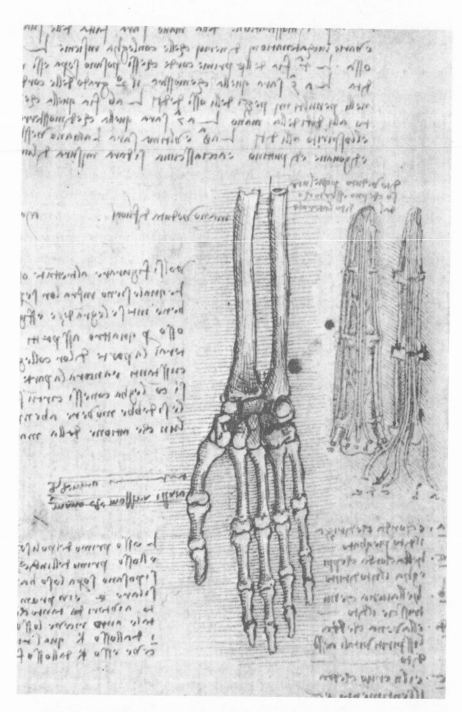

Figure 71.

Before leaving the brachial plexus it is of interest to consider the curious relevance of a remark in the notes of Figure 69 which has led to speculation that Leonardo may have had field experience in dealing with the wounded while campaigning in the Romagna as Engineer General to Cesare Borgia, 1502-1503. He points out correctly that, "Any one of the five branches saved from a sword-cut is enough for sensation in the arm."[20]

20. Keele, "Research on the central nervous system," p. 22.

His concern with the practical application of this knowledge of the nervous system is amplified in a statement at the very bottom of the same sheet:

> ...describe the distances interposed between nerves in depth as well as breadth and thus the proportions of their sizes and lengths and the differences between their heights and descents from their origins. You will do the same for muscles, veins and arteries; and this will be most useful to those who treat wounds.[21]

21. Keele and Pedretti, *Anatomical Studies*, I:174.

Appreciation of this ultimate achievement in brachial plexus layout must not distract us from other significant developments in Figure 69. Branching nerve fibers seen emanating from D1 and succeeding intercostal nerves, as these nerves issue between adjacent vertebrae, mark the discovery of the sympathetic chain. This chain which forms the sphlanchnic nerves can be seen coursing along the spine just anterior to transverse processes and rib articulations. The intercostal nerves from which the sympathetics arise are exceedingly well demonstrated. They are shown again with exquisite delicacy in Figure 72. If Leonardo can be

Figure 72.

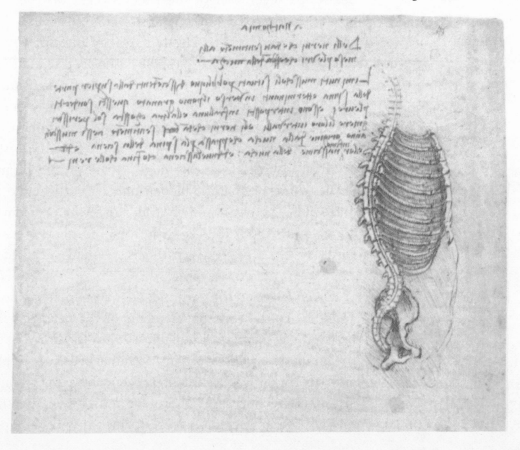
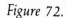

forgiven for the seven-segment monkey sternum and canal-filling spinal cord seen in sagittal section in Figure 72, this beautifully wrought drawing merits praise for several unique features that eluded other investigators for centuries; namely, normal spinal curvature, proper obliquity of ribs and intercostal muscles, and an authentic human iliac crest, accurately shaped and aligned. Above and to the left of the sketch in Figure 72, is stated:

> The very small muscles placed obliquely descend from the upper part of the spine and end obliquely towards the xiphoid process. These are called pleuri (intercostal muscles) and are interposed between one and the other rib solely for narrowing the interval between them. And the nerves which give stimulation to these muscles take origin from the spinal cord which passes through the spine of the back; and the lowest of their origins from the spinal cord is where the back borders on the kidneys.[22]

22. Keele and Pedretti, *Anatomical Studies*, I:120.

Although Leonardo had given careful attention to the ultimate course of the peripheral nerves serving the lower extremities during his earlier neurological studies in Milan, the spinal nerves below the level "where the back borders on the kidney" were entirely neglected. Figures 73 and 74 together with Figure 66 from the earlier period (1487-1492) reveal an inexact, yet detailed and intensely probing effort to establish the proper relationships in the legs. Note that a full expression of what he was trying to describe entailed considerable technical creativity, including such new devices as the segmented cross-sectioning of limbs and the three-dimensional transparency seen in Figure 66. No attention was given in any of these drawings to the arcane origins of these nerves which remained hidden and obscure in the complicated maze of the pelvis. When he readdressed the problem in Florence, about 1506-1508, it was with some consciousness of a pelvic corollary to the plexus patterns he had attacked with such diligence in the cervical area.

Given a second time around, Leonardo managed to disentangle and identify the essential elements of the pelvic labyrinth rather brilliantly as manifested in Figure 75. In the drawing on the right the femoral nerve fans out in a terminal brush to supply individual anterior thigh muscles in deference to his conviction that, "there are as many nerves as there are muscles in the thigh."[23] Just mesial, the obturator nerve, formed by three spinal nerves

23. Keele and Pedretti, *Anatomical Studies*, I:204.

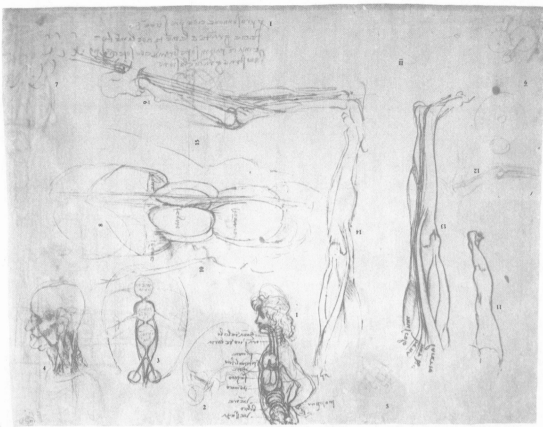

Figure 73.

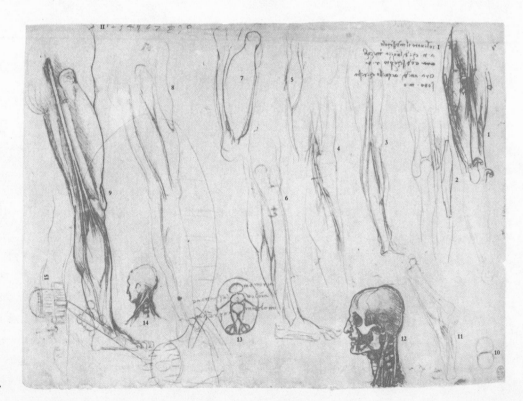

Figure 74.

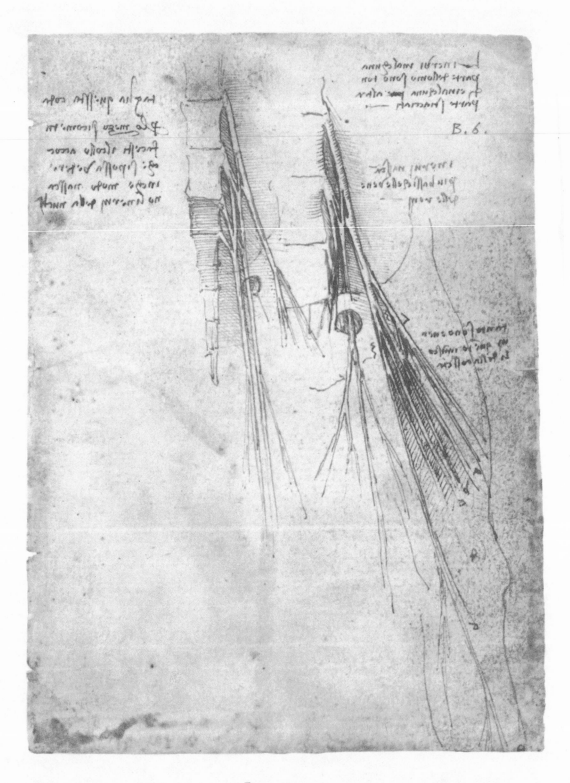

Figure 75.

transversing a reasonably accurate plexus, passes comfortably through an adequate obturator foramen to supply mesial thigh muscles and overlying skin. Taking origin from the lower lumbar roots and exiting from the pelvis above the pubic bone is a third well defined nerve which is best construed as the lateral femoral cutaneous nerve to the anterolateral thigh although, in fact, it actually should come off higher in the plexus. Nothing additional can be extracted from the drawing on the left which merely reduplicates the right design.

In the paragraph on the left side of the page there is a statement, "Cut this tail through the middle just as you did the neck in order to see how the nerves of the spinal cord arise."[24] Keele astutely traces this manner of anatomical exposition to Mondino's injunction, "When you have completed the head divide the whole body into two parts along its length, beginning with the neck as far as the tail." Indeed, Leonardo does precisely this in Figure 76 where, unfortunately, as in most cases where his purpose is to visualize the texts of authority, the illustration is schematic, a composite of reworked material, or insufficiently developed. This sketch is redeemed, at least in part, by the presence of a properly contoured spine and an appropriate alignment of the parts in the erect posture; however, the gross errors of extended spinal cord, crudely perceived sacral plexus, and divided sciatic nerve are glaringly repeated. Identical misconceptions are schematized in the left sketch of Figure 77. Both figures fail to meet the expressed intention of exploring the origins of the spinal nerves that shape the lumbrosacral plexuses, and there are no known drawings extant to fulfill the promise. It would seem that the dissection protocol, which necessarily relegated exploration of the spinal canal to a late period, predisposed him to failure, insofar as viable tissues for study was concerned. The unfixed cord melted down to a necrotic slime filling the entire thecal sack by the time he got around to it, and this must explain why he was never able to identify the cauda equina or separate anterior and posterior roots which form the spinal nerves. How he persevered in the presence of such nauseating stench, without the approbation and respectability afforded conventional anatomists, and still accomplish what he did in these drawings merits admiration; what he missed is certainly forgivable under the circumstances. The sketch on the right of Figure 77 illustrates the contents of the

24. Keele and Pedretti, *Anatomical Studies,* I:204.

femoral sheath, including the femoral nerve, and it is worthy of our attention for the pictorial presentation of a simple method of exposure which still prevails.

If the simplified, rather primitive, rendering of the sacral plexus lacked the care and precision of the drawings on the lumbar plexus, his meticulous examination of the nerves and muscles in the lower extremities did not, and here again we find a high level of functional understanding that went far beyond merely assigning the correct nerve to a particular muscle.

Leonardo had undertaken his anatomical adventures already convinced from his bottega experiences that, "...the secret of movement and expression of human emotions, so vital to the artist, lay in the nerves and muscles of the body."[25] It was while studying the nerves and muscles of the lower extremities that he perceived a coordinated antagonistic action of muscles. Observing the mutual dependency of involved muscles when the hip was flexed, he wrote:

> When the two muscles *a* and *m* (tensor fasciae latae and sartorius) pull, the leg is carried forwards, and the two muscles, *b* and *c* (gluteus medius drawn with two heads) are relaxed, and *d* (gluteus maximus) is elongated: describe this rule in the action of all muscles (QA, 15v).[26]

Of course, Leonardo had no idea of the complicated reflex mechanisms involved or the concept of inhibition, but quite clearly, he recognized that when a muscle contracted there was a relaxation of its antagonist, and he comprehended this principle as a general rule. McMurrich cites this discovery as, "...an interesting foreshadowing of the law of the reciprocal innervation of antagonistic muscles so admirably worked out by Sherrington."[27]

When he resumed his studies of the nerves in the lower extremities during the Florentine period, it was with greater attention to detail and more concern for their relationships with arteries and veins than in his preliminary drawings (Figures 66, 73, and 74), made about fifteen years earlier in Milan. A single folio with supplemental sketches on the two sides reflects his renewed interest. A series of three drawings in Figure 78 feature on the right (A) a somewhat complicated, dense clutter of nerves, arteries, and veins about the knee as seen from the lateral aspect. Relationships are made discernible by separating the clutter into com-

25. Keele, "Research on the central nervous system," p. 15.

26. Ibid., p. 22.

27. McMurrich, *The Anatomist*, p. 132.

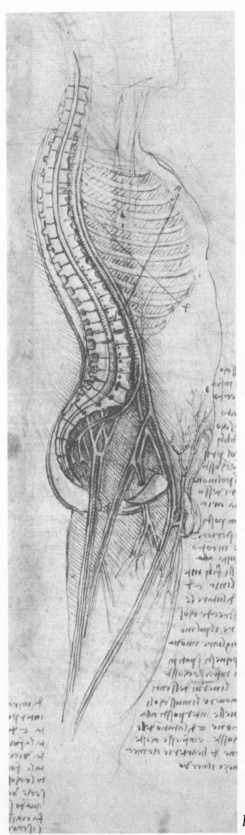

Figure 76.

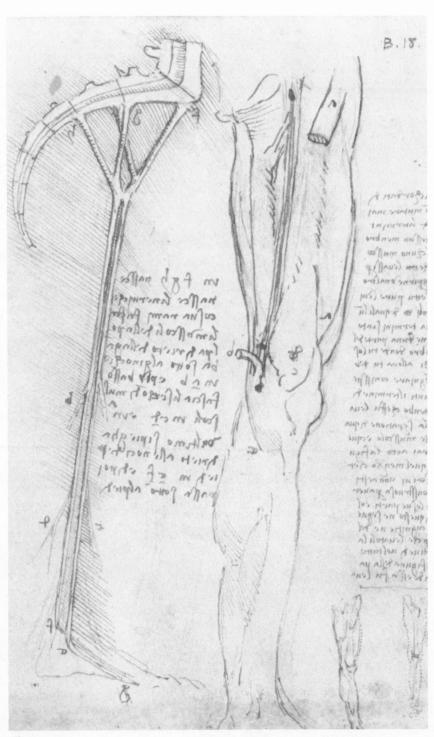

Figure 77.

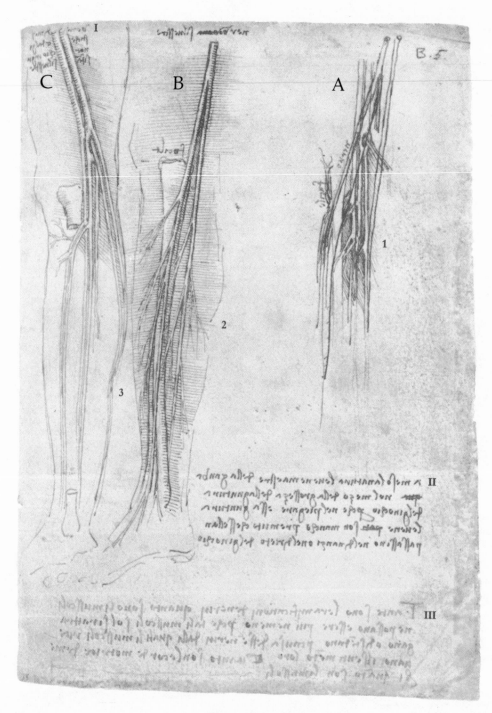

Figure 78.

Figure 79.

ponent systems, demonstrating the nerves in sketch B and arteries in sketch C. In contrast to the crude representation of the sciatic nerve in Figure 77 where it passes to the leg as two separate divisions, it is accurately depicted in sketch B, bifurcating just above the knee. The sciatic nerve, largest peripheral nerve of the body with a diameter almost that of a thumb, is shown more completely in the drawings on the verso (Figure 79), where it

originates from a primitive three-root sacral plexus, passing out of the pelvis through the greater sciatic foramen. Its bifurcation is higher in Figure 79, a normal variant, but one not seen often. The tibial nerve passes down between the heads of the gastrocnemius muscles to supply the posterior calf, but Leonardo fails to continue its terminal branches which normally curve under the medial arch of the foot to serve medial and lateral phantar nerves on the sole of the foot. He is more diligent with the terminal branches of the common peroneal nerve, the lateral division of the sciatic nerve, which faithfully rounds the neck of the fibula (labelled 'fucile') in the illustrations on both sides of the folio to divide into deep and superficial branches. The deep peroneal branch penetrates more anteriorly to supply the muscles of the anterolateral leg region while the superficial peroneal nerve goes to the lateral compartment to supply the peroneal muscles. Leonardo draws these muscles quite accurately in other drawings intended to show muscle and joint relations, leaving these illustrations unencumbered for better delineation of finer nerve distributions. Terminal sensory branches of the superficial peroneal nerve continue down over the dorsum of the foot in B of Figure 78 and C, D, and E of Figure 79, an altogether thorough appreciation and demonstration of what the nerves were meant to do in the lower extremities. Having reached the peripheral limits of his work on the nervous system our study comes to an end.

Overall, Leonardo's studies of the peripheral nerves lack the coherence and sustained tension of his studies in other areas of anatomy. The fact that nerves maintain their integrity rather well comparatively in the decomposing cadaver allowed him to choose his time better and to return to them with better results. However, the delay probably affected continuity and predisposed to the intermittent character of nerve studies. Nevertheless, the originality and brilliant rendering of so many of these drawings give credence to the contention that Leonardo lent an enlightening touch of genius to all he surveyed. His contributions to art and science were incredibly vast and largely incalculable; his work in neuroanatomy was not inconsiderable.

CHAPTER NINE

Summary

AN ASSESSMENT OF LEONARDO'S ACHIEVEMENTS AS A NEUROANATOMIST AND his place in history on this account entails a dichotomy of thought that requires a separate frame of reference for measuring his accomplishments against the background of his time and place, in contrast to the question of his influence on history which is necessarily moot for lack of firm evidence.

At age 67, tired and crippled, Leonardo died without fulfilling his oft-repeated intention to organize and publish his widely-separated anatomical notes. The notebooks containing his anatomical works have remained in private hands. They were not studied seriously until late in the nineteenth century. Reference to the anatomical notes in published works and private correspondence of the sixteenth century, notably those of Vasari, Cellini, de Beatis, and Giovio, are all highly complimentary generalities that helped to create a legend but did nothing to advance the state of anatomy. Accordingly, he remains a figure in isolation, interesting and provocative for comparison and speculation, but outside of the mainstream of anatomical progress right up to the modern period.

We know that some of his anatomical material was left behind in Florence when he departed for France in 1516, and that the dispensation of the collection after Melzi's death in 1570 resulted in further losses to the anatomical corpus. Moreover, statements in the texts allude to a larger dissection experience than what we are able to confirm from the available material. A sense that we may be dealing with a depleted stock is further substantiated by the diary of Antonio de Beatis who wrote on October 10, 1517 that, "...he said that he had dissected more than thirty bodies, both of men and women, of all ages."[1] Nevertheless, we do have a well-preserved and considerable volume of autograph material for our assessment of his achievement in neuroanatomy, and it is the

1. MacCurdy, *The Notebooks*, p. 12. Extracted from *The Journal of Cardinal Luis of Aragon through Germany, the Netherlands, France and Northern Italy, 1517-1518*, writ-

ten by Antonio de Beatis. Edited by Ludwig Pastor and published at Freiburg im Breisgau, 1905.

purpose of our study to present this material in a form that best expresses his intentions for an analysis of his accomplishment.

If we concede that Leonardo possessed a highly developed mastery of the artists' craft, a wide-ranging curiosity and ingenuity that predisposed to original discovery, an independent mind, and a flair for experimental demonstration, it is important to comprehend that he was not operating in an intellectual vacuum, and that medieval science had established a solid body of scholarship in physics and mechanics that was readily available and pregnant with meaningful information for the properly prepared mind. To the extent that Leonardo failed to utilize, shabbily misinterpreted, or merely reiterated the established principles of this heritage, his status as an original and creative genius must be questioned. Medieval science in general is not to be confused with medical illustration which had failed to participate in the intellectual awakening and had remained quite primitive.

It will be apparent to the observer that the skull series, executed in the early years of his anatomical investigations, mark the artist as an accomplished master of perspective, geometrical proportions, light and shade, and exquisite line drawing. However, Leonardo's debt to traditional doctrine is revealed as he projects imaginary forms and fills the contents of these beautiful skulls with unchallenged and essentially unmodified misconceptions of brain anatomy and physiology which carried the weight of authority from conventional dogma. Here the concept of the artist as an empirical scientist with high standards of objectivity conflicts with the unmindful repetition of traditional speculative theory to create an uneasy tension that is slow to dissipate, but becomes less evident with intellectual maturity.

Anatomical discovery, technical innovation, and experimental demonstration were Leonardo's strongest suits, and these were the areas where medieval anatomy was most deficient. When the cultural awakening instigated by Renaissance humanist scholars spread to involve that art world, it was in the bottegas of the artists that these qualities were most assiduously nourished. Topographical illustration of the human form measurably improved as manifested in the works of Antonio Pollaioulo, Signorelli, Michelangelo, and Raphael, but it was Leonardo, virtually alone, who looked beyond the mechanics of muscle and joint action to

explore the neurological origins of motion and physiological functions.

Anatomical discovery is not to be confused with original illustration which merely visualizes known parts and relationships for the first time; however, there is an element of discovery and surprise in every first illustration as there is also in every superior representation of familiar parts. In the skull series, discovery of the maxillary sinus is original, exposition of the nasolacrimal duct a first illustration, and the entire series a splendid evocation of the artist's craft.

Technical innovations abound in the skull series; especially noteworthy is the wedge resection device appropriated from his architectural exposure of building interiors and his engineering experience in demonstrating the inside of castings and missiles. Sagittal resection of the cranium combined with deft light and shade treatment gives a three-dimensional appearance to the cavities.

Experimental demonstration was most effectively portrayed in the injection technique to obtain wax castings of the cerebral ventricles, and in the early physiological experiments on the frog from which he concluded that the upper spinal cord (medulla oblongata) was the center of life. In some unexpressed manner he conducted experiments, possibly on himself, which made him aware of the mixed motor and sensory nature, sometimes exclusively one or the other, of peripheral nerves. Otherwise, experimental procedures were more extensively utilized in other areas, particularly the cardiovascular and respiratory systems.

Discovery and technical innovation were more or less on-going developments in his studies of the nervous system. Some of the luster from his clever devices and his analogies for explaining the mechanisms of sensory function, such as the camera obscura, the pebble analogy, and the pyramidal law, is diminished by his confused and distorted application of optical theory to visual experience. Lindberg fully acknowledges Leonardo's ingenuity and occasional brilliant observations in dealing with sensory phenomena, but points out the ultimate futility of his efforts to advance optical knowledge because of his failure to understand the well-established content of medieval optical theory. Lindberg further cautions against construing Leonardo's analogy of the waves

2. David C. Lindberg, *Theories of Vision from Al-Kindi to Kepler* (Chicago and London, 1976), p. 154-168.

spreading from a pebble tossed in a pool to the images of objects filling the surrounding air as implying a wave theory of light propagation.[2] The paucity of anatomical discovery and of meaningful advances in sensory organ explication may be attributed to the unresolved theoretical errors that characterized these early scientific studies.

Aside from the wax castings of the ventricles which improved his structural drawings of the brain, Leonardo added nothing to our knowledge of its functional capacities. His notions of brain function were vague and confused, based upon a garbled interpretation of traditional philosophical doctrine. Conversely, discovery and original illustration are intimately interwoven in the excellent drawings that reveal the course and interrelationships of the cranial nerves. The optic chiasm is a first illustration of this complex structure, and then demonstration is facilitated by the innovative techniques of "transparency" and the "exploded view." Extracranial vagus nerve extensions are elaborated in great detail and with considerable accuracy. Speculation about cranial nerve differentiation and function in textual passages are not fully investigated, or at least never materialized in drawing, as his interests in neuroanatomy shifted to the heart and motion mechanics in later years.

Drawings of the spine reached a level of excellence comparable with any of his best works. It was more than a hundred years before other anatomists began to appreciate the proper contour, alignment of pelvis, and essential slant of rib attachments necessary to support standing, walking, and breathing. A few minor errors, consistent with asymptomatic congenital anomalies, do not detract from the accurate portrayal of boney articulations and spinal nerve emanations, the discovery of the intervertebral disk, and an "exploded view" of the upper three vertebral segments.

A dissection protocol that left the bones for late resection probably explains why his observations on the spinal cord, a fragile and rapidly necrotizing extension of the brain, always depicted it as filling the entire thecal sac to its termination at the coccyx. Ancient speculative absurdities regarding the role of the spinal cord in generation were perpetuated with graphic non-existent details of structural relationships. The cord was always portrayed diagrammatically. Partially off-setting the speculative errors were

the notes in the texts that reveal his awareness of the true function of the cord as the conductor of motor and sensory stimuli between brain and peripheral nerves. His drawings and descriptions of the meningeal investments were reasonably well executed.

In his dealings with the brachial and lumbar plexuses, an interesting groping progression can be documented over the years from crude, careless portrayal to sophisticated finesse which tends to reflect the general context of his development as a mature anatomist.

Peripheral nerves were depicted with fairly good accuracy in his early drawing with finer attention to detail in the later works. A point of departure in the quality of design can be traced to the dissection of a centenarian at Santa Maria Novella Hospital in Florence about 1508, and some of his best drawings of peripheral nerves derive from this encounter. If there is less delicacy and subtlety in the early drawings of the peripheral nerves made from 1487-1492, there was certainly no less ingenuity in devising techniques for better pictorial exposition. The first instance of "transparency" rendering involved the stereoscopic demonstration of nerves coursing through a leg. On the same sheet the anatomy of a calf is exhibited in cross-section with labelling of parts. In this series of time-related drawings he uses the cross-sectioning device to further advantage by segmentally cross-sectioning an entire leg to illustrate the changing anatomical relationships in-situ.

Thus, it becomes apparent that his flair for technical innovation was a persistent factor in his development as a neuroanatomist, leading eventually to a more confident reliance on his own research methods. By collating, organizing, and integrating the scattered sheets on the nervous system, this work hopes to facilitate the process of assessing his achievements.

Leonardo, as an anatomist, became a legend in his own time. It was a legend that grew as the unsubstantiated generalities became more exuberant after his death, sustained and implemented by his growing reputation as a painter, but his neuroanatomical endeavors ostensibly lay hidden in unyielding private hands. As far as history is concerned, there are those who insist that his voice in anatomical matters was muted in the lonely isolation of private libraries. This hardly explains the sudden dramatic improvement in the illustrative aspect of anatomical exposition that attended his

passage—improvements haunted by lingering stylistic imitations which, like ghostly signatures, attest to his influence and invite provocative deductive inferences. The splendid drawings and textual corpus are fortuitous legacies for fruitful research and reflection.

ADDENDUM

The Handwriting of Leonardo da Vinci

An analysis of the handwriting of Leonardo da Vinci, however distinctive or anomalous the writing may appear, must take into account the prevailing script of Renaissance Florence and an appreciation of historical perspective. Italian Renaissance writing had a very ancient lineage traceable to the Chalcidians from western Greece who settled Cumae on the Tyrrhenian Sea (now the beautiful bay of Naples where awesome physical attractions still seduce the wanderer). Included in the travelling baggage of the early Greek colonists was the Pelasgic script (Figure 1) dating back to the eighth century B.C. All subsequent alphabets of the Italian peninsula, and of Latin Christendom as well, had their

Figure 1. Pelasgic script.

origins in this source.[1] It is believed that the Etruscans acquired the Pelasgic script from the Cumaen settlers. The ancestry of the Etruscans remains purely speculative. Lydia in Asia Minor has been suggested as a site of origin, and other mysterious oriental sources have been fancied from objects found in an Etruscan tomb with the Marsiliana Tablet of about 750 B.C., but no derivative writings have ever been found (Figure 2, disclosing a right to left orientation). The Latini, or early Romans, are believed

1. Samuel A. Tannenbaum, *The Handwriting of the Renaissance: Being the Development and Characteristics of the Script of Shakespeare's Time*, with an Introduction by A. H. Thorndyke (New York, 1958), p. 3.

Read leftward.

Ⴧ♦ⴜⴸ ↇᄀ⑨ᕮMⴖ◌ ⊞•ꙮꙂ ⤳⊗ⴱႨꙃꙃⴖⴱᗄ

Figure 2. Etruscan alphabet of the Marsiliana Tablet about 750 B.C.

to have acquired their learning and letters from their quarrel-some Etruscan neighbors whom they eventually absorbed into their own culture A fine specimen of the earliest Latin writing is incised on a gold fibula (brooch), found at Praeneste near Rome and dated about 600 B.C.[2] (Figure 3)

2. Douglas C. McMurtrie, *The Book: The Story of Printing & Bookmaking* (New York, 1937), pp. 40-41.

Figure 3. The Praeneste Gold Brooch.

Over a period of several hundred years the Roman alphabet lost much of its Greek influence, either by deletions or additions of letters. Eventually the completed alphabet contained twenty-three letters, each having only one form, i.e., the capital. Examples of two variations are the simple, direct, and legible Square Capital, used for inscribed monuments and the finest manu-scripts, (Figure 4) and the thinner and more elongated Rustic

ABCDEF GHIL
MNO P QRS TVX

Figure 4. Square Capitals.

3. Ibid., pp. 40-41.

Capitals, (Figure 5) seen in less formal writings.[3]

ʌ B C D Ɇ G Ħ ɪ L
MNO P QRS ɪ V X

Figure 5. Rustic Capitals.

The slow, tedious task of writing capitals was time consuming for the Roman man of affairs. The practice of shaping letters more rapidly was facilitated by an increasing use of perishable materials such as parchment, vellum, and waxed tablets, but this roman "cursive" writing, characterized by loose and straggling letters, (Figure 6) became so casual that it proved to be almost illegible.[4]

4. Alfred Fairbank, *The Story of Handwriting: Origins and Development* (New York, 1970), p. 42.

Figure 6. Roman cursive script.

The scribes were also guilty of making subtle changes in the formation of capitals, no doubt because of tiring hours spent copying very precise straight strokes. They occasionally relaxed through boredom to form letters with curves and even some that extended above and below the drawn guidelines.

The compromise between the stiff majuscules and scrawled cursive script influenced the rise of an entirely new book hand, the uncial, which shows a clear similarity to our small letter. (Figure 7) Used in the writings of law and government as well as

Figure 7. Uncial script.

the church, the uncials, reached a height of popularity during the fifth and sixth centuries. Before this script went out of use, still another script was developing, the half-uncial. This appears to have been used first by scribes and scholars when they wrote notes in the margins of manuscripts.[5] (Figure 8)

5. McMurtrie, *Book*, pp. 48-52.

Figure 8. Half-uncials, seventh century.

The half-uncials were transmitted to Ireland in the fifth century where a truly distinctive script developed. (Figure 9)

$$\alpha\ b\ c\ d\delta e\ f\ g\ h\ i\ l\ m$$

$$\text{un}o\ p\ q\ r\kappa\int s\tau\ u\ x$$

Figure 9. Irish half-uncials.

The Irish monks wandered to the Continent and established monasteries in Germany, France, Switzerland, and Italy where they influenced all subsequent scripts in Europe. It was definitely the precursor of the eighth and ninth century Carolingian minuscule which was based on a very carefully selected mixture of regional styles.[6] (Figure 10)

$$a\ b\ c\ d\ e\ f\ g\ h\ i\ l$$

$$m\ n\ o\ p\ q\ r\int\tau\ u\ x$$

Figure 10. Carolingian minuscule.

In the eleventh century scribes from northern France began to write the letters with more angularity, resembling the pointed arch of medieval architecture, thus it was dubbed the Gothic style. (Figure 11) By the beginning of the Renaissance, the Gothic

$$a\ b\ c\ d\delta e\ f\ g\ h\ i\acute{i}\ l$$

$$m\ n\ o\ p\ q\ r z\int s\tau\ u\ x$$

Figure 11. Gothic minuscule.

style had become artificial and overly elaborate and it was displaced by the Italic script, a return to the Caroline minuscule.[7] The humanist scholars of the Renaissance in the fifteenth century were bent on resurrecting and reduplicating new-found texts of the classics. The humanist scribal reform was not a battle pitting Roman against Goth, and even though the Carolingian minuscule was considered beautiful, it was adopted principally because it was old. Thus the Caroline script was appropriately named "lettera antica"—the old writing. If the humanists had not liked the Gothic handwriting, they would no doubt have modified

6. Tannenbaum, *Handwriting of Renaissance*, p. 8.

7. Ibid., pp. 10-11.

it.[8] Petrarch complained that the Gothic, although pleasing to scan, was tiring to the eyes when read for any length of time. (Eyeglasses had been invented, but they were neither widely used nor were they very satisfactory.)[9]

The Gothic script remained the traditional script in the vernacular texts for many years, but the scholar wished to create a script both expeditious and clear. Gradually, the rather blunt and amorphous terminal of the early Caroline model copied by scholars was transformed into a sharp clear serif which tended to induce greater care and deliberation in the formation of the minuscules. Tannenbaum refers to this modified Caroline minuscule writing as "Italian Cancelleresca" because it was officially adopted in 1431 by the Papal Chancery.[10] Evidence seems to indicate that Petrarch's beautiful writing (Figure 12) exemplifies that script which was a model for the succeeding semi-cursive type, the Aldine.

Figure 12. Petrarch's script.

The business or notary's script was a cursive variant and is referred to as "lettera italica" or "roman." Wardrop claims that this is the "latent basis of our present handwriting." It served well for writing business transactions because it was informal and rapid and its smaller size was very space-saving. Vellum was no longer as abundant and it had never been inexpensive. The "italic" was usually written with a narrow rounded pen but this caused little differentiation between thick and thin strokes. Wardrop quotes from an earlier study by Schiaparelli that "Italic is simply the gothic cursive under humanistic influence."[11] Thus the humanistic script became the chosen medium of polite correspondence and everyday writing.

Paleography is the study of the evolutionary processes of

8. James Wardrop, *The Script of Humanism: Some Aspects of Humanistic Script 1460-1560* (London, 1963), p. 4.

9. B. L. Ullman, *The Origin and Development of Humanistic Script* 79 (Rome, 1960), pp. 12-15.

10. Tannenbaum, *Handwriting of Renaissance*, p. 14.

11. Wardrop, *Script of Humanism*, p. 12, quoting Schiaparelli, 'Paleografia'. in *Encicl. Ital.*

scripts that strives to discover how and why changes develop. Scripts do not change by themselves, but are controlled by people set in a specific intellectual, social, and economic background. It can be inferred that scripts illustrate and explain the personalities and the temper of the times.[12]

The temper of the times when Leonardo da Vinci was born was characterized by rediscovery and rebirth of lost knowledge and lost thinking. By the fifteenth century the "reawakening of the human spirit"[13] was rapidly developing new outlooks and new purposes. Leonardo was born in 1452 in the small village of Vinci, a mere twenty miles west of Florence, the heart of the intellectual movement challenging traditional medieval culture.[14] He was both a product and a shaper of his times.

Leonardo's formal education probably consisted of reading, writing, basic mathematics, and perhaps the rudiments of Latin. It may be assumed that his handwriting was influenced by the style used by his father, Ser Piero, who as a notary wrote in a Gothic cursive script, i.e., "roman."[15] However, there is little existing evidence of Leonardo's writing from his youthful years (Figure 13); nor is there any formal or private correspondence extant. It was not until he was thirty-seven or thirty-eight years old that he apparently began his "note-taking." As Hart remarks, "...he could scarcely have made them more difficult to decipher if he had intended to do so."[16]

The tedious task of deciphering the notebooks has been attempted by a number of Vincian scholars. Jean Paul Richter spent several years compiling transcriptions from more than five thousand pages of Leonardo's literary labors. He found that the persistent use of a mirror to aid in reading the reversed handwriting was extremely fatiguing and very inconvenient.[17] He learned to read the backwards-running script, written on manuscript pages made available for his research investigation. Richter suggested the theory that Leonardo was naturally right-handed, but possibly received a crippling injury either in an accident or a fight during his youth and found it necessary to teach himself how to use the left hand.[18] This is substantiated by an article written by Norman Capener, F.R.C.S., based on medical and neurological grounds. He states that Leonardo was not a "right-cerebral-hemisphere-dominant" individual, therefore, not left-handed. For his evidence he used a sketch of an alleged self-

12. Ibid., pp. 2-3.

13. Ladislao Reti, ed., *The Unknown Leonardo* (New York, 1974), p. 11.

14. *Encyclopaedia Britannica*, 15th ed. s.v. "Leonardo da Vinci," by W. H. H, Vol. 10, Macropaedia, 1976, p. 810.

15. A well preserved deed written by Ser Piero for a client can be viewed in The Elmer Belt Library of Vinciana at University of California at Los Angeles.

16. Ivor B. Hart, *The World of Leonardo da Vinci* (New York, 1962), p. 192.

17. Jean Paul Richter, Preface to *The Notebooks of Leonardo da Vinci*, comp. and ed. from the original manuscripts by Jean Paul Richter, in two Volumes, (New York, 1970), I:xiv-xv.

18. Jean Paul Richter, *Leonardo da Vinci* (London and New York, n.d.), p. 110.

Figure 13. Leonardo's handwriting at age 25.

Figure 14. Alleged self-portrait of Leonardo's right hand, as seen in a mirror.

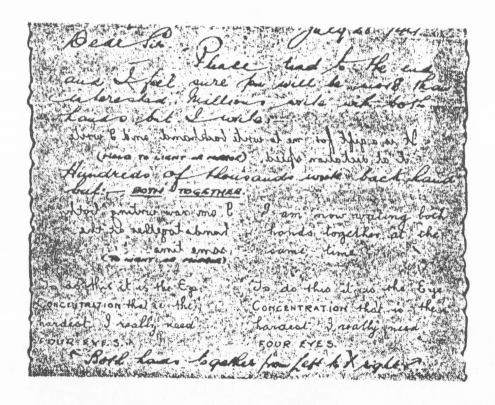

Figure 15. Writing by an ambidextrous writer.

portrait of Leonardo's right hand showing some indication of a deformity. This was sketched as seen through a mirror and drawn with the left hand.[19] (Figure 14) Pedretti feels it is more likely a sketch by a pupil of Leonardo's left hand.[20] Ivor B. Hart conjectures that, as a youth, Leonardo may have accidentally discovered the ease and pleasure of mirror-writing and eventually cultivated this style to the stage where it became quite natural for him to use it. He says further that anyone can try to produce mirror-writing and some will even master it readily.[21] (Figure 15) Reflecting on the influence of ancient alphabets it is interesting to recall that the Phoenician, from which the modern alphabet derived, ran from right to left. It has been suggested that the Phoenicians were left-handed people and that the Semitic people may have been left-handed at some period.[22] Still other scholars believe that Leonardo deliberately adopted his left-handed, back-

19. Norman Capener, "Leonardo's Left Hand," *The Lancet*, April 19, 1952, pp. 813-814.

20. Interview with Carlo Pedretti. Vinciana Library, UCLA, Los Angeles, California. 22 February 1983.

21. Hart, *World of da Vinci*, p. 195.

22. Millais Culpin, in a discussion on a paper presented before the Royal Society of Medicine and cited in "Mirror-Writing," *The Literary Digest* (February 12, 1927), p. 26. Dr. Culpin quoted two passages in the Book of Judges. In the paper presented by Dr. Macdonald Critchley, a medical neurologist, he alleged an association between mirror-

II. Leonardo's Handwriting

The first to discuss the characteristics and peculiarities of Leonardo's handwriting was Jean Paul Richter in his edition of *The Literary Works of Leonardo da Vinci*, published in London in 1883 and in a second, expanded edition at Oxford in 1939. A two volume *Commentary* by Carlo Pedretti, published in 1977, contains much additional material as well as further information on Leonardo's writings and an updated inventory of his manuscripts.

With a detailed explanation of the transliteration system adopted in his edition of the Leonardo text, Richter gave an account of the main features of Leonardo's handwriting, with a sample of the individual letters (p. xxxiii, Text Fig. 11 (b)). Charts of Leonardo's script have also been given by Ravaisson-Mollien and Calvi (Text Fig. 11 (c) and (d)), the latter according to the chronological development of the forms of the letters from c. 1478 to c. 1500. It is customary to say that Leonardo's handwriting after 1500 remained practically unchanged. This may be true as a generalization, but there is still a development of Leonardo's handwriting after 1500 that affects the ductus of the written page as a whole more than the character of the individual letters. Any attempt at describing this development would be cumbersome and inadequate, and in fact style can only be used as a tool after the eye has become sufficiently conditioned to it. There are however a few obvious characteristics as already pointed out in the Richter *Commentary*, I, p. 91:

1. The use of the 'reversed hook' in such letters as b, h, and l.

The following examples show the difference in the forms of such letters at different periods:

1490s after 1500

2. The capital Q at the opening of a sentence, with a bold tail which is arched around to encompass the whole word, usually 'Questo'. Before 1500 the tail is more sinuous and slow, almost timid. A transitional form can be detected in manuscripts dating from 1497 to 1500:

1490-5 1497-1500 1508 and later

3. The use of such symbols as △, □, O, for triangle, square and circle.

4. The frequent use of the symbol ¶ to single out a sentence in the text, usually as a quotation to one of his own treatises. Compare Paris MS. D, f. 1 v.

5. The use of 'ecc' or 'cet' for &c., which appears almost exclusively in writings after 1500, especially in 1510-15.

Finally, as a characteristic of the late writings we must mention the formal compilation format with text and marginalia in manuscripts other than notebooks for casual annotations.

Figure 16. Main features of Leonardo's handwriting.

Figure 17. *A sample of individual letters from Richter (a), Leonardo's own chart of the sounds of the vowels, 114v (b), and an English translation of the vowel exercise (c).*

wards script as a type of code to protect his writings from ecclesiastical censorship or against plagiarism.[23]

The right to left writing, however, is not the only obstacle to deciphering the texts. Leonardo created his very own "short-hand," often using abbreviations, failing to dot letters, amalgamating several short words into one long one, dividing a long word into two separate halves, using no punctuation and no accents, and employing uniquely original symbols that have worked havoc on transcription and translation efforts.[24] (Figures 16, 17, 18, & 19) Numerous research theories are scattered throughout his notebooks in utter confusion. On a single page one can find a paragraph of some principle of astronomy or motion of the earth, a section on the laws of sound, and a few lines squeezed in of some precepts as to color. Surprisingly, these paragraphs are distinct and well-defined and it has been possible to construct a well-planned order out of chaos because each "idea" is usually complete on one page. (Figure 20) A few pages offer instructions to "Turn over" or "this is the continuation of the Previous page."[25]

writing and brain damage. Commenting on the statement of Cardinal Louis of Aragon who had described a form of paralysis that impaired the manual power of Leonardo when he visited him during the last two years of his life, Critchley hypothesized that the mirror image writing might relate to left cerebral disease. He recalled that mirror-writing was not uncommon among the insane, as well as among backward and feeble-minded children. No attempt was made to correlate mirror-writing with genius and thus add to our understanding of da Vinci.

23. Hart, *World of da Vinci*, p. 193.

24. Kenneth D. Keele and Carlo Pedretti. *Leonardo da Vinci Corpus of the Anatomical Studies in the Collection of Her Majesty The Queen at Windsor Castle*. 3 vols. (New York, 1979), pp. xxxii-iii. See also Carlo Pedretti. *The Literary Works of Leonardo da Vinci: A Commentary to Jean Paul Richter's Edition*. 2 vols. (Berkeley and Los Angeles, 1977), pp. 91-2.

25. Ibid., p. xiv.

Figure 18. Charts of Leonardo's script from Calvi, 1925.

Figure 19. An arrangement of individual letters in their chronological development from Ravaisson-Mollien, 1891.

Richter claimed that Leonardo's handwriting altered so little over the years that it was impossible to judge the date of the individual texts.[26] This was later refuted by G. Calvi's study of the notebooks. He established that the writing changed considerably, and especially between the years 1489 and 1495. Pronounced differences enabled Calvi and later scholars to date his manuscripts to a precise year. After 1495 the writing seems to become set or exhibits very little change. By 1510 it begins to grow blunt, heavy, and labored.[27] Against the grain of those who feel inclined to show a neat, datable progression in his writing is a paper by

26. Ibid., p. xv.

27. Kenneth Clark, *Introduction to the Drawings of Leonardo da Vinci in the Collection of Her Majesty the Queen at Windsor Castle* 2d ed. rev. with the assistance of Carlo Pedretti, 3v. (London, 1968), I:xx-xxi. Mr. Clark cites the findings of Gorolami Calvi, *I Manoscritti di Leonardo da Vinci dal punto di vista cronologico, storico e biografio*, 1925.

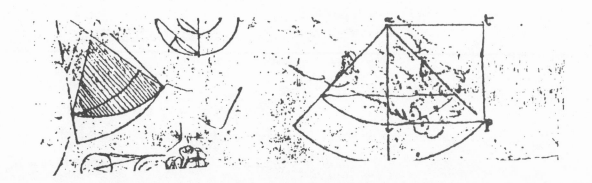

Figure 20. A paragraph of a principle of astronomy, a section on the laws of sound, a few lines of some precepts as to color.

"Lionardo fa bene"—grammar exercise in proper use of an adverb.

"LONAR"—angry, offended, and impatient.

"Leonardo, disciple of experience."

Figure 21. *Variations in Leonardo's signature.*

Introducing himself with a beautiful decorative flourish.

"Profetia di Leonardo da Vinci." (prophecy)

"Leonardo Vostro" in the mathematical speculations.

Explaining his mirror-writing to another, who then tries to copy.

68/2
Ornamental variations on the letter E.

68/5
Left and above: The letter Q with a long tail.

68/6
Left: His shorthand for the syllable per.

68/7
Right: A study of equilibrium in the arms of a balance.

68/9
Above: Decorative flourishes on the tails of small letters.

68/10
Left: Three variations on the shorthand syllable di.

68/11
Left: A demonstration of numerical proportion.

Figure 22. Artistic jottings.

Kate Steinitz which demonstrates an arbitrarism and moody variation in the way he signs his name.[28] (Figure 21)

Augusto Marinoni's essay describes Leonardo's distinguishing and artistic hand even in his everyday exercise of jotting down his thoughts and observations. (Figure 22) Marinoni found this especially true after examining the recently rediscovered Madrid I and Madrid II manuscripts. "The careful craftsmanship...indicates that the author intended to show it to others and perhaps even to publish it."[29] (Figure 23)

On the other hand, Leonardo often wrote haphazardly, hastily scrawling in his apparent impatience to put his thoughts on paper. Quite often these jottings are seen in the margins of some handy notebook or scrap of paper in which he "spelled arbitrarily, skipping words and phrases."[30]

To further confuse any transcription Leonardo filled these same notebooks with the writings and erudition of others on which he seemingly wanted to improve and expand. Still other entries appear to serve as source material for his self-education,"...lists of abstract nouns, adjectives, and verbs known

28. Kate T. Steinitz, "Leonardo da Vinci Signs His Name," *Autograph Collector's Journal* Vol. V, I (Fall, 1952).

29. Augusto Marinoni, "The Writer: Leonardo's Literary Legacy," *The Unknown Leonardo*, ed. Ladislao Reti (New York, 1974), p. 58.

30. Ibid., p. 60.

Figure 23. An example of Leonardo's concern for proportion and harmony.

to scholars but not ordinary people." Marinoni believes that he was "...forever fretting about his scholarly critics, he wrote, 'They will say that, being without letters, I cannot say properly what I want to treat of.'"[31] (Figure 24)

31. Ibid., p. 77.

Among his jottings are those that suggest that he was an individual who liked to entertain and amuse his friends. He scribbled jokes, fables, and riddles (which he called "prophecies"). He sketched many pictographs and picture puzzles for his friends and patrons. (Figure 25)

Clark and Pedretti offer two other forms of evidence valuable to dating Leonardo's writings and drawings: a study of watermarks and different kinds of ink. However, even an expert must be cautious as a watermark may vary from day to day or it may remain the same for three centuries.[32] The preference in certain inks at certain times relates mostly to Leonardo's drawings.

32. Clark and Pedretti, *Drawings of Leonardo*, p. xxii.

In summary, it may be said that Leonardo da Vinci and his handwriting must be considered against the background of time and place, but both were unique, extremely complex, and too mysteriously individual for precise categorization. The strange smile that gently plays on the lips of the Mona Lisa possibly anticipates the specious predicament of such labors.

Figure 24. Self-education exercise.

Cogli acierbi'
With the bitter ones

85/6 ·

Po[n] l'occhio.
Be careful.

In center above
'M'asomiglio ala
(I look like the..)
Then a sketch of an ant

Figure 25. Pictographs and picture puzzles.

LIST OF ILLUSTRATIONS

Abbreviations

Leonardo da Vinci Manuscripts

Anatomical Ms A, An. A, Fogli A.
> *I manuscritti di Leonardo da Vinci della Reale Biblioteca di Windsor, Dell'Anatomia, Fogli A*, pubblicati da Teodoro Sabachnikoff, trascritti e annotati da Giovanni Piumati, Paris, 1898.

Anatomical Ms B., An. B, Fogli B.
> *I manuscritti de Leonardo da Vinci della Reale Biblioteca di Windsor, Dell'Anatomia, Fogli B*, pubblicati da Teodoro Sabachnikoff, trascritti e annotati da Giovanni Piumati, Turin, 1901.

Anatomical Ms C, QA., Q I-VI.
> *Leonardo da Vinci, Quaderni d'Anatomia*, pubblicati da Ove C. L. Vangensten, A. Fonahn, H. Hopstock, 6 vols, Christiana, 1911-16.

Arundel Ms, Codex Arundel.
> *I Manuscritti e i Disegni da Leonardo da Vinci*, pubblicati della Reale Commissione Vinciana. 1, *Il Codice Arundel* 263, 4 pts, Rome, 1923-30.

Codex Atlanticus, CA., Cod. A.
> *Il Codice Atlantico di Leonardo da Vinci nella Biblioteca Ambrosiana di Milano*, riprodotto e pubblicato dalla R. Accademia dei Linei, 35 fasciculi, Milan, 1894-1904.

Codex Leicester, Codex Hammer.
> *Il Codice di Leonardo da Vinci della Biblioteca di Lord Leicester in Holkham Hall*, pubblicato sotto gli auspici del R. Instituto Lombardo di Scienze e Lettere (premio Tomasoni) da Gerolamo Calvi, Milan, 1909. Now at the Los Angeles County Museum of Art.

Madrid Mss, I, II.
> *Leonardo da Vinci, The Madrid Codices*, ed. Ladislao Reti, 3 vols, New York, 1974.

Paris Mss, A-M.
> *Le manuscrits de Leonard de Vinci. Manuscrit A. (etc.) de la Bibliotheque de l'Institut*, plublies...par M. Charles Ravaisson-Mollien, 6 vols, Paris, 1881-91.

Symbols

K/P Catalogue numbers in the Keele/Pedretti edition.

RL Windsor Royal Library inventory numbers.

Bibliography

I. LEONARDO DA VINCI MANUSCRIPTS

I manoscritti di Leonardo da Vinci della Reale Biblioteca di Windsor: Dell'anatomia, Fogli A. Published by Teodoro Sàbachnikoff, transcribed and annotated by Giovanni Piumati. Paris: Rouveyre, 1891.

I manoscritti di Leonardo da Vinci della Reale Biblioteca di Windsor: Dell'anatomia, Fogli B. Published by Teodoro Sabachnikoff, transcribed and annotated by Giovanni Piumati. Turin: Roux & Viarengo, 1907.

Il Codice Atlantico di Leonardo da Vinci nella Biblioteca Ambrosiana di Milano. Reproduced and published by R. Accademia dei Lincei. Milan: Hoepli, 1894-1904.

Il Codice di Leonardo da Vinci della Biblioteca di Lord Leicester in Holkham Hall. Published under the auspices of R. Instituto Lombardo di Scienze e Lettere by Gerolamo Calvi. Milan: Cogliati, 1909. Now *Codex Hammer* in the Los Angeles County Museum of Art.

Leonardo da Vinci: The Madrid Codices. Edited by Ladislao Reti. 3 vols. New York: McGraw-Hill, 1974.

Leonardo da Vinci: Quaderni di anatomia. Published by C. Ove, L. Vangesten, A. Pohnan, and H. Hopstock, with English and German translations. 6 vols. Christiania: J. Dybwad, 1911-1916.

Leonardo da Vinci: A Treatise of Painting. Translated by J. Senex from the Original Italian, and Adorn'd with a great Number of Cuts. To which is prefix'd, *The Author's Life*: Done from the Last Edition of the French. London: Globe, 1721.

Rouveyre, E. *Feuillets inédite, reproduits d'après les originaux conservés à la Bibliothèque de château de Windsor.* 23 vols. Paris: Rouveyre, 1901.

II. GENERAL BIBLIOGRAPHY

Abetti, Giorgio. "Ottica e Astronomia in Leonardo." *Studi Vinciani: Medicina-Fisica-Scienze*, pp. 211-216. Edited by Leo S. Olschki. Florence: Ariani e L'Arte Della Stampa, 1954.

Ackerknecht, Erwin H. *A Short History of Medicine.* New York: Ronald Press Co., 1968.

Ackerman, James. "Concluding Remarks: Science and Art in the Work of Leonardo." *Leonardo's Legacy: An International Symposium*, pp. 205-25. Edited by C. D. O'Malley. Berkeley and Los Angeles: University of California Press, 1969.

Alberti, Leon Battista. *Della Pittura.* Edited by J. W. Spencer. *Leon Battista Alberti, on Painting.* New Haven, Conn.,: Yale University Press, 1956.

Andressey, R. J. and Hagood, Clyde C., Jr. "Leonardo da Vinci: Anatomist and Medical Illustrator." *Southern Medical Journal.* 69(6 January 1976):787-8.

Argentieri, Domenico. "Leonardo's Optics." *Leonardo da Vinci*, pp. 405-36. Milan: Instituto Geografico De Agostini, 1938; reprint ed., New York: Reynal and Co. with William Morrow & Co., 1957.

Asimov, Isaac, *A Short History of Biology.* Garden City, N.Y.: The Natural History Press, 1964.

Bacci, Mina. *Leonardo.* New York: Avenel Books, 1978.

Bazzi, F. and Panebiamo, D. "L'anatomica in Terra di Tuscana nei secoli XV e XVI." *Minerva Medica.* 67(1) (1 January 1976):54-60.

Beck, James. *Leonardo's Rule of Painting: An Unconventional Approach to Modern Art.* New York: The Viking Press, 1979.

Bell, Charles. *Ideas of a New Anatomy of the Brain Submitted for the Observations of His Friends.* London: Strahan and Preston, 1811.

Belt, Elmer. *Manuscripts of Leonardo da Vinci.* Los Angeles: Ward Ritchie Press, 1948.

_____. "Les dissections anatomiques de Léonard de Vinci." *Léonard de Vinci et l'expérience scientifique au seizième siècle*, pp. 189-224. Paris: Presses Universitaires de France, 1953.

_____. "Leonardo da Vinci, Medical Illustrator." *Postgraduate Medicine.* 16(2) (August 1954). Reprint.

_____. "Leonardo The Florentine (1452-1519)." *Investigative Urology*, pp. 99-109. 3(1) 1945.

Benedetti, A. *Sine Anatomice Historia Corporis Humani.* Cited in C. D. O'Malley. *Andreas Vesalius of Brussels, 1514-1564*, p. 441, fn. 9. Berkeley and Los Angeles: University of California Press, 1964.

Benedicenti, Alberico. "Leonardo da Vinci e la medicina dei suoi tempi." *Studi Vinciani: Medicina-Fisica-Scienze*, pp. 3-28. Edited by Leo S. Olschki. Florence: E. Ariani e L'Arte Della Stampe, 1954.

Benivieni, Antonio. *De abditis nonnullis ac micandis morbo rum et sanationum causis.* Florence: Philippi Giuntae, 1507.

Berengario Da Carpi, *Commentaria cum amplissimis additionibus super anatomis Mundini.* Bologna: Benedictic, 1521.

Berenson, Bernard. "An Attempt at Revaluation." *Leonardo da Vinci, Aspects of the Renaissance Genius*, pp. 112-136. Edited by Morris Philipson. New York: George Braziller, Inc. 1966.

Berti, Luciano. *Masaccio.* University Park and London: Pennsylvania State University Press, 1967.

Bloch, Harry, M.D. "Human Dissection: Epitome of its Evolution." *New York Journal of Medicine.* 77(8) (July 1977):1340-2.

Blunt, Anthony. Foreword to *Leonardo da Vinci: Anatomical Drawings from the Royal Collection.* London: Royal Academy of Arts, 1977.

Bodenheimer, F. S. "Léonard de Vinci, biologiste." *Léonard de Vinci et l'expérience scientifique au seizième siècle*, pp. 171-88. Paris: Presses Universitaires de France, 1953.

Bottazzi, Filippo. "Leonardo as Physiologist." *Leonardo da Vinci*, pp. 373-88. Milan: Instituto Geografico De Agostini, 1938;

reprint ed., New York: Reynal and Co. with William Morrow & Co., 1957.

Breasted, James Henry. *The Edwin Smith Surgical Papyrus in Facsimile and Hieroglyphic Translations with Translations and Commentary in Two Volumes.* Chicago: University of Chicago Press, 1930.

Brizio, Anna Maria. "Correlazioni e rispondenze tra fogli del Codice Atlantico e fogli dell'Anatomia B e Codici A e C su l'occhio, la prospetiva, le piramidi radiose e le embre." *Raccolta Vinciana,* pp. 81-9. XVII. Milano: Castello Sforzesco, 1964.

――. "The Painter." *The Unknown Leonardo,* pp. 20-55. Edited by Ladislao Reti. New York: McGraw-Hill, 1974.

――. "The Words of Leonardo." *The Unknown Leonardo,* pp. 292-301. Edited by Ladislao Reti. New York: McGraw-Hill, 1974.

Browne, E. G. *Arabian Medicine.* Cambridge, Mass.: Cambridge University Press, 1921.

Brunschwig, Hieronymus. *Buch der Cirurgia.* Strassburg: Editions Medicina Rara, Ltd., 1497.

Burckhardt, Jacob. *The Civilization of the Renaissance.* London: Phaidon Press, 1944.

Bylebyl, Jerome Joseph. *Cardiovascular Physiology in the Sixteenth and Early Seventeenth Centuries.* New Haven: Yale University, 1969.

Calder, Ritchie. *Leonardo and the Age of the Eye.* New York: Simon and Schuster, 1970.

Capener, Norman, "Leonardo's Left Hand," *The Lancet* (19 April 1952):813-14.

Carli, Enzo. *Luca Signorelli. Gli Affreschi Nel Duomo Di Orvieto.* Bergamo, Italy: Istituto Italiano D'arti Grafiche, 1946.

Cassirer, Ernst. *The Individual and the Cosmos in Renaissance Philosophy.* Translated from the original German of 1927 by Mario Domandi. Oxford: Basil Blackwell, 1963.

Casson, Sir Hugh. Preface to *Leonardo da Vinci: Anatomical Drawings from the Royal Collection.* London: Royal Academy of Arts, 1977.

Chastel, André. *The Genius of Leonardo da Vinci.* A Translation of *Traite de la Peinture, Leonardo de Vinci,* 1960. New York: Orion Press, 1961.

――. "Léonard et la culture." *Léonard de Vinci et l'expérience scientifique au seizième siècle.* pp. 251-63. Paris: Presses Universitaires de France, 1953.

――. "Treatise on Painting." *The Unknown Leonardo.* Edited by Ladislao Reti. New York: McGraw-Hill, 1974.

Choulant, Johann Lugwig. *History and Bibliography of Anatomic Illustration.* Translated and annotated by Mortimer Frank. New York: Schuman, 1945.

Clark, Kenneth. Assisted by Carlo Pedretti. *The Drawings of Leonardo da Vinci in the Collection of Her Majesty The Queen at Windsor Castle.* 2d ed. Edinburgh: R. & R. Clark, Ltd.; 1968.

――. "Leonardo da Vinci." *An Account of His Development as an Artist.* London: Penquin Books, 1973.

――. "On the Relation Between Leonardo's Science and His Art." Leonardo da Vinci. *Aspects of the Renaissance Genius.* Edited by Morris Philipson, pp. 209-21. New York: George Braziller, Inc., 1966.

――. "Leonardo and the Antique." *Leonardo's Legacy. An International Symposium,* pp. 1-34. Edited by C. D. O'Malley. Berkeley and Los Angeles: University of California Press, 1969.

Clarke, Edwin and O'Malley, C. D. *The Human Brain and Spinal Cord.* Berkeley and Los Angeles: University of California Press, 1968.

Corner, George W., M.D. *Anatomical Texts of the Earlier Middle Ages: A Study of Culture* with a revised Latin Text of *Anatomia Cophonis* and Translations of Four Texts. Washington: Carnegie Institution of Washington, 1927.

Critchley, Macdonald. "Mirror Writing." *Literary Digest* (12 February 1927):26.

Crombie, Alistair C. *Robert Grosseteste and the Origins of Experimental Science.* Oxford: Clarendon Press, 1953.

――. "Early Concepts of the Senses and the Mind." *Scientific American,* (May 1964):2-10.

Cruttwell, Maud. *Donatello.* London: Methuen & Co., Ltd., 1911.

Culpin, Millais. "Mirror Writing." *Literary Digest* (12 February 1927):26.

Cumston, Charles G. *An Introduction to the History of Medicine.* London: Dawsons of Pall Mall, 1968.

Daremberg, C. *The Sites of Diseases.* Cited in Clarke, Edwin and O'Malley, C. D. *The Human Brain and Spinal Cord,* p. 590. Berkeley and Los Angeles: University of California Press, 1968.

Daremberg, C. and Ruelle, Emile. *Oeuvres de Rufus D'Ephese.* Texte Collationne sur les Manscrits. Paris: L'Imprimerie Nationale, 1879.

De Toni, Nando, editor. *Il Codice Trivulziano.* Milan: Castello Sforzesso, 1939.

Dijksterjuis, Edward J. *The Mechanization of the World Picture.* Translated by C. Dikshoozn. Oxford: Clarendon Press, 1961.

Duhem, Pierre. *Etudes sur Leonard de Vinci: Ceux qu'il a lus et ceux qui l'ont lu.* 3 vols. Paris: F. De Nobele, 1955.

Eissler, K. R. *Leonardo da Vinci: Psychoanalytic Notes on the Enigma.* New York: International Universities Press, 1961.

――. "Psychoanalytic Notes." *Leonardo da Vinci: Aspects of the Renaissance Genius,* pp. 284-339. Edited by Morris Philipson. New York: George Braziller, 1966.

Encyclopaidia Britannica, Macropaedia. 15th ed. S.v. "Leonardo da Vinci," by Ludwig Heinrich Heydenreich.

Eustachii, Bartolomaei. *Tabulae anatomicae.* Amsterdam: R. & G. Wetstenios, 1722.

Fairbank, Alfred. *The Story of Handwriting: Origins and Development.* New York: Watson-Guptill Publishing, 1970.

Feaver, William. "Leonardo's Curiosity." *Art News.* 77(February 1978):122-3.

Freud, Sigmund. *Eine Kindheitserinnerung des Leonardo da Vinci.* Translated into English by Alan Tyson, under the title, *Leonardo da Vinci and a Memory of His Childhood.* New York: W. W. Norton, 1964.

Funagalli, Giuseppina. *Leonardo Omo Sanza Lettere.* Florence: Sansoni, 1952.

Gaddiano, Anonimo. *Codex Magliabechiano.* Cited in Goldscheider,

Leonardo: Paintings and Drawings, pp. 30-2. London: Phaidon Press, 1975.

Garin, Eugenio. *La Cultura Filosofica del Rinascimento*. Florence: G. C. Sansoni, 1961.

Garrison, Fielding H. *An Introduction to the History of Medicine*. 4th ed. Philadelphia, PA: W. B. Saunders, 1929.

_____. *The Principles of Anatomic Illustration before Vesalius: An Inquiry into the Rationale of Artistic Anatomy*. New York: Paul B. Hoeber, 1926.

Gille, Bertrand. *Engineers of the Renaissance*. Cambridge: Massachusetts Institute of Technology Press, 1966.

_____. "Léonard de Vinci et la technique de son temps." *Léonard de Vinci et l'expérience scientifique au seizième siècle*, pp. 141-9. Paris: Presses Universitaires de France, 1953.

Giovio, Paolo. *Leonardo Vincii Vita*. (ca. 1527). Quoted in Goldscheider, Ludwig. *Leonardo: Paintings and Drawings*, p. 29. London: Phaidon Press, 1975.

Gordon, Benjamin L. *Medicine Throughout Antiquity*. Philadelphia: F. A. Davis, 1949.

Gruner, O. C. "Commentary on the Canon of Medicine of Avicenna." *Hamdard*. XI(7-9) Karachi, Pakistan. (July-Sept. 1967):25.

Hart, Ivor B. *The World of Leonardo da Vinci*. New York: The Viking Press, 1962.

Herrlinger, Robert. *History of Medical Illustration: From Antiquity to 1600*. New York: Editions Medicina Rara, 1970.

Heydenreich, L. H. *Leonardo da Vinci*. New York: Macmillan, 1954.

Holl, M. and Sudhoff, K. "eine dem Leonardo da Vinci zugeschribene Skelettzeichnung in der Uffizien zu Florenz." *Arch. für Geschichte de Medizin*. VII, pp. 323-334. Leipzig, 1914.

Huizinga, A. J. *Men and Ideas: History, the Middle Ages, the Renaissance*. New York: Meridian Books, 1959.

Keele, Kenneth D. *Anatomies of Pain*. Oxford: Blackwell Scientific Publications, 1957.

_____. *Leonardo da Vinci on Movement of the Heart and Blood*. London: J. B. Lippincott, 1952.

_____. *Leonardo and the Art of Science*. London: Wayland, 1977.

_____. "Leonardo da Vinci's Anatomical Drawings at Windsor." *Studi Vinciana: Medicine-Fisica-Scienze*, pp. 76-85. Edited by Leo S. Olschki. Florence: E. Ariani e L'Arte Della Stampa, 1954.

_____. "Leonardo da Vinci's Physiology of the Senses." *Leonardo's Legacy: An International Symposium*, pp. 35-56. Edited by C. D. O'Malley. Berkeley and Los Angeles: University of California Press, 1969.

_____. "Leonardo da Vinci's Research on the Nervous System." *Essays on the History of Italian Neurology*, pp. 15-29. Varenna: International Symposium on the History of Neurology, 1961.

_____. "Leonardo da Vinci The Anatomist." *Leonardo da Vinci: Anatomical Drawings from the Queen's Collection at Windsor Castle*, pp. 12-13. Los Angeles: County Museum of Art, 1976.

_____. "Leonardo da Vinci, the Anatomist." *Leonardo da Vinci: Anatomical Drawings from the Royal Collection*. London: Royal Academy of Arts, 1977.

Keele, Kenneth D. and Pedretti, Carlo. *Leonardo da Vinci Corpus of the Anatomical Studies in the Collection of Her Majesty The Queen at Windsor Castle*. 3 vols. New York: Johnson Reprint Co., and Harcourt Brace Jovanovitch, 1979.

Kemp, Martin. "Dissection and Divinity in Leonardo's Late Anatomies." *London Journal of Warburg and Courtland*. 35 (1972):200-25.

_____. "Il Concetto Dell'Anima in Leonardo's Early Skull Studies." *London Journal of Warburg and Courtland*. 34(1971): 115-34.

_____. "Leonardo and the Visual Pyramid." *London Journal of Warburg and Courtland*. 40(1977):128-49.

Ketham, Johannes. *Fasciculo de Medicina*. Venice: Zuane e Gregorio di Gregorii, 1493.

Kristeller, P. O. *The Philosophy of Marsilio Ficino*. New York: Columbia University Press, 1943.

_____. *Renaissance Thought: The Classic, Scholastic and Humanistic Strains*. New York: Harper & Bros., 1961.

Lambertini, Gastone. "Leonardo Anatomico." *Studi Vinciana: Medicina-Fisica-Scienze*, pp. 55-75. Edited by Leo S. Olschki. Florence: E. Ariani e L'Arte Della Stampa, 1954.

Last, R. J. and Thompsett, D. H. "Casts of the cerebral ventricles." *British Journal of Surgery*. 40(London 1953):525.

Lilley, Sam. "Leonardo da Vinci and the Experimental Method." *Studi Vinciani: Medicina-Fisica-Scienze*, pp. 167-86. Edited by Leo S. Olschki. Florence: E. Ariani e L'Arte Della Stampe, 1954.

Lind, L. R. *Studies in Pre-Vesalian Anatomy: Biography, Translations, Documents*. Philadelphia: American Philosophical Society, 1975.

Lindberg, David C. *Theories of Vision from Al-Kindi to Kepler*. Chicago and London: University of Chicago Press, 1976.

Littré, Émile. *Oeuvres Completès d'Hippocrate*. 10 vols. Paris: Hachette et Cie, 1839-61.

Locy, William. "Anatomical Illustration Before Vesalius." *Journal of Morphology*. 22(1911):945-89.

Los Angeles County Museum of Art. *Leonardo da Vinci: Anatomical Drawings from the Queen's Collection at Windsor Castle*. Los Angeles: Los Angeles County Museum of Art, 1976.

Lyons, Albert S. and Petrucelli, Joseph II. *Medicine An Illustrated History*. New York: Harry N. Abrams, 1978.

MacCurdy, Edward. *The Notebooks of Leonardo da Vinci*. New York: George Braziller, 1954.

McCorquodale, C. "Leonardo da Vinci's Anatomical Drawings from the Royal Collection at the Royal Academy of Arts." *Art International*. 22(1) (January 1978):74-6.

McLanathan, Richard. *Images of the Universe. Leonardo da Vinci: The Artist as Scientist*. Garden City, N. Y.: Doubleday & Co., 1966.

McMurrich, J. Playfair. *Leonardo da Vinci the Anatomist*. Baltimore: Williams and Wilkins Co., 1930.

McMurtrie, Douglas C. *The Book: The Story of Printing & Bookmaking*. New York: Covici-Friede Publishers, 1937.

Magendie, François. "Esperiences sur les fonctions des nerfs rachidiens." *Journal of Physiological esp. path*. Paris. 2(1822): 276-9.

Marinoni, Augusto. "The Writer." *The Unknown Leonardo*, pp.

56-85. Edited by Ladislao Reti. New York: McGraw-Hill Book Co., 1974.

Mathè, Dr. Jean. *Leonardo da Vinci Anatomical Drawings*. Translated by David Macrae. Fribourg: Productions Liber SA, 1978.

May, Margaret Tallmadge. *Galen on the Usefulness of the Parts of the Body*. 2 vols. A translation from the Greek, with an Introduction and Commentary by M. T. May. Ithaca, N. Y.: Cornell University Press, 1968.

Merejcovski, Dmitri. *The Romance of Leonardo da Vinci*. Translated from the Russian by Bernard Gilbert Guerney. New York: The Heritage Reprints, 1938.

Meyer, Alfred M.D. *Historical Aspects of Cerebral Anatomy*. London: Oxford University Press, 1971.

Michel, Paul Henri. "Léonard de Vinci et le problème de la pluralité des mondes." *Léonard de Vinci et l'experience scientifique au seizième siècle*, pp. 31-42. Paris: Presses Universitaires de France, 1953.

Neuburger, Max. *Geschichte de Medizin*. Stuttgart, 1906. Cited in Fielding H. Garrison. *An Introduction to the History of Medicine*. 4th ed., pp. 746-7. Philadelphia: W. B. Saunders, 1929.

Nievo, C. "In Search of the Soul: Leonardo's Anatomical Drawings." *Country Life*. 162 (15 December 1977):1836-7.

O'Malley, C. D. *Andreas Vesalius of Brussells 1514-1564*. Berkeley and Los Angeles: University of California Press, 1969.

———. ed. *Leonardo's Legacy: An International Symposium*, Berkeley and Los Angeles: University of California Press, 1969.

O'Malley, Charles D. and Saunders, J. B. de C. M. *Leonardo da Vinci on the Human Body*. New York: Henry Schuman, 1952.

Panofsky, Erwin. *The Codex Huygens and Leonardo da Vinci's Art Theory*. London: The Warburg Institute, 1940.

Parsons, William Barkley. "Leonardo da Vinci, the Man and the Scientist." Part I in William Barkley Parsons' *Engineers and Engineering in the Renaissance*. Baltimore: Williams & Wilkins, 1939.

Payne, Robert. *Leonardo*. Garden City, N. Y.: Doubleday & Co., 1978.

Pazzini, Adalberto. "Il Pensiero Biologico de Leonardo da Vinci." *Studi Vinciani: Medicina-Fisica-Scienze*, pp. 29-54. Edited by Leo S. Olschki. Florence: E. Ariani e L'Arte Della Stampa, 1954.

Pedretti, Carlo. *Leonardo: A Study in Chronology and Style*. Berkeley and Los Angeles: University of California Press, 1973.

———. *Leonardo da Vinci Inedito. Tre Saggi*. Florence: C. E. Giunti, 1968.

———. *Leonardo da Vinci on Painting: A Lost Book (Libro A)*. Berkeley and Los Angeles: University of California Press, 1964.

———. *The Literary Works of Leonardo da Vinci: A Commentary to Jean Paul Richter's Edition*. Berkeley and Los Angeles: University of California Press, 1977.

———. *Studi Vinciani: Documenti, Analisi e Inediti Leonardeschi*. Geneva: Librairie E. Droz, 1957.

———. Introduction to *Leonardo da Vinci: Anatomical Drawings from the Royal Collection*. London: Royal Academy of Arts, 1977.

———. "Ancora sul Rapporto Giorgione-Leonardo e L'Origine del Reitratto di Spalla." *Giorgione: Atti del Convegno Internazionale di Studi*. Held at Castelfranco Veneto, 29-31 Maggio,

1978. Rome: Banca Popolare di Asolo e Montebelluna, 1978.

———. "Belt 35." *Leonardo's Legacy: An International Symposium*, pp. 149-70. Berkeley and Los Angeles: University of California Press, 1969.

———. "Leonardo da Vinci: disegno come linguaggio." *Il Vetro*. 1-2 Anno XIX (Gennaio-Aprile 1975):27.

———. "Reconstruction of a Leonardo Drawing." *Master Drawings*, A Reprint by The Master Drawings Assoc., Inc. XVI (1978):151-7.

———. Vinciana Library, University of California at Los Angeles. Interview, 22 February 1983.

Penfield, Wilder. *The Mystery of the Mind*. Princeton: Princeton University Press, 1975.

Philipson, Morris. *Leonardo da Vinci: Aspects of the Renaissance Genius*. New York: George Braziller, 1966.

Popham, A. E. *The Drawings of Leonardo da Vinci*. London: Jonathan Cape, 1946.

Pullan, Brian. *A History of Early Renaissance Italy: From the Mid-Thirteenth to the Mid-Fifteenth Century*. London: Allen Lance Penquin Books, 1973.

Rahman, F. *Avicenna's Psychology*. An English translation of *Kitab-Najat*, Book II, Chapter VI with Historico-Philosophical Notes and Textual Improvements on the Cairo Edition. London: Oxford University Press, 1952.

Read, Herbert. "The Illustion of the Real." *Leonardo da Vinci: Aspects of the Renaissance Genius*, pp. 137-43. Edited by Morris Philipson. New York: George Braziller, 1966.

Reisman, D. *The Story of Medicine in the Middle Ages*. New York: Paul B. Hoeber, 1935.

Reti, Ladislao, ed. *The Unknown Leonardo*. New York: McGraw-Hill Book Co., 1974.

———. "Elements of Machines." *The Unknown Leonardo*, pp. 264-87. Edited by Ladislao Reti. New York: McGraw-Hill Book Co., 1974.

Richter, Irma, ed. with commentaries. *Selections from the Notebooks of Leonardo da Vinci*. Oxford: Oxford University Press, 1977.

Richter, Jean Paul. *Leonardo da Vinci*. London and New York: Bridgman Publishers, n.d..

———. *The Notebooks of Leonardo Da Vinci*. Unabridged edition of *The Literary Works of Leonardo da Vinci*. London: Sampson et. al., 1883. New York: Dover Publications, 1970.

Roberts, Jane and Pedretti, Carlo. "Drawings by Leonardo da Vinci at Windsor newly revealed by Ultra-violet Light." *Burlington Magazine* CXIX(June 1977):396-408.

Ronchi, Vasco. "L'optique de Léonard de Vinci." *Léonard de Vinci et l'expérience scientifique au seizième siècle*, pp. 115-20. Paris: Presses Universitaires de France, 1953.

Rosci, Marco. *The Hidden Leonardo*. Chicago: Rand McNalley and Co., 1977.

Royal Academy of Arts. *Leonardo da Vinci Anatomical Drawings from the Royal Collection*. London: Royal Academy of Arts, 1977.

Santillana, Georgio de. "Man Without Letters." *Leonardo da Vinci: Aspects of the Renaissance Genius*, pp. 188-208. Edited by Morris Philipson. New York: George Braziller, 1966.

Sarton, George. *A History of Science: Ancient Science Through the*

Golden Age of Greece. New York: W. W. Norton and Co., 1952.

———. *A History of Science: Hellenistic Science and Culture in the Last Three Centuries, B.C.* New York: W. W. Norton and Co., 1959.

———. "Art and Science." *Leonardo da Vinci: Aspects of the Renaissance Genius*, pp. 158-71. Edited by Morris Philipson. New York: George Braziller, 1966.

———. "Léonard de Vinci, ingénieur et savant." *Léonard de Vinci et l'expérience scientifique au seizième siècle*, pp. 11-22. Paris: Presses Universitaires de France, 1953.

Seman, B. *Man Against Pain*. Philadelphia: Chilton Co., 1962.

Simpson, M. W. H. *Arab Medicine and Surgery*. Oxford: Oxford University Press, 1922.

Singer, Charles. *The Evolution of Anatomy*. London: Kegan Paul, Trench Trugner, 1925.

———. *Fasciculus medicinae. Facsimile of the first (Venetian) edition of 1491 with Introduction by Karl Sudhoff*. Translated and adapted by Charles Singer. Milan: R. Lier, 1924.

———. *Greek Biology and Greek Medicine*. Oxford: Oxford University Press, 1922.

Smith, Alistair. "Anatomical Drawings from the Royal Collection: Royal Academy of Arts, London: Exhibit." *Connoisseur*. 197(February 1978):147-8.

Smith, E. S. *Galen on Nerves, Veins and Arteries: A Critical Edition and Translation from the Arabic, with Notes, Glossary and an Introduction Essay*. Ann Arbor: University Microfilms, 1970.

Steinitz, Kate T. *Bibliographical Report of The Elmer Belt Library of Vinciana*. Los Angeles: University of California Press, 1946.

———. "Leonardo Signs His Name." *Autograph Collector's Journal*. V. I(Fall, 1952).

Streeter, Edward C. "The Role of Certain Florentines in the History of Anatomy, Artistic and Practical." *Johns Hopkins Hospital Bulletin* XXVII (April; 1916):113-8.

Strong, Donald S. *Leonardo da Vinci on the Eyes: The Ms D in the Bibliothèque de L'Institut de France, Paris translated into English and annotated with a study of Leonardo's Optics*. Ann Arbor: University Microfilms, 1967.

Sudhoff, Karl. *Ein Beitrag zur Geschichte de Anatomie im Mittelalter*. Hildeshim, Germany: Georg Olms Verlagsbuchhandlung, 1964.

———. *Essays in the History of Medicine*. Translated by various hands and edited, with foreword and biographical sketch by Fielding H. Garrison, M.D. New York: Medical Life Press, 1926.

———. *Tradition und Naturbeobachtung in den Illustrationen medizinischer Handscriften und Fründracke vornehmlich des 15 Jahrhunderts*. Leipzig: Johann Ambrosius Barth, 1907.

———. *Archiv I-IX, passim*. Leipzig, 1907-16.

Tannenbaum, Samuel A. *The Handwriting of the Renaissance: Being the Development of the Script of Shakespeare's Time*. Introduction by A. H. Thorndyke. New York: Frederick Ungar Publishing Co., 1958.

Taviani, Siro. *Il Moto Umano in Leonardo da Vinci*. Florence: Tipocalcografia Classica, 1942.

Telfer, William, ed. *Cyril of Jerusalem and Nemesius of Emesa*. The Library of Christian Classics, V iv. Philadelphia: The Westminster Press, 1955.

Todd, Edwin M. "Pain: Historical Perspectives." *Chronic Pain*, pp. 39-56. Edited by Benjamin L. Crue, Jr. New York and London: SP Medical and Scientific Books, 1978.

Truex, Raymond C. *Strong and Elwyn's Human Neuroanatomy*. Baltimore: Williams and Wilkins Co., 1959.

Valentier, W. R. "Leonardo as Verrochio's Co-worker." *Leonardo da Vinci: Aspects of the Renaissance Genius*, pp. 57-95. Edited by Morris Philipson. New York: George Braziller, 1966.

Valery, Paul. "Leonardo and the Philosophers." *Leonardo da Vinci: Aspects of the Renaissance Genius*, pp. 350-372. Edited by Morris Philipson. New York: George Braziller, 1966.

Vallentin, Antonina. *Leonardo da Vinci: The Tragic Pursuit of Perfection*. Translated by E. W. Dickes. New York: Viking Press, 1938.

Vasari, Georgio. *Le Vite de Piu Eccelenti Pittori, Scultori e Archetettori*. (Florence, 1568). Cited in Ludwig Goldscheider. *Leonardo: Paintings and Drawings*, pp. 9-23. London: Phaidon Press, 1975.

Venturi, Adolfo. "The Drawings of Leonardo." *Leonardo da Vinci*, pp. 89-92. Milan: Instituto Geografico De Agostini, 1938; reprint ed., New York: Reynal and Co. with William Morrow and Co., 1957.

Vesalius, A. *De humani corporis fabrica libri septum*. Basel: Oporinus, 1543.

Vescovini, Frederica Graziella. *Studi sulla Prespectiva Medievale*. Turin: Stamperia Editoriale Rattero, 1965.

Von Gersdorff, Hans. *Feldtbuch Der Wundtartzney*. Strassbourg: Editions Medicina Rara, 1517.

Von Simson, Otto. *The Gothic Cathedral*. New York: Harper and Row, 1962.

Walsh. J. J. *Medieval Medicine*. New York: Macmillan, 1920.

Wardrop, James. *The Script of Humanism: Some Aspects of Humanistic Script. 1460-1560*. London: Oxford University Press, 1963.

Zerbi, G. *Liber anathomie corporis humani et singulorum membrorum illius*. (Venice, 1502). Quote in L. R. Lind. *Pre-Vesalian Anatomy*, pp. 146-56. Philadelphia: American Philosophical Society, 1975.

The text of this book was set in Palatino,
a modern type inspired by classic Italian forms
and designed by Hermann Zapf.

❦

Design and typography by Jim Cook
Santa Barbara, California.

❦

Printed and bound by Kingsport Press,
Kingsport, Tennessee

❦

November 1983

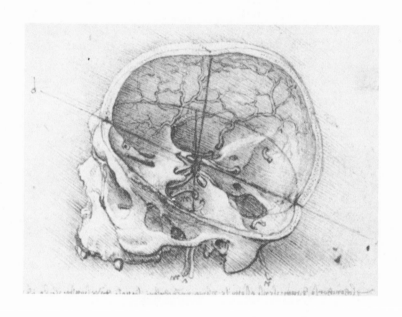